For: Jin ♡

I found this book
to be helpful in discerning
what Christian art is
suppose to be; as well as
inspiring to create — as we
were created to do — to the glory
of God!

with love,
Robin
Emily
Tong
Chang

Square Halo Books

IT *was* GOOD—
MAKING ART *to the* GLORY OF GOD

- not so good
√ good
* amazing

CONTENTS

First Edition 2000

Copyright © 2000 Square Halo Books
P.O. Box 18954, Baltimore, MD 21206

ISBN 0-9658798-2-8

Library of Congress 00-105398

Printed in the United States of America.

This book is dedicated to
Alan and Diana—
who are responsible
for this, and so many other
good things in my life.

Foreward

Early in my artistic career I was encouraged to read *The Christian Mind* by Harry Blaimires. The book challenged Christians to "think Christianly," to grapple with our faith in relation to every area of life from a Christian perspective, and to struggle with issues that touch on our work and world. The book did not deal in any way with art, but it set in motion the principles that would help me question from a Christian perspective how and why I worked as an artist.

Thirty years ago there were only a limited number of books addressing art and faith and even fewer written by Christian artists about their art-making. How did we exist? How did we grow? In what context did we create?

Even though artists essentially work alone in the studio, there is a deep need for community. The local church is supposed to be a place for personal and spiritual development, but most Christian artists find themselves lonely with few to help them work through theological or practical issues of concern to them. At the same

time Christian artists experience a sense of alienation from the arts community.

To help fill this void CIVA, Christians in the Visual Arts was founded in the late 70's. Over the years hundreds of artists, theologians, and art historians have come together to help work through some of the issues, to challenge one another to excellence, and to create an environment in which relationships could develop that would nurture and build Christian community among artists. The fruits of some of those relationships have begun to surface as is evidenced in this collection of essays, *It Was Good: Making Art to the Glory of God.*

Much has changed in these years. There is a quiet renaissance in the church with renewed interest in the arts surfacing at many levels. At the same time a cry for the 'spiritual' comes from all corners of our culture. The time is ripe for the Christian artist to be a presence seen.

However, some questions beg our attention. Are we ready for the next century? Do we as artists know how to "think Christianly" in matters of art-making? Is our work grounded in good theology? Are we prepared to create work that is so compelling it will leave its mark on the next generation? Are we engaged in the culture enough to offer anything of significance?

This book is a valuable gift to the next generation of Christian artists who must grapple with these questions. It offers voices of experience and insight from godly artists who have dedicated their lives and talents to the arts. Their commitment to being artists of integrity as well as thoughtful Christians has laid a foundation for the next generation.

—Sandra Bowden
 President of CIVA

okay,

you're
A CHRISTIAN
and
AN ARTIST—
NOW
WHAT?

Intent

The goal of this book is to provide a deeper discussion of what believers practicing their discipline for God's glory would (or should) look like. Rather than defending the believer's place in the arts—which has been done very well in other works—this book is intended to be primarily about issues related to making art.

The premise of this work is that a Christian looks at the world differently than the non-Christian due to a restored relationship with the Creator. With that restored relationship comes certain responsibilities which are presented in *True Spirituality* by Francis Schaeffer when he says,

> Christians are to demonstrate God's character, which is a moral demonstration, but it is not only to be a demonstration of moral principles; it is a demonstration of His being, His existence.

This moral demonstration will be worked out in the creative process. If not seen thematically in their work, it will be seen

foundationally in their existence. It is not the believers' goal to integrate their art with the Faith, rather the art of God's chosen people must spring from faith. Our relationship to our Creator is the one core issue that matters and this relationship gives us the freedom to have "no prescriptions for subject matter," as Hans Rookmaaker says.

Imagine a Christian sitting down to create a piece of pottery, write a novel, or paint a picture. This believer has decisions to make: color, form, content, theme . . . as well as where they fit into their church and larger community. Of course this book can't dictate things such as, "Paint a red bird . . . write the song in standard time . . . the pot should have three handles . . . " But decisions do need to be made and it is the intent of this book to give the readers ideas to work through so they can develop the internal tools needed to carry out their artwork with a biblical worldview.

In this way, *It Was Good—Making Art to the Glory of God* will offer both theoretical and practical insights into the making of art from a biblical perspective. And this is crucially important in our age since the area of Beauty is the only point of connection with society since the bridges of Truth and Goodness have been burned. Kuyper's concept of the dual purpose of art to imitate and transcend nature resonates at this point. We as believers in the arts can show through the common grace of art a fleeting picture of Eden. We should not allow the arts to be the sole dominion of the enemies of God but instead we should join with Martin Luther in affirming our desire to see all the arts "in the service of Him who has given and created them."

Acknowledgments

This book was a labor of love of many people. First off, a huge amount of thanks needs to be given to the writers who contributed graciously of their time, talents, and insights to see this project come into being. Thanks also to those who offered encouragement, ideas, and read early drafts of the book. Unending thanks must also go to Mary Grace O'Rourke, Carl Petticoffer and all those who were responsible for the reading and proofing—often making sense of muddled sections of this book.

Above all there is my wife Leslie, who was the most enthusiastic supporter of this project, without whom this book would not have come into existence.

GOD IS GOOD *like no* OTHER

"Why do you ask me about what is good?" Jesus replied. "There is only One who is good." Matthew 19:17a

And It Was Very Good

As believers making art to the glory of God, goodness is not merely something to strive for in our morality, but is also something we should attempt to communicate through our aesthetic efforts. Portraying 'good' well, however, is excruciatingly difficult. The efforts of most artists who attempt to present a picture of 'good' tend toward dishonest, sugary sweet propaganda. They ignore the implications of the Fall, and paint the world as a shiny, happy place. Usually 'goodness' or the 'good' is ignored in favor of pursuing negative themes or motifs. Stuart McAllister, of Ravi Zacharias International Ministries, asserts in his essay entitled *What Is Good and Who Says?* that "much of the energy and effort of our artists and cultural architects has gone into debunking, dismantling, or deconstructing all that is good, beautiful, and respected, to be replaced with the shallow, the ugly,

the ephemeral." In contrast, followers of Christ who labor in the arts must take up the subject of 'good' or 'goodness' to the glory of God. They need to struggle to understand it and to present it in such a way that a world—forgetful of true goodness since the Fall—can be taught what the word means, and so be led to the only good One. This is a unique opportunity. Christ gives believers the potential to understand good. If one knows Christ he knows God. God is good. Otherwise one's knowledge of God is perverted.

We are confronted with the concept of 'good' from the very beginning of Scripture. God's motive and goal for making the cosmos was to display His goodness. We are informed by the writer of Genesis that what God made was good. God said so himself. The Creator evaluated his own work and pronounced, "It was good." God's goodness moved His wisdom to conceive of creation and His power to make it. This world He created bore no resemblance to the yin-yang pictures of the world presented in other creation stories. What the Almighty made was good in every way for its purpose. It was useful, healthy, and morally perfect.

God's pronouncement transcends the mere usefulness to us of creation because the evaluation of creation's goodness came before anyone could use it. For example, following the creation of light, God said that "it was good." This is not just a pragmatic 'good,' because at that point in the sequence of creation there were no plants existing to conduct photosynthesis using the light, and no humans to work and play in the light. The light merely existed and it was good. In his book *At the Crossroads,* Charlie Peacock-Ashworth states, "Creation is useful because it is good. It is not good just because it is useful." The universe was made by God, it conformed to His nature, reflected His image and therefore was pronounced 'good.'

Though it is drastically altered in the Fall, this goodness of creation has not been completely obliterated. Man, for example, retains goodness as a bearer of the image of God, and even Satan retains a natural goodness in that he is God's handiwork, while morally he is completely corrupt.

The word used throughout most of Scripture for "good" in the Hebrew is *ṭôḇ* (pronounced "tōv") or when translated in the Greek, *agathos*. Both words convey the broad meaning of that which is good, useful, and especially good morally while also conveying the aesthetic moment of beauty. We find this word applied to God in at least three ways. The first application is in *creation* by God making us in His image, giving us souls and placing us in a beautiful garden. Second, in *redemption,* since God was not obligated to show us mercy (as He hadn't shown any to the fallen angels) after we, through Adam, rebelled against the Creator's goodness. Third, God's *providence* displays His goodness. As J.I. Packer points out in *Knowing God,* He is "good to all in some ways and to some in all ways." God's goodness is evident in so many areas: the very gift of life, the offer of salvation, the provision of deep and lasting relationships, the ability to create art, and a beautiful world to inhabit, not to mention our daily bread. This entire book could be devoted to describing His glorious goodness and it would not even begin to scratch the surface of its depth.

God's goodness isn't merely something He does or pronounces. Goodness is an essential part of His being. In Exodus, when Moses asked to see God's glory, we find that His goodness isn't just a small part of His glory but that his glory *is* His goodness.

> And the LORD said, "I will cause all my goodness to pass in front of you, and I will proclaim my name, the LORD, in your presence. I will have mercy on whom I will have mercy, and I will have compassion on whom I will have compassion."
> *Exodus 33:19*

We also see in God's response that justice is integral to His goodness when God tells of His right to show mercy as He chooses. The act of showing mercy requires the presence of actions that justify punishment. Any permitting of the twisting of good to be evil without consequences issuing from God would impune His goodness. Goodness must hate evil and therefore punish evil. Because sin is evil, God's goodness is shown in His just punishment

of evil actions. If God did not show justice and punish evil then He could not be good, and by default He would not be God.

Our God is infinitely, perfectly, immutably, essentially, primarily and necessarily good. As the infinite and unchanging initiator of good, goodness is inseparable from his nature. Stephen Charnock underscores this in *Discourses Upon the Existence and Attributes of God* declaring that God, "is the efficient cause of all good, by an overflowing goodness of his nature; ... Goodness is the brightness and loveliness of our majestical Creator."

Certainly a divine attribute like goodness deserves our attention, reflection, and devotion to understanding it more and our energies spent in portraying it as a theme in our art. Some might claim that they already are pursuing this theme in their work. This may be the case, but often good is not portrayed well in the artwork of believers. I would maintain that this is due to a general misunderstanding of what the word 'good' really means. Usually 'nice' or 'sweet' are presented as synonyms of good. This is where we begin to see our collective understanding of the concept of good begin to break down. A 'nice' or 'sweet' God would not destroy every living creature, except those who could fit on one boat, in a worldwide cataclysmic flood. When we think that God's mercy, grace, patience, and abundance of truth all spring from His goodness we are reminded by Charnock that "All the names of God are comprehended in this one of good" and then we can see that this makes creating artwork concerned with goodness extremely difficult.

"I'm Not Bad—I'm Just Drawn that Way."

One reason goodness is hard to represent in art is that we all have a misunderstanding of the word 'good' resulting from a distortion of true goodness observable in the world around us. For example, imagine a conversation between a fish and a turtle. Both creatures would be able to discuss the idea of 'land' but the turtle would have a very different understanding of the concept due to his experience which would include the idea of *dry* dirt,

a worldview which would be in contrast to the fish's experience of only *wet* dirt. We use the word "good" and believe that we understand it, but having only experienced a post-Fall type of goodness in our unregenerate state, like the fish's understanding of dirt, our comprehension of good is *bent.*

In *Out of the Silent Planet,* C. S. Lewis introduces the idea of 'bent.' In that book the protagonist, a philologist from Cambridge, goes to Mars where he meets creatures who don't have the word "bad" in their vocabulary; therefore he uses the word 'bent,' a visual term, in order to describe 'bad.' Toward the end of the story, Lucifer is referred to as "the Bent One" during a discussion of Lucifer's rebellion against God. Using the word 'bent' to describe the situation we experience in the world around us is helpful because we know from Romans 8:22 that creation is groaning under the burden of the Fall. Yet it is not completely perverse because we are still able to see God's goodness as we look into His handiwork (Romans 1:20). Furthermore, we can still find the image of God in the faces of mankind in spite of our total depravity.

The Christian worldview has the ability to address the issues of a bent world with a message of redemption, hope, and goodness. Therefore the follower of Christ has the usually unrealized potential of having a greater insight into the true nature of goodness than someone who does not follow Christ. But the believer's efforts to portray goodness in art can possibly run into problems, even if a truly Christian worldview is utilized, because the Christian cannot control or determine the perception or reception of the art itself. Frequently goodness may be misunderstood or simply not even perceived. This wrong perception is due to living an entire life in a bent world. In other words, when we view and create art we are not able to escape the fallen world we live in. We can neither rise above it, nor go around it. We are bound to it. It pervades everything we think and do. There is a communication problem when trying to portray a proper understanding of good to those whose catalog of images and experiences is thoroughly bent.

The assertion that a believer has a greater insight into the true nature of goodness does not imply an inherent superiority of intelligence or moral superiority that gives the believer the potential to understand goodness better than his neighbor. In fact, the good news of Christ boldly asserts that it is only by the mercy of God and His grace that followers of Christ are given new hearts and therefore a sensitivity to the Spirit. And then it is only as we resist conforming to the world's mold and instead be transformed by the renewing of our minds that we are able to *begin* to understand true goodness.

Once we are *in Christ* we are a new creation with a new world view and new experience of reality, making us different from those around us. We then have the possibility of finding ourselves in situations like the turtle with the fish, where true understanding of the former's condition is simply beyond the latter's experience. As believers making art, part of the story we have to tell, part of the meta-narrative, is the idea of 'good.' So then where do we go for an understanding of 'good' that we can use to begin building bridges across chasms of misconception?

A Good Foundation

The first thing required of Christ's followers when engaging the concept of 'good' is that we look to God for insight because 'goodness' is one of His attributes. Unfortunately, because 'good' is a perfect attribute of an infinite Creator and we are only finite creatures, a complete grasp of good is beyond our reach. Though we can't know goodness fully, we can know it truly if the Creator reveals it to us His creatures.

The almighty, infinite and personal God has revealed Himself through Scripture so it is to Scripture we must turn. If we are to even attempt to communicate good in our art we must push out beyond our bent understanding of it and draw from the depths of God's character. By using the means of grace made available to us—those things that God uses to strengthen our faith—we can begin building

the spiritual and philosophical foundation required for greater insights and discovery about good during the creative process.

To begin "unbending" our understanding of good we must read, memorize, meditate on, and receive through preaching God's holy Word. And when we study Scripture, we must approach God's Word mindful that we carry bent preconceptions or 'filters' of what we think God has said before we bother to find out what is actually written there. A. D. Bauer has observed, "Believers read the Bible through filters that deny the reality of God and preachers preach the Bible using filters that make 'good' not truly good."

In addition to Scripture study, other means of grace available to us for mining the depths of God are fellowship, prayer, and the sacraments. We learn much about God when we spend time with the body of Christ and when we tell others of the amazing grace offered through Jesus. We need to practice 'good' to understand more about 'good.' When meditating on the attributes of God such as His goodness, during sacrificial fasting, giving and serving others, God is often generous in revealing aspects of His person. And when we focus on the person of Christ and His deity during prayer and worship, He helps us understand more adequately the attributes of God, including goodness.

By applying these means of grace in our lives, under the supervision of the Spirit, we can grow in our sanctification, becoming the new creatures that we already are in Christ. Then we can also begin to really see things—such as goodness—as it truly is. It is at this point, after the foundation has been laid by the means of grace, that we learn something new of God. We can add the dimension of that insight to our palette, enabling us to discover much more in the process of creating art, and then make something new within our artistic discipline. Each of us must wrestle with what goodness is and expand our knowledge of goodness before attempting to portray it in art.

Tohu and Disney

After our hearts and minds are sensitive to the Spirit's voice which offers insight into the Trinity's attribute of goodness, we can proceed to struggle with the hard work of making art.

Speaking to the issue of the portrayal of goodness in art, Edward Knippers insists, "Goodness needs to be attached to the real world because if you separate it from reality what you are left with is Disney World." The 'good' portrayed becomes the two-dimensional, sweet, niceness of Snow White. Instead, the believer's art should be rooted in the rich soil of the Christian worldview. It is out of the life-giving understanding that humanity is far worse off than we think and God's grace extends far beyond that which we can imagine, that we can produce good fruit that is rich in the fullness of our humanity.

There could be as many ways to illustrate 'good' as there are believers who are willing to prayerfully take up the task. Yet as with a blank sheet of paper, one has to begin making marks somewhere, so we'll start in this discussion with chaos. Chaos may seem out of place in a discussion regarding the portrayal of good, but if we look back to God's aesthetic efforts in creation, chaos is where we see Him beginning. Genesis begins "tohu," meaning in Hebrew "without form." It communicates the idea of a trackless, empty wasteland. Into this formlessness God brings form. He makes something good. In art, one possibility of portraying good can be presented in a similar way by placing in sharp contrast order and design with chaos and waste. Perhaps using elements such as a honeycomb, the wing of a dragonfly or a nautilus shell to show God's grand design (as Gaylen Stewart describes in his essay on symbolism) then placing them in a context of formlessness, would jar the receiver of the art into seeing the good of God's creation.

A classic example of how to portray the goodness and righteousness of God's redemption is found in Michelangelo's *Last Judgment*. In this painting Christ in all of His glory is depicted as condemning the unregenerate to Hell as they are dragged down by devils while Charon waits below in his boat. With his left hand

warmly extended, God's Son gently receives the elect. The angels below him blow their horns and hold out the book of life for all to see. On Jesus' left and right the saints are gathered into heaven with their instruments of martyrdom as badges of honor. Above this amazing scene we find the angels displaying the elements which were used in the Messiah's torturous sacrifice for our benefit and salvation.

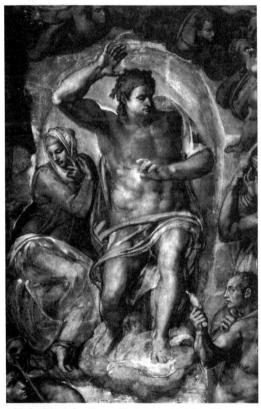

Michelangelo. LAST JUDGMENT (*detail*), 1535-1541. Fresco. 40.93 meters long by 20.70 meters high.

The composition of the painting is rooted in concentric circles that lead to the figure of Jesus Christ as the judge of the whole earth. The damned are displayed as descending to the fires of Hell and the ascent on the left of the elect believers emphasizes the rotation of the entire piece and further underscores the drama of the End. Michelangelo's use of torsion and rotation seen in so much of his work reaches a peak in this masterpiece which communicates the apocalyptic end of history as we know it, pointing all toward Jesus. Having returned from hearing the sermons of Savonarola, the *Last Judgment* illustrates Michelangelo's newly reformed ideas, his awareness of his own sin,

and his desire to give praise to the wonderful gift of God's grace alone. This shows God's goodness by pointing out the justice of God. As shown earlier, good cannot tolerate evil. Even on a human scale, justice in the face of evil is demanded. Critiquing the lack of general German resistance to the Holocaust during World War II provides a classic example of this. We cry "foul" to such social neglect and call into question the goodness of individuals of that time. In the same way we must require God, if He is God to hold to an extremely high standard of moral excellence. Therefore the *Last Judgment* is a great example of portraying divine goodness.

Another example of portraying God's goodness—specifically His providential goodness—is found in some lines from The Innocence Mission's song "Bright as Yellow" taken from their album *Glow*. The music they make is exemplary in matching lyric to melody so that in the final piece the music helps to convey more meaning than the lyric alone possesses. This song speaks of those rare and wonderful people who aren't self-conscious when talking with others. They are only aware of other's needs as they reach out in love, not held back by the awkwardness of self-concern.

> And you live life with your arms reached out.
> Eye to eye when speaking.
> Enter rooms with great joy shouts,
> happy to be meeting.
> And bright,
> bright,
> bright as yellow,
> warm as yellow.

Though not a song specifically about 'goodness,' this song portrays one of the good, quiet blessings of life we receive from the Father's hand. Like the paintings of so many of the Dutch Reformed painters, it is in the earthy basics of life that we can often see God's tender care for us most clearly.

Recently I had the opportunity to wrestle with the problem of portraying God's providential goodness. I was given the privilege

of illustrating a children's book about the nautical adventures of
an Irish abbot of the early Middle Ages named Saint Brendan
entitled *The Sailing Saint*. In the story Brendan and his crew of
monks set sail in faith toward the edge of the world and encounter
many wondrous and strange things. Several times in the story they
pray to God asking for His care and protection. Mimicking the
Hiberno-Saxon style of the Book of Kells, the knotwork frames of
the illustrations set the story within God's complex but orderly
creation. In *Bless the Boat* [see color plate 2] "God the One Person of
the Three" is petitioned for care and protection. God's providential
care is seen as He comes to abide in and around the boat. The
Trinity is shown as separate but a whole as the Spirit indwells the
boat, the Father's hand of protection overshadows the boat and the
Son is both in and out of the boat as an intermediary. The boat
becomes a symbol for the believer in Christ as the Spirit lives in us.
The Father cares and watches over us and the Son intercedes for us
in Heaven. Good may be mercurial to represent in regards to the
Almighty, but his acts of goodness in creation, redemption, and
providence can be seen as clearly as we see the path of the wind
through the trees.

Edward Knippers' work *Potiphar's Wife* [see color plate 3]
portrays moral goodness strikingly as he creates a tension between
evil and moral goodness. The painting graphically presents the
viewer with Joseph's moral dilemma. Joseph is tempted by his
employer's wife daily to go to bed with her. Finally one day while
alone with her he is forced to flee from her advances and it is in the
heat of this moment that Knippers paints 'goodness.' We see in
Joseph's response to the seductions of Potiphar's wife blinding
good burning through corrupt advances. The painter has said that
one man who saw this painting said that Joseph was crazy; that he
would have taken Potiphar's wife up on her offer. In this way we see
Knippers' painting working because it shows a goodness that goes
beyond conventional wisdom.

In the sculptural piece *Taste and See* [see color plate 5], Ted
Prescott presents another example of portraying the concept of

the providential goodness of God, springing from out of Psalm 34:8a, "Taste and see that the Lord is good." Psalm 34 is a record of David praising God irrespective of his circumstances.

In this sculpture, Prescott has placed honey in a hand-blown glass bowl which disappears as it nestles beneath a lip in the white Colorado Yule marble which has been placed on a frame made from butternut wood. Though the design, no doubt, owes a great deal to Japanese sculpture and aesthetics, the piece is part of a larger interest in the religious underpinnings of nature, and nature imagery. This work reminds us that God's goodness is not abstract but is also sensual. It brings God—whom we might feel is distant—close to us.

The title *Taste and See* acts as an unintentional command when the piece is exhibited in an open setting. People will actually taste the honey, which over time gets spread around on the top of the marble. Though a bit messy, it gives the piece a ceremonial and participatory quality. This furthers the altar-like, liturgical feel. It also fulfills in a very literal way the invocation of Psalm 34. The use of honey in the piece can also direct the audience to Psalm 19:10 where we read that God's law is sweeter than honey. The honey used in this sculpture is Tupelo honey, one of the most expensive honeys to produce. It has a light golden amber color with a greenish cast. The flavor is delicate and distinctive and it will never crystallize due to its high fructose content. The nature of this particular kind of honey further develops the concept of God's goodness. That the honey remains a liquid gives a timeless sense to the piece. The expense of the honey also can remind one of the Psalm 19 reference to God's law being more desired than gold and silver.

The three-dimensionality of the work brings God's goodness into real space, encouraging the viewers to 'see' with all of their senses, thereby leading them out of themselves to an intuition of hidden realities. This sense of seeing brings to mind the account in the Gospels of Jesus offering to Thomas the opportunity to 'see' through touch. Thomas had insisted on placing his fingers in the wounds of Christ before he'd believe in the resurrection. Then when Jesus reappeared to the disciples, Thomas was told by our

Lord to "Put your finger here; see my hands. Reach out your hand and put it into my side. Stop doubting and believe." As stated earlier, Paul says in Romans 1:20 that one of the important ways we sense God, experience something of His character, providence, and goodness, is through creation. *Taste and See* is not meant to be didactic, but to evoke the kind of delight we have when we experience something that is good, beautiful, and true.

Prescott's sculpture echoes the psalmist's command to experience God's goodness, and in this teaches the receiver that God's goodness *can* be experienced. With this knowledge in hand, responsibility is now upon the viewer to investigate God's goodness further.

These examples show how true goodness can be shown in art by focusing on the glorious goodness of God in his creation, redemption, and providence. Set before us in all these works of art is the measure that is the goodness of God. Stephen Charnock identifies this yardstick when he writes, "Nothing is good, but as it resembles him;" It is clear, one hopes, that there is the potential to portray biblical 'goodness' through art.

The presentation of 'good' as a theme in the context of a fallen humanity will inevitably include the presentation of elements of sacrifice, mercy, and grace if it is to be presented with integrity. These elements need to be presented in the light of the goodness of God and not in a preoccupation with evil. Edward Knippers commented to me once on this subject that, "evil has no substance ... evil is destructive as water is wet." C. S. Lewis touches on this same thought in *The Letters of C. S. Lewis to Arthur Greeves*:

> evil is not a real thing at all, like God. It is simply good spoiled. That is why I say there can be good without evil, but no evil without good ... Evil is a parasite. It is there only because good is there for it to spoil and confuse.

This is not to say that evil must be avoided in art but that, unlike goodness, it should not be an artist's steady diet. That is the advantage of portraying 'good' instead of evil. Though difficult,

the portrayal of good is a portrayal of *something*. Goodness finds its substance in the eternal sense as the glory of God.

Why Portray Good?

Daniel Lee wrote in an essay entitled "Filling the Cultural Void" that believers "are called to a different path, a path of obedience. Our lives and work are to be an offering." Later in the same piece he says that we are called to create and commission "new works of art that refuse to be timid, that speak the truth plainly and reveal the glory of our God in a way that gives our despairing age new hope."

The challenge to offer hope by portraying the glory of God's goodness should be embraced because it is the philosophical life raft people need; it is the new language people need to learn to speak. The Christian message offers the good news of gospel, offers light in darkness. The more we focus on good and delve into good, the more we reveal who God is—that God *is* good—and we give a vocabulary of grace to those who are needing it.

This is why a concept of 'good' is important. As believers we are to be pointing to the good, to the Creator, showing this generation what 'good' is, so that people can understand what they're missing and so direct them to Christ. But we should not attempt to portray moral goodness as a concept or theme in our artwork merely as a pre-evangelistic tool. We need to think back to the creation of all that is and remember that God made light and called it good before it was useful and before it could be looked to by mankind as a picture of God's invisible attributes thereby leading to salvation. No, the universe was brought into being as an act of goodness. It was 'good,' and it therefore gave glory to God. And so we should make artwork that reflects on the idea of 'good,' since, as Charnock states, God's "whole catalogue of mercy, grace, long-suffering, abundance of truth, [are] summed up in one word." And that word is *good.*

As we are urged in Galatians, "Let us not become weary in doing good."

W H Y
is L I G H T
G I V E N
to the
M I S E R A B L E?

"I speak through my music. The only thing is that a poor musician like myself would like to believe that he was better than his music." (Letter from Brahms to Clara Schumann, September, 1868)

C. S. Lewis once said that the Christian writer should have blood in his veins, not ink. What he meant was that if an artist sets out to make a Christian statement in an art object, the chances are it will not be art, but a contrived pronouncement. Rather, the believer, like anyone else, should first be passionate about his chosen medium, work in it, and let any "message" emerge almost as a by-product. If one is a writer, then let him be captivated by words. If a painter, let him be fascinated by colors and shapes. Living in the real world, being human, knowing about life and people, believing in truth, and wrestling honestly with the troubles and sufferings that inevitably come along, these are the best ways to prepare to create.

Perhaps the most challenging part of artistic work in any medium is how to handle the problem of evil. Music presents a

particular difficulty, since its medium is sound. How to say it in notes? Given that music is not merely a vehicle for words, how does the Christian composer articulate a view of the world which has been profoundly polluted by sin and yet that provides for genuine hope at the same time? I believe this question provides us with a kind of test of authenticity. Artists often fall into one of two extremes. For simplicity's sake, we could call them optimism and pessimism. The optimist arrives at a happy ending, so to speak, without honestly passing through the valley of the shadow of death. A good deal of music today is optimistic in that it tells of joy and peace without reckoning with evil, the evil from which we can be redeemed in order to know that joy and peace. Obvious (and extreme) examples would include jingles written for commercials, or the mindless music in shopping malls. The pessimist is realistic about evil but has little or no hope. The element of redemption is the missing dimension. Some of the darker music of the Punk style, Grunge music, and the violent pessimism of various rap singers would qualify. Optimism and pessimism are not simply temperamental characteristics of the artist; they stem from a worldview, a philosophy of life. In fact, it is crucial to remember that one can never finally separate a work from the artist. The creator informs the work out of the rich material in his or her own soul. Beginning in the soul, though often not self-consciously, the worldview then transpires into artistic production in distinctive ways.

A joke has it that the only difference between an optimist and a pessimist is that the one believes we are in the best of all possible worlds, while the other fears this may be so! In contrast, the biblical worldview is neither optimistic nor pessimistic. It begins with God's Creation as good ("very good," according to Genesis 1:31), because God the creator is good. But then it confesses there has been the introduction of evil into the world by the treasonable revolt of mankind. The Fall, then, brought both sin and misery, evil committed and affliction received. This is a crucial distinction, one which is unique to revealed religion. Albert Camus captured one

of the most persistently held non-biblical views of evil in the efforts of his hero, the Doctor Rieux from *The Plague,* with the catchphrase, "fighting against Creation as he found it." But if this is right, according to the Scriptures, then all is lost. Rather we fight against the plague, which is an alien invader of Creation's goodness. And therefore, finally, redemption has come into the world, and is working its way toward a new heavens and new earth, through Jesus Christ, the savior. This is utterly different from the two extremes of optimism and pessimism. Unlike optimism, this biblical worldview tells us to look evil in the eye. It is real, though not some substance or thing. Because of the great fault there will be oppression, struggle, doubt, tension, so that with the Psalmist we often may ask the questions, "Why, O Lord?" or "How long, O Lord?" But unlike pessimism, it proclaims genuine hope because Christ has inaugurated a great reversal of the fault, centered in the Resurrection. As a result, beginning substantially now, and concluding in the great day of the consummation, death, the result of sin, and guilt, its cause, are fully eradicated. We will live in an unbroken communion with God himself.

Music that voices this philosophy will be both realistic about the darkness and unashamed of the light. There will be trouble, "tribulation," as our Lord put it. There will be tensions and doubts along the way. But there is always reason for hope (1 Peter 3:15). One could not find a more fascinating illustration of this double-edged sword than in the life and music of Johannes Brahms. This most extraordinary composer from the golden era of German choral and symphonic music was well aware of the need for authenticity. He often compared the quality of his works to the quality of his own person as he judged himself, and hoped that his life was somehow more noble than his music. Considering the glories of his music, he set very high standards for his person! A reflection on his life and times.

Theological Moods

Just before the First World War a building went up at Harvard University to be called Emerson Hall. Because it was destined to be the Philosophy Building, just before completion the professors in that discipline were asked to chose an appropriate motto for the outside wall. After a series of meetings, the likes of George Santayana, William James and others decided what should be engraved for all to see was Pythagoras' famous epithet, "Man, the measure of all things." A pause came because of the war years. When the professors finally came back to take up their work in the new building, they looked up to see, to their horror, quite a different motto from what they had requested: "What is man that thou art mindful of him?" No one knows for certain, but apparently a local architect could not abide the arrogance of the first choice, and so substituted the biblical phrase from Psalm 8. It is still there—all the clearer now that the ivy has been removed—for the world to ponder today.

The received wisdom about the nineteenth century is that it was a time for optimistic thinking. The spirit of self-reliance and especially confidence in reason gave assurance that indeed man was at the center of all that mattered. Then, so the story goes, the Great War came to disabuse everyone of such confidence. In his famous *Römerbrief* Karl Barth proclaimed a theology of crisis in the place of the naive liberalism of Schleiermacher and Ritschl. The twentieth century brought a sobering wind which blew away the self-possessed outlook of the nineteenth. This account is plausible, and true in part. But it ignores the prophets of a troubled world and the honest doubters who were present all along. We need only think of Dickens' novels, with their unmasking of the poverty in London, or the passionate concern for the human condition in the works of Dostoevski and Zola. And while indeed Schleiermacher and Ritschl tended to reduce theology to its horizontal, human level, this approach is hardly the vision of all other contemporary theologians. Consider the strange and wonderful Dane, Søren Kierkegaard, whose notion of paradox and

faith powerfully challenged the cold, institutionalized dogmatism of the church. Not satisfied with the complacent trust in unaided reason in the surrounding philosophies, he treated the deepest questions of life with a combination of respect, anger, and mystery, that belie logical answers.

A number of the Romantic composers were similarly perplexed by the problem of evil and the inadequacy of unaided human reason to resolve basic dilemmas. Standing in a very different place from many of his peers, especially in consideration of the problem of evil is the prodigious genius, Johannes Brahms (1833–1897).

Necessary Sharp Shadows

In the spring of 1877 Brahms wrote a letter of congratulations to the Joachim family upon the birth of their new son. Josef Joachim was one of the great violinists of the day, and the family's friendship with Brahms was so deep they named their first son Johannes. This latest child was born on Brahms' forty-fourth birthday. He wrote the Joachims the following line: "One can hardly in the event wish for him the best of all wishes, not to be born at all." Then, as if shaken out of a bad mood, he added, "May the new world citizen never think such a thing, but for long years take joy in May 7 and in his life." It would be hard to find a more apt summary of the paradox of Brahms' life, one which pervades his music as well.

In the summer of that same year, he came to Pörtschach, a lovely village outside Vienna on Lake Worth. It was an inspiring setting for writing music, one that included the snow-capped mountains and lots of good food. There he wrote his Second Symphony in the space of four months. Writing this piece in his full artistic maturity was in marked contrast to the fifteen years of agony it took him to compose the First Symphony. Responding to a self-imposed pressure to do honor to his hero, Beethoven, he needed to build on the nearly insuperable legacy of the immortal Ninth, while yet moving the genre further and deeper. Written in

C minor, Brahms' First Symphony was undoubtedly such an achievement. Immediately after the premiere of the monumental work, Hans von Bülow, always ready with a *mot juste,* labeled it "The Tenth." While it carried strong echoes of the past, it was a strikingly original composition. The first movement is one of the most dramatic symphony beginnings ever written, taking us into a nether world of angst, questions, revolt. Throughout the piece light battles as it were against darkness, joy against sorrow, and finally, hope emerges triumphant. The last movement, unlike most classical symphonies, is as weighty as the first, with its chorale-like resolution in the last section (using the trombones for the very first time!) moving the piece to a final C major.

By contrast, the Second Symphony appears effortless, almost entirely tranquil and confident. Almost. Written in the bright, "positive" key of D major, it begins with a pastoral serenade in slow 3:4 time. We are put into a bucolic mood. Then, suddenly, in the thirty-third measure, the trombones enter with a dark and gloomy theme that mars the tranquility of the scene. Here, unlike the First Symphony, the trombones are introduced right away. No sooner do we hear these disturbing tremors than the movement resumes with the main theme again, as though dark clouds had threatened, then disappeared. So troubling is this interruption that one of Brahms' greatest admirers, the conductor Vincenz Lachner, inquired about it. He wrote two warm and complimentary letters to the composer, showing remarkable understanding of the beauty and intricacy of the work. But then he inserted two queries for the master. First, why such "gloomy and lugubrious tones" at the outset of a luminous piece? Trombones had long been connected with death in music. The *Dies Irae* in the Mozart Requiem is perhaps the most poignant example of this, connecting the low brass sounds with the Day of Judgment. The idea is also present in the Lutheran Bible. So why such a contradiction? Second, why does Brahms make the ending phrase so dissonant, superimposing two harmonies (plagal and tonic) that do not belong together? Brahms answers characteristically:

I'll tell you just as fleetingly [as this word of thanks] that I very much wanted and tried to manage without trombones in that first movement. (The E minor passage I would gladly have sacrificed, as I now offer to sacrifice it to you.) But that first entrance of the trombones, that belongs to me and so I cannot dispense with it nor with the trombones, either … I would have to admit, moreover, that I am a deeply melancholy person, that black pinions constantly rustle over us, that in my works—possibly not entirely without intent - this symphony is followed by a small essay on the great "Why." If you do not know it (the motet) I will send it to you. It throws the necessary sharp shadows across the lighthearted symphony and perhaps explains those trombones and kettledrums. But I also ask you not to take all this so very seriously or tragically, particularly that passage! But that A in the G minor in the coda, that I would like to defend. To me it is a sensuously beautiful sound, and I believe it comes about as logically as possible—quite of its own accord.

What are we to make of these ambiguous statements? As we saw above, first, Brahms, like many artists, is anxious for his music to speak from its own logic, and not depend on a "key" to the work, or a program that would explain it. After guessing he might have been thinking of ultimate questions he says not to take such a speculation too seriously. The meaning of a piece of music is there in the composition, in its inner logic. Attempts to connect with an outside program are often artificial at best, and reductive at worst. Yet Brahms said it himself: he struggles with melancholy. Black wings flutter threateningly over his life. And he volunteered that it may be no coincidence that he wrote that most hauntingly powerful motet, *Warum?* immediately afterwards.

In our own day, trends in literary criticism have cautioned us against making too much of an author's life story as background for a text. They have a point. Limiting our interpretation to events

in the author's life or to the psychology of the artist risks missing the text itself, which has a life of its own. Once the work is finished, it may carry meanings not intended by the author, much as a child develops independently from the parents. Still, it is erroneous to imagine, as some of the more radical theories do, that there can be no connection at all. According to the Christian view of the world, everything is connected. Human beings, made as God's image, are not mere vehicles of a text, but creators in their own right. And they leave their own imprint on the work of their hands, whether intentionally or not. Their art says something. It narrates a meaning, however difficult to elucidate.

Brahms was aware of the problem. In an important letter to Clara Schuman he once said,

> But the artist cannot and should not be separated from the man. And in me it happens that the artist is not so arrogant and sensitive as the man, and the latter has but small consolation if the work of the former is not allowed to expatiate his sins.

One of his life's desires was to be a man of integrity, a *Menschenbild,* the very picture of an ideal human being. So, while Brahms himself wanted to ward off simplistic explanations that might spoil the mystery of his work, he also sensed the reality of a connection to the larger philosophical questions posed by the man. These were questions that followed him throughout his life, questions that simply wouldn't go away. Though at one level they are our perennial struggles, undoubtedly for Brahms they were triggered by personal events in his life as well.

All Flesh Is as Grass

It was Josef Joachim who had urged Brahms as a young man of twenty to visit the great composer Robert Schumann, a visit that would change his life forever. For one thing, Schumann made him play the piano. Upon hearing this young genius he hailed him as a "young eagle" who would save German music! This had the effect

of giving the young composer great notoriety, and gave him the freedom to develop more rapidly than most into a consummate artist. For another, he met Clara Schumann, Robert's devoted wife, perhaps the major feminine figure of nineteenth-century music. Theirs was to be a stormy friendship, full of tenderness, but fraught with misunderstandings and disappointments. Schumann was severely ill. Recently published medical diaries give evidence it was from syphilis. Just five months after this first meeting with Brahms he attempted suicide by jumping into the Rhine. He spent much of the next two years in an asylum. He spoke nonsense and was plagued by sounds in his head of sustained, screaming pitches. He finally died after weeks spent in a delirious state.

The tragic condition of Schumann would haunt Brahms throughout his life. Without resorting to speculation one can find many references to Schumann's agonies in his music. For example, the First Piano Concerto begins with dizzying ambiguity, giving the effect of falling, like the suicidal plunge into the water. In other well-known examples, we can think of the insistent pedal points of the First Symphony and the German Requiem's "All Flesh Is As Grass," which could well be echoes of Schumann's screaming hallucinations. They are sounds of anger. In his more mature years these sounds become more lyrical, even dream-like, but still melancholy.

Schumann had surely expected the young Brahms to take care of his widow. Clara no doubt wanted him to marry her. Johannes certainly loved her, but could not accept such a permanent commitment. Shocked and hurt by his decision, Clara saw a change in him which spelled the end of his innocence. She eventually rose above it and forgave him, even writing her children: "That I have never loved a friend as I loved him; it is the most beautiful mutual understanding of two souls." But Brahms had become distant. What reasons might Brahms have had for his refusal? He loved Clara deeply. It seems to have been, however, a spiritual love, nurtured on the fantasy of a woman from another era, in a word, romantic love. If he got too close, the imperfections of real human

friendship would intrude and he might not know how to handle them. And yet if he stayed too far away he would deny his own feelings, even ignore and afflict his closest friend. Brahms was awkward, not always tactful. But he was also painfully honest.

His music illustrates his struggles. Deceptively so, because his compositional art is so remarkable that we resist looking for qualities much beyond the unsurpassed craft of the music. He is a near-perfect contrapuntalist, as well as a master of harmony and an endless source of melodic invention. He had all the technical ability he might need to be the most competent composer in the world. But because of the insistence of his doubts, his struggles with depression, and, no doubt, his refusal to accept easy answers from the church, Brahms rises far above mere excellence. He indeed lived with the question, Warum? (Why?). Did he find answers?

Let Us Lift up Our Hearts

The music tells us he did, at least to some extent. In any case he found resolution, perhaps even joy, at times. But there is a lingering doubt, something not quite settled nevertheless. Consider now the great motet written during that extraordinary summer of 1877 in Pörtschach. Opus 74 No. 1 is a polyphonic choral composition in four movements. The first is based on Job 3:20-23:

> Warum ist das Licht gegeben den Mühseligen
> und das leben den betrübten Herzen?
> Die des Todes warten und kommt nicht,
> und grüben ihn wohl aus dem Verborgenen
> Die sich fast freuen und sind fröhlich,
> daß sie das Grab bekommen?
> Und dem Manne, des Weg verborgen ist,
> und Gott vor ihm denselben bedecket?

Wherefore is light given to him that is in misery
And life unto the bitter in soul;
which long for death, but it comes not
and dig for it more than for hid treasures;
which rejoice exceedingly, and are glad,
When they can find the grave?
Why is light given to a man whose way is hid,
And whom God has hedged in?

The introductory four measures are strongly stated open chords (the directions state, "slowly and full of expression"), asking, plaintively, perhaps even defiantly, why?, why? These same chords with their insistent question will reemerge four times, acting as hinges separating the richly expressive settings of the text from Job. The main body of this first movement is, then, a series of statements, gradually weaving together the voices in a prayer of perplexity before God. It is, of course, a display of Brahms' mastery of choral art. Though profoundly indebted to Bach's craft, with Brahms' style we are no longer in the liturgical world of the weekly cantatas of the Leipzig church in the eighteenth century. Rather, we have here, combined with the artistic intricacy, an intensely personal statement. Brahms here has made some use of elements of the Mass, but in a manner not quite appropriate for a service of worship. It is more like a Psalm for private moments. Honest moments. The final statement of the question, warum?, is so compelling it is almost heart-breaking.

One can almost feel the presence of all the suffering of the world; here, crying children, starving people, broken marriages, and the haunting question: what is the good of it? Then comes the second movement to quiet the storm of the first. It does not answer the question, but, using words from Lamentations 3:41, it tells us to worship God:

Lasset uns unser Herz samt den Händen aufheben
zu Gott im Himmel

Let us lift up our heart with our hands
Unto God in Heaven

This beautiful, shorter movement is in answer to the first. From
the stormy D minor, we move to the serene D major. It has the effect
of a mother comforting her child after a bad dream. But it is more
than comfort. It articulates a response to the *warum?* It begins with
confidence in a hymn-like texture, a canon in four voices. It then
builds in intensity until, adding two more voices, we are borne
along, exhorted to heaven in worship. Do we believe God is there
for us? Here Brahms clearly states that we must look to the place
where He is. Although music is not a philosophy book, it is hard to
miss the transition. Brahms clearly joins company with the many
Christians who have wrestled with the problem of evil and
concluded that while the question is insistent, and human
suffering is all too real, tragic things cannot always be explained,
but yet we had best to turn to God for solace.

The third movement is a lush composition which continues the
'argument,' but adds a personal element. Using the section of
James where Job's patience is emulated, the song encourages us to
endure and persevere, because of God's mercy. The movement is in
two parts. The first is a simple, slow, but beckoning statement on
the theme of the need for patient endurance. It is in C major, with
all the depth and solidity that key tends to signify:

Siehe, wir preisen selig, die erduldet haben.

Behold, we count them happy which endure.

Then the second part is rather animated, stressing the vivid nature
of the basic communication, "ye have heard." It moves up to
F major. The final line, "That the Lord is full of pity and of mercy,"

returns, almost literally, to the radiant conclusion of the previous movement, stressing the presence of God in his mercy:

> Die Geduld Hiob habt ihr gehöret,
> un das Ende des Herrn habt ihr gesehen;
> denn der Herr ist barmherzig und ein Erbarmer.

> Ye have heard of the patience of Job,
> and have seen the end of the Lord;
> That the Lord is full of pity and of mercy. [James 5:11]

Finally, a chorale tune, based on Luther's version of the *Nunc Dimitis* is in the modal key of Dorian D major. This is truly a consummating thought. Bach's cantatas and passion music are all punctuated with these wonderful chorales which bring resolution to the narrative or prayer of the body of his works. Brahms here echoes this approach with his perfect craft:

> Mit Fried und Freud ich fahr' dahin
> In Gottes Willen,
> Getrost ist mir mein Herz und Sinn
> Sanft und stille.
> Wie Gott mir verheißen hat,
> Der Tod ist mir Schlaf geworden.

> In peace and joy I now depart,
> According to God's will,
> Comforted are my soul and heart,
> Calm and still.
> As God has promised me,
> Death has become a sleep to me.

A journey, a departure indeed. Peace and joy are not easily won. They are possible because God is sovereign. He comforts the afflicted, and gives sleep to the weary, the sleep that ushers into eternity.

Is It the Whole Gospel?

It has not escaped the Brahms connoisseurs that this shorter sequence of four movements, with its combination of anxiety, its sense of the ephemeral, but then also its sure confidence in the providential care of God which takes us through life's trial right into heaven, is a reproduction of the German Requiem. This greatest of all the Brahms choral compositions did not come into the world without controversy. To begin with, it was not a standard requiem mass, but is in the vulgate language, German, and based on texts from the Bible or the Apocrypha, chosen by Brahms himself. Though with roots in the liturgical music of Heinrich Schütz and J. S. Bach, it is an intensely personal reflection on mortality and on the comfort of God. One might call it a sermon in music, or even a personal testament. Furthermore, for those standing in the Christian tradition there is a significant concern about the *German Requiem*. Brahms deliberately left out any explicit mention of the person and work of Jesus Christ. What are we to make of this? Many biographers have argued that Brahms was a humanist, albeit one who had a general hope in immortality. He did tend to resist dogmatic theology. But does this make him a humanist?

Brahms gave some credence to this when he called it a Human requiem, meaning that it was meant to be universal, and not a specifically German threnody. And he then seemed deliberately to want to leave out texts such as John 3:16, which are an appeal to the gospel of Christ. A now well-known exchange occurred between Brahms and the conductor of the premiere, Karl Reinthaler, which illumines the issues. The latter, actually a great friend and admirer of Brahms, writes, "For Christian sensibility the central point about which all else turns is missing—namely, redemption through the death of our Lord," adding that he could insert a more directly Christian reference in the place of the last two words of the Revelation 14:13 text, "Blessed are the dead which die in the Lord from henceforth." To this Brahms replies:

As far as the text is concerned, I will confess that I would very gladly omit the "German" as well, and simply put "of Mankind", also quite deliberately and consciously do without passages such as John ch 3 verse 16. On the other hand, however, I did accept many a thing because I am a musician, because I was making use of it [i.e. the biblical text], because I cannot challenge or strike out the text of my revered bards, not even a "from henceforth."

So while he refused to change the text on aesthetic grounds, he did also seem to want a broader vision than traditional Christianity appeared to afford, on philosophical grounds. The point was not lost on the first listeners. Other clergy shared Reinhalter's theological qualms so that at the first performance of the Requiem in Bremen (April 10th—Good Friday—1868) the aria from Messiah, "I Know That My Redeemer Liveth," was inserted half-way through the program! (This tradition continued in Bremen for some time.)

All the same, the German Requiem is hardly a statement of just any hope in a better world. There is here no apotheosis, no idealization of the future of man, but rather a deep joy, one that could only be nourished by God himself. Friedrich Nietzsche erroneously believed Brahms to express colorless and careworn kinds of joy. On the contrary, when Brahms portrays the life to come, it is profoundly real. Like Job, he can say, "I shall see him again … " Consider also the setting of "Death, where is thy sting?" from 1 Corinthians 15. It powerfully combines a defiance of death with the certainty of lasting treasures in heaven. The final chorus, "They rest from their labors," brings the same feeling of resolution that we have seen in the great Opus 74 motet *Warum?*

Still, we wonder at the absence of any reference to the pivotal point in all human history, the event that made death (and its cause, sin) to die. Why is that central ingredient of our hope, the resurrected Christ, not presented in the music? What are we to make of this paradox?

Again, why?

We noted earlier that there was in Brahms' music a certain resolution, perhaps even joy, but also a lingering doubt. Surely these relate to his own spiritual pilgrimage. Did Brahms' understanding of evil and hope fully express the biblical worldview described earlier? Before answering that question, one other should be considered. As Brahms himself had declared to Clara Schumann, it is possible that the man be better than his art. That is to say, his personal moral and theological qualities could have been far more orthodox and mature than what comes across in the music. It is possible, but not likely, in my opinion. We know Brahms to have been a good person. He was not judgmental. He had high ideals. His correspondence is simple and to the point, usually to interact with someone on a particular practical matter. In any case, it shows no sense of grandeur or a provision for a legacy of greatness. He was also very generous. He gave away money to those in need, often giving anonymously. He loved children. But we also have certain clues that Brahms was not altogether at home with the standard doctrines of the church. He had a deep knowledge of the Bible, and was educated in theology, but it is not certain how much of it he personally believed. In his great song, the *Schicksalied,* he sets a poem by Friedrich Hölderlin, which is at best a statement of alienation, and the impossibility of achieving the Elysian bliss of the gods. In any case, if Brahms the man was a "better" Christian than Brahms the composer, there is not much evidence for it.

The truth is, the music is as discrepant as the man. Brahms could say what he felt. The greatness of Brahms' music is that he could voice his thoughts with amazing craft, with great melodic and harmonic depth. He truly writes as a man in whose veins flowed the most vigorous human blood. We will have to be satisfied to admit that as far as we can tell, Brahms did not see Jesus Christ as the epicenter, either in his life, or in his music. At least, he did not focus his outlook on the God-man in the way recommended by traditional orthodoxy. This does not mean he

was not a believer. He had a deep trust in God, and had the highest regard for the Scriptures. We cannot know at what various points he departed from standard evangelical theology. In fact we cannot be altogether sure exactly which parts of Christian doctrine he accepted and which parts he struggled with. About such hidden things of the heart we simply cannot know with certainty.

But here is my thesis. At the very least Brahms' treatment in music of the problem of evil was an extraordinarily powerful rebuke to the sentimental romanticism of his times. We could liken him, as mentioned earlier, to Charles Dickens, or Fiodor Dostoevski, because he faced the drama of human suffering with passion, but not always with clear answers. In fact, a sub-theme of his life is surely the struggle to make sense of the human condition. He began with the question *warum?* He knew quite a good deal about the answers. One of them, which he believed dearly, is captured in the text from his motet: "Ye have heard of the patience of Job, and have seen the end of the Lord; That the Lord is full of pity and of mercy." But he never could state unambiguously that evil had been overcome in the expiation of Jesus Christ. At least, we have no evidence of such complete confidence. The question *warum*, would remain with him throughout.

Brahms is not unlike his excellent neighbor from the North, of the previous generation, Søren Kierkegaard. He wrote extensively against the careless complacency of the official church with essays on the problem of evil that still make us sit up and listen today. In his masterpiece of 1843, *Fear and Trembling*, he examined the dilemma of Abraham, faced with the divine requirement to sacrifice his only son. Using the heteronymous mouthpiece Johannes de Silentio, he comments that "He who struggled with the world became great by conquering the world, and he who struggled with himself became great by conquering himself, but he who struggled with God became the greatest of all." This for Kierkegaard is the greatness of Abraham's faith. I would venture to say this too is the greatness of Brahms' faith. It is a struggling faith, but he is struggling at the greatest level, moving in the right direction.

Deep Sorrow, Deep Joy

Despite obvious contrasts, the church in our time faces the same issues. Artists who are followers of Christ still need to avoid both optimism and pessimism, and forge a third way. Often, we fall over on one side of the cliff: we have not been able to face the ugliness of evil and "tell it like it is." As a result, our work may be romanticizing the world. But then, to rectify that, we fall over again on the other side of the cliff. We then are in the opposite case, describing evil so powerfully that there is no relief, no redemption. The ability to avoid both errors in our art and steer a different course, based on the biblical motif of Creation-Fall-Redemption will depend on our artistic skill, of course. But it will also depend on our very convictions. Faithfully articulating our theological convictions in an artistically credible fashion begins with faithfully viewing the world through biblical lenses.

Here is the crux of the matter. How does one describe a world in which God's good creation has been spoiled by sin, but is being redeemed by His grace? Brahms could be our model. Often in art that claims to be Christian, the balance is wrong. Either there is a "happy end," without really admitting the depths of sin and evil. Some (not all!) of our traditional American evangelical music unfortunately falls into this category. It tends to praise God and focus on the believer's confidence without any significant acknowledgment of sin. At the other extreme, some of the music of church musicians is so pessimistic about the human condition that it fails to bring any hope. In my judgment, works such as Leo Sowerby's "Epilogue" from *Forsaken of Man* fits in to that category. Perhaps also Healey Willan's "My Soul Is Exceedingly Sorrowful" from *Tenebrae of Maundy Thursday.* My examples could be disputed, but the point is that a truly biblical approach in music, as in doctrine, will be neither optimistic nor pessimistic, but hopeful, even joyful.

This balance can only be fully achieved, at least in theory, when one's experience of the world is interpreted in the light of Christ. The great French apologist Blaise Pascal had it right, when he said:

Knowing God without knowing our own wretchedness
makes for pride. Knowing our own wretchedness without
knowing God makes for despair. Knowing Jesus Christ
strikes the balance because he shows us both God and our
own wretchedness.

This is no less true of artistic endeavor. Brahms has taught us
much about the two equally opposite errors of pride and despair.
And although he may not have been altogether clear about the
centrality of Christ in resolving the tension he certainly pointed us
in the right direction, inspiring us to yearn for great faith. We could
cite a number of musical traditions which parallel Brahms'
achievement. Many contemporary musicians have taught us
elements of this third way. Few people have as powerfully stood
with integrity, neither yielding to optimism nor pessimism, as
African-Americans. Forged in the clandestine church, hammered
out on the anvil of oppression and immense suffering, spirituals,
gospel music, the blues, jazz, ragtime, these are so many related
styles that express the central message of deep sorrow and deep joy.
The theme of sorrow and joy in black music is a subject in itself.

The negro spiritual, one of the treasures of American
indigenous music, is replete with biblical themes and imagery. But
it centers on the sufferings of the people of Israel, the agony of
Christ on the cross, and the promise of victory over all oppression
and evil. The story of the conversion of African slaves to
Christianity is complex. Plantation heads and slave owners were
not anxious for their laborers to discover a message of liberation.
Yet through the efforts of tireless missionaries, and because of the
power of the message itself, the gospel did spread far and wide in
the slave community during particular episodes over three
centuries. Music was always a central aspect of the encounter.
From the rather opaque references to the music of African-
Americans in the chronicles of the times we gather that it was
lively, haunting, and biblical. A certain Edward Alfred Pollard
records hearing the hymns or religious chants of the "Negroes,"

describing them as " . . . sung with a natural cadence that impresses the ear quite agreeably. Most of them relate to the moment of death … [for example:]

> 'Oh, carry me away, carry me away, my Lord!
> Carry me to the buryin' ground,
> The green trees a-bowing. Sinner, fare you well!
> I thank the Lord I want to go.
> To leave them all behind.

On the surface the stylistic difference between the spiritual and the sophisticated choral music of Johannes Brahms is considerable. At a deeper level there is remarkable similarity. Looking squarely at death, yet seeing it as a release from the burdens and injustices of this life, hope in the mercy of God, a quiet confidence in the world to come, these themes, and even the soulful way of singing about them, are in common.

It is encouraging to find in our day a number of musical trends emerging which strive for this third way. Some are in a popular or folk style. Some comes from the classical repertory. The music of the Estonian composer Arvo Pärt is in stark contrast to much in the modern Western canon. He has been labeled a minimalist, because he specializes in stark texture, and subtle changes. His choral music exemplifies our third way, but in a style that is more reminiscent of the Eastern Church than the Western approach to spiritual music. For example, his *De Profundis,* a setting of Psalm 130 [129 in the Vulgate], is scored for male voices, punctuated by the tones of a bell. It moves ever so slowly from the Psalm's beginning supplication, "Out of the depths have I cried unto thee, O Lord," to the open assurance of "Let Israel hope in the Lord: for with the Lord there is mercy," and finally it returns to the quiet confidence that "He shall redeem Israel from all his iniquities." It is Brahms' *warum?* Or the negro spiritual's "Sometimes I Feel Like a Motherless Child," but in a mobile-like liturgical stillness?

A Call for Candor

Perhaps because there is so much confusion and hostility in the surrounding culture followers of Christ have been tempted either to retreat into tribal safety, or worse, to lash-out in a winner-takes-all fundamentalist assault on the enemy. The reason for this is simple. We don't quite dare walk between the flames trusting that God can guide us and deliver us. We refuse to admit of tension and ambiguity. Because of that we can't honestly ask with the Psalmist, "Why, O Lord?" Our artistic production is not surprisingly one-dimensional. Being real in art is only possible when we can be real with God. Brahms was. The slaves in the antebellum South were. Arvo Pärt is. They are among the many in "misery" to whom the light has been given. And so they have asked, "Why?" When we have recovered their candor we may be able to say it in our artworks.

that FINAL
DANCE
<small>*that* FINAL</small> — FINAL

Joel Sheesley, a painter, begins his lecture called "Content: the Substance of Things Hoped For" by stating his conviction that

> the important questions about content in art do not revolve around issues of abstraction or recognizable subject matter, but rather around the possibility that human beings can sustain belief in their own existence as responsible individuals.

His comments become my starting point because any discussion of content must rely on an existential presupposition of God. Sheesley is correct in connecting belief with content. Existence of content requires faith. We are not Platonic shadows, but in us, *imago dei*, remains a trace of the solid 'substance.' Without the source of content, or the content of all contents, there is no point in talking about content at all.

With modernity, with the advent of photography, the central theme for artists became not "How do I depict a flower?" but "What is a flower?" Then postmodernity asked "Is there a flower at all?"

Postmodernity, highlighted with Duchamp's "ready made" urinals, challenges us in its question, "Is there content?" The knowledge of existence requires faith in existence. Postmodernity is skeptical of such faith. It is agnostic by nature (as opposed to the modernist's often atheistic stance), and thus it is also agnostic in its stance towards our own existence. Thus, as Professor Sheesley correctly points out, discussion of content is a discussion of "our own existence as responsible individuals."

A discussion of form/content in a fragmented postmodern reality requires we take off the agnosticism 'hat' and consider, "the substance of things hoped for." In Christ, God became flesh, and his historical presence points to a world where hope is assured to be substance. With this gospel of incarnation, then, and only then, it is possible to speak of fusing spirit and body, content and form. Christ's incarnation resolves the most difficult dichotomy that exists for an artist; that is the dichotomy of form and content.

The Japanese poet Kinotsurayuki in the 10th century wrote of this dichotomy in his poem, "Ka-jitus-so-ken" which can be literally translated "flower-form-mirroring-jointing." He meant by this that we must strive to fuse form and content together so well that the form (words) becomes the content (flower). Ben Shahn brought this concept home to the 20th century when he stated, "I think that it can be said with certainty that the form which does emerge cannot be greater than the content which went into it. For form is only the manifestation, the shape of content." Francis Schaeffer echoed this aesthetic perspective when he said, "For those art works which are truly great, there is a correlation between the style and the content."

Christ's uniqueness lies in not just the content (divinity) but also in the form (humanity). He was the form of all forms, the content of all contents. This uniqueness gives an artist fundamental motivation and reason to pursue the daunting task of bringing form and content together. The first commandment tells the artist there is only one source, one content from which all other contents derive. And the "manifestation, the shape of content" is Christ

Himself. All art owes the unique figure of Christ a tribute; without Him, we simply do not have any model to fully meet the challenge posed by aestheticians of the ages past.

Form and content may be hard to separate in some cases where form may be the content and content may be the form itself. Christ's presence even frees us from the artificial separation between form and content. My approach to form/content dichotomy flows out of His being.

The series of mineral pigment on paper entitled *The Mercy Seat* uses the exact dimension of the Mercy Seat of the Ark of the Covenant as described in Exodus. "Have them make a chest of acacia wood—two and a half cubits long, a cubit and a half wide, and a cubit and a half high" (Exodus 25:10). In today's measurements, it is about 3 3/4 feet long and 2 1/4 feet wide and high. I used this dimension not to replicate the Ark of the Covenant, but as a departure point for a visual dialogue.

I have repeatedly made works of these dimensions in the past. From December 24, 1999 through February 13, 2000 I had some of my work on display in the St. Boniface Chapel at The Cathedral at St. John the Divine. A reproduction of two Mercy Seat paintings are included [see color plate 8] to help the viewer get a feel for the scale of the works.

When I first made the wooden panels, I realized that the proportions produced a very dynamic visual movement on their own; the dimensions of the piece alone proved to be inspirational. Its size also communicates a physical presence: it does not dominate nor recede, it is neither 'big' nor 'small,' it is both imposing and intimate. In mere dimensions and proportions, the mercy seats anticipate the person of Christ—Christ was both imposing (God) and intimate (Man) at the same time.

In fact, the material used to create the ark itself was symbolic. Kevin J. Conner writes, "The ark was made of acacia wood overlaid with gold within and without. Wood speaks of His incorruptible humanity, and gold His Divinity. Two materials, yet one ark; two natures yet one person, the God-Man." The materials symbolically

point to Christ. I use gold (divinity) on paper (humanity) to allude to Christ in all of my works.

A question may be raised here: "Are you trying to depict God (content) through your works (form)?" And the answer is "No." I cannot depict God (and I believe any attempt to do so will lead to breaking the second commandment), and I do not need to. Christ is the ultimate and only true fusing of content and form. But because of Christ, we are free to create works on the foundation of Christ. We are free to be his creatures, living under the sovereign rule and power of the Creator. We are free to see natural forms and human experiences as an extension of Christ's rule and reality. When we create, we can create without trying to fuse content and form but to base our works on the notion that the fusing has already occurred—that this ultimate fusion can power our art.

A Christocentric perspective on the arts can also release our creativity from being enslaved to a particular form, or style of art. while I was in Japan to study Nihonga (Japanese style painting), I remember telling a friend of mine, who also used Nihonga materials and techniques, about Jesus' statement regarding the Sabbath. He said (in Mark 2:27), "The Sabbath was made for man, not man for the Sabbath," warning against the Pharisaic, legalistic view of the day of rest. I told him that "Nihonga (or any type of art-form) was made for the artist, not the artist for Nihonga." In Japan, where traditional forms, 'kata,' are seen as sacred, my comments must have sounded disrespectful. But a Christocentric perspective honors our humanity in Christ; and any form must follow the content of our expression, not the other way around.

Tohaku Hasegawa, who has been called the Michelangelo of Japan, painted the "Shorinzu" byobu (a folding screen piece) in the 16th century, a work which many consider to be one of the greatest paintings of Japanese history. The painting, done in sumi ink on thin rice paper stretched over a byobu screen, depicts pine forests, but in essence he evokes the fog and the breeze which move the trees in simple, calligraphic lines. If there ever was a painting which captured the "sound of silence," this would be it. Hasegawa

forged new ground, moving beyond his formal education in Chinese paintings with its harsh representationality, and he moved into the arena of ambiguity and transcendence. (If you don't think that Chinese paintings are highly representational, you haven't seen Chinese landscapes. Believe me, they are more representational than Giotto.) Less was indeed more. He did not merely want to capture a pine forest, he wanted to get to the essentiation, the core of being and seeing.

I remember going to the Arshile Gorky retrospective in the early eighties at the Guggenheim, and having the paintings speak to me in ways the Shorinzu byobu speaks to me today. In fact, I believe that experience convinced me that I should seek to pursue art. Gorky's later works spoke in a language I could not comprehend but yet yearned for. His exquisite lines opened space and closed them at the same time. His colors, both delectable with their focused intensity like that of the stamen of a lily, remained in my memory and affect my vision today. And this is not to speak of the influence of Rothko and Diebenkorn. The language of abstraction both eastern and western, came to me early, and stayed with me.

Many, seeing my paintings today, would call my works abstract, or semi-abstract. Labels not withstanding, I am still conscious of Gorky and Hasegawa. Even with my new angle, I see their attempt to reach transcendence as noble and bold. In the works of many abstract expressionists I see not only abstract paintings but a yearning and groping for the heavenly language. They were convinced that earth and history did not contain the language to capture the fear and power of the age.

They were right. I see abstraction as a potential language to speak to today's world about the hope of things to come. My works exegete both classical Japanese works and contemporary American paintings. I interpret them in a way that I hope will increase the viewer's passion for seeing the physical reality and heavenly reality. To me the weakness of abstraction does not lie in its denial of the spiritual: the weakness of abstraction lies in its Platonic, Gnostic denial of the physical. I want to affirm and

celebrate the physical. As Paul Mariani, a writer, stated, we need to affirm "the splendid grittiness of the physical as well as the splendor and consolation of the spiritual. In a word, a sacramental language." This sacramental language must address reality and confront what we see, but must transcend it to grasp what we can't see yet. Therefore I use precious minerals, gold, and silver on delicate handmade Japanese paper to affirm and celebrate the physical with the "sacramental language."

I believe that true, Christ-filled expression results in more diversity than what Christ-suppressing expression would allow. The more we center ourselves in Christ, the freer we are to explore new arenas of expression. When Christ gave his disciples the commission to "therefore go and make disciples of all nations," he was literally empowering them with his authority. Here, the Author entitles authorship to his creatures, to be authors (with a small "a") of spreading God's Kingdom. This sovereign authority encompasses all the earth, and therefore, with Abraham Kuyper we are able to say, "There is not a single inch of the whole terrain of our human existence over which Christ...does not exclaim, 'Mine!'" The centrifugal, outward movement of the gospel hence moves beyond culture and geography. Therefore, in this sense, the gospel is always cross-cultural. The resulting diversity mimics and transcends the extravagant diversity of creation, breaking-in of the New Kingdom. This diversity is also a glimpse of the world to come.

Christ-suppressing expression, on the other hand, leads to disintegration of expression and identity. "Truth," as Calvin Seerveld noted, "is the way God does things." And the unbelieving world will always wrestle against the whole fabric of creation by suppression, however unconscious, of God. "The wrath of God," Romans 1:18 states, "is being revealed from heaven against all the godlessness and wickedness of men who suppress the truth by their wickedness." Paul notes that the result produces idols as we exchange "the glory of the immortal God for images made to look like mortal man and birds and animals and reptiles" (vs. 23). Forms, here, counterfeit Content as the "Real Thing." Christ-suppressing

expression pretends to be truthful but reduces God to a concept. Such expression may even be "Christian," but often with a false notion of beauty and order that is more Platonic than biblical.

Art reaches to both heaven and earth, fusing them together. If we attempt to do this in our wisdom, the result will be a greater schism between heaven and earth. Christ is the ultimate example of this fusing—the incarnation of Christ, the divine becoming man—and is therefore the greatest example in which all artists can find inspiration. Christ's unique significance for the artist goes even deeper than mere inspiration. I believe that He is the only true source of inspiration available to us to learn from.

In order for this fusing to occur, our thoughts and creativity must be driven by prayer. "To look is to pray," Sister Wendy quotes St. Benedict—substituting "look" for "work." For a redeemed mind and heart, our new nature prompts the believer to direct praise and intercession to God always. We seek "God's Kingdom and His righteousness," and thereby ask God to limit evil, and help us to bring the news of His Kingdom advancing into our broken world. And it is to seek the fulfillment of the Great Commission, "to make disciples of all nations" (Matthew 28:19). Prayer is to our lives as glue is to pigments. Prayer, in the Spirit, mediates (and is a true "medium"), and God uses prayer as a powerful binding agent in the world.

Prayer is central to the making of art. When I work on large paintings of gold surface, the rhythm of laying on gold leaves (about three inches square) prompts me to pray. I usually go through the Lord's prayer, letting each section of the prayer direct my thoughts. I often wonder if the artisans Bezelel, Oholiab and others in the Exodus passages prayed as they put gold on the tabernacle. The prayer for the Kingdom to advance, and for God's will to be done, naturally go together with laying of gold, which for most cultural settings symbolizes divinity.

Prayer requires us to move in the world, and her cities. Cities are the greatest expressive forms of our culture. Paul intentionally sought after influential cities first to spread the good news of

Christ's death and resurrection. The Bible begins at the garden and ends in a city. And by moving into cities (metaphorically and literally) we have to face the reality of evil and depravity as well as glory and splendor. Often times, being "in" the world and not "of," requires a peculiar grace of what I call "praying with our 'Eyes Wide Shut'." (I chose not the see the movie so-named, but the title captures the idea.) That is, I must face evil and depravity, but to look beneath and beyond the surface, to wrestle with the underlying tension of culture at large. We need to approach culture with the intensity of what Simone Weil called "orientation of all the attention" (p 105, *Waiting for God*). According to Weil, prayer is paying attention to God and God's world. Such holy attention, given her gaze to the world, unravels the true horrors of the darkness, and yet does so with a redemptive vigor.

In our prayer life, content (The Holy Spirit) must drive how we view form (a lifestyle of prayer), and not the other way around. We must examine carefully, as Paul has done in Athens, cultural "voices" of the city and her poets from the content of gospel freedom. We cannot be afraid to send our children into such cities, because we would be the first to suffer from (and we are the first to complain about) such neglect of our cultural mission field. We need to ask God to create genuine biblical communities within the cities of the world; because such cities will far outshine any earthly ones. There is something wrong if people find more connected-ness and grace in the gay communities than in Christian communities, and yet this is an example of what we find today. The world's cities have become the greatest mission opportunities available. It is time we send talented young people to prosper and express their creativity, to move, with Jeremiah, into our cities and "settle down and build houses," to seek the peace and prosperity of the city into which " I have carried you into exile." Christ's Bride, His Church, is meant to be the ultimate fusing of form and content, representing a new paradigm that Christ instituted when he "breathed on" his disciples after the resurrection.

Conversely, this unique perspective creates an opportunity for us to depict and exegete evil in the light of grace and the light of Christ. Evil needs to be portrayed in a way that is true about evil. It takes artistic vision and grace-oriented imagination to depict hell. Eric Fischl, in an *Art in America* interview, stated

> Artists connected to the church were asked to imagine four things: what heaven was like, what hell was like, and what the garden was like before and after the Fall. Those are four profound archetypes and they're part of many cultures. What has happened over the centuries is that artists in the West have become specialized. You still can find heaven painters, hell painters, and Garden painters, but you rarely find them in the same person.

Who can better depict a hell, heaven, or garden vision than Christians who are cognizant of Christ's grace? It is time that Christians took seriously this calling that the world beckons for, to provide new archetypes that communicate clearly and convincingly the reality of hell, heaven, and that garden.

Instead of an honest and truthful visual presentation of heaven, hell and the garden, the suppression of the truth continues. Rather than giving specific examples here, I would venture to say that all form of expression is tainted with suppression of God. As Christians, we need to constantly seek the "joy of repentance," but when the issue relates to the unbelieving world, Christians must realize, with Cornelius Van Til, that such suppression of truth is the "point of contact." Therefore, when we see Duchamp's urinal, we need to speak to the Duchamps of the world to say, "we are all 'ready made' in the eyes of Modernity; but is your experience as a human being consistent with reality?" And when we encounter Serrano's *Piss Christ*, we need to say, as a friend of mine had the opportunity to say, "Andres, did you know that that is exactly what we have done to our Lord? We have put him in the refuse of our lives!" Forms of suppression can become an important bridge to lead people to the Content of Christ.

"God in His wisdom," Nigel Goodwin states, "did not give all His gifts to Christians." And I often find myself learning from nonbelievers about the realities of our condition and the ache for Heaven. I often see in "secular" artists redemptive seeds and valuable insights. At those moments, I see that prayer given by God is also used by God to fuse Heaven and Earth together. As I believe Christ is the only source of true inspiration to learn from, and the only true content, I will accentuate this principle for the Great Commission. It is true that art needs no justification, as Rookemakker points out, and we do not need to be superficially driven to paint "Christian" images. In fact, a sentimental, superficial depiction of Christ will only impede the true message of the gospel to be communicated. The best way possible to advance the Kingdom is to attain a state of T.S. Eliot's "unconscious" Christianity. But part of this unconsciousness assumes our passion for Christ. We cannot separate art from the context of such a missiological vision, any more than you can separate breathing from a living being, or an engine from an automobile.

Samuel Escobar, speaking at last year's C. S. Lewis Celebration in Oxford, stated, "the Incarnation is the greatest translation ever, and poetry is a little incarnation." Just as Christ entered our world, translating heavenly existence to the earthly, the arts enter one human heart from another, sharing the experiential reality. Christ's incarnation is the greatest example, the greatest of translations. All art forms attempt to translate what is unseen into what is seen. Art, especially as we engage with a redeemed vision, becomes an activity of faith, translating the "substance of things hoped for" with words, paint and other materials into both the content and form of art. Content meets form in translation, and the art process mirrors this.

If we are to see the Incarnation as the greatest of translations, then we also need to see that the person best suited for the task of translation is God himself. In other words, the reality of Christ precedes and supersedes the act of incarnation. There remains what an artist friend of mine has expressed as the "ing" factor for

both content and form. Content, in some way, is always *content-ing*, and form always *form-ing*. Christ remains at the center of all creative activities, and He is the "ing." He causes each little translation to take place, and in order for art to become a "little incarnation," we also must allow Christ to be at the center of our activities.

As Ted Prescott notes, we exist in the "co-inherence" state of having two identities: one of Christ having entered our hearts through faith, and the other of our independent identities as individuals. We do not cease to be ourselves when we enter into a relationship with God; rather, we find our true selves by Christ's redeeming blood and the Holy Spirit changing us within. We become more and more like Christ (2 Corinthians 3:18), but, conversely, we become more and more like ourselves made by and for our Creator. Our *content-ing* and *form-ing* both may have much to do with the source of our identity—Christ, and our identities being transformed. As Ted articulates, our identities must be lived out in order to have any meaning. Mysteriously, both the form and content must interdependently grow into fullness. Both, though, are utterly dependent upon the work and the person of Christ, who said "apart from me you can do nothing" (John 15:5).

I have written in *IMAGE* (issue #22) that my approach to art resembles the paradigm set by a woman in the gospel who broke her jar of nard upon Christ's feet. Christians must take on this disintegration of today's culture with a bolder vision flowing directly from the very aroma of Christ—an aroma that spreads, like the nard, from Christ's feet to the world. In other words, fusing content and form is one thing, seeing form and content dance together is another. Christ provides for that final dance, and that joy needs to be reflected in our works. To the degree that we, artists cognizant of God's grace, can express this dance, to that degree the language of art will find freedom and renewal. This fruit feeds not only Christians but also culture at large.

Togyu Okamura, a great Nihonga (Japanese-style) painter, once commented, "What matters is not how finished the works looks, but how unfinished it remains." Such understanding gives the

"completed" form space to breathe and live. Ultimately, a type of faith is required to release forms to be driven by content. This faith, a shadow of the faith God gives, allows the artist to trust another to complete the vision. This transaction is not unlike the Christian's journey to lose his or her life in Christ: "He who tries to save his life shall lose it, but loses his life for me and the gospel shall save it." The *form* of a Christian is Christ himself; the only way to attain this *form* is by dying to his calling. Christ gives all artists vision of that transaction from death to life, by the One who turns our "wailing into dancing" (Psalm 30).

SINGING
in UNISON

"Art is at once exhaustively personal and inescapably social."
Conductor Robert Shaw

Into Relationship

Art cannot exist in a vacuum. Color and shape have no acuity in darkness; neither can melody or harmony resonate in silence. For art is perception. It presumes a recipient, a distinctly human one. Art is art because it is observed by someone who can perceive and assess its meaning. It is seen with eyes that can know and heard with ears that can understand. Art is art because it encapsulates a part of the human experience and elicits response. We, the receptors, are moved and in some way changed. At its essence, art is marrow and sinew of the human soul and a mark of God's image on created man. It has value only to those who bear His image, we of the uniquely human community.

We don't generally think of ourselves as a community of living beings distinct from other things in the created order. Our understanding of a community comes from the distinction

between groups of people—those that are linked geographically, or that are kindred in tastes or interests. We seek out others who share similar experiences and align ourselves with them. It's in our nature to "belong," so we form communities—groups of people that have something in common. As we function within them we develop friendships, enrich our lives, and find a source of personal satisfaction.

In a sense, every human community on earth can be considered an artistic community. Art is so infused with the human spirit that our lives themselves are a work of art—a living drama carried out over time. Paul describes it as "a letter from Christ, written not on tablets of stone but on tablets of human hearts." There are times, though, when a group of people will come together to create a specific work of art. In these settings, the community is not merely those who perceive and appreciate. The community becomes the instrument of expression that brings a work to life. These are the performers, the craftsmen, composers, screenwriters, technicians, actors—the architects of sound and light over time. Their act of purpose and their collective spirit generate works of power and impact. (The whole is greater than the sum of its parts.) They assemble and embrace creative process to pursue a mutual goal.

Here is a dominant theme in Scripture and a concept of prominence in the mind of God. The living out of a community (the church) and artistic process (worship) is no less than a paradigm of the godly life and a dwelling place for the Holy Spirit. God inhabits the praise of his people. Two great events in the life of the young Hebrew nation bring this to light: Moses building and dedicating the tabernacle in Exodus 35, and the dedication of the Temple by Solomon in I Kings and II Chronicles. More than ten chapters of the Bible are devoted to describing the artistry and detail of these events. On the day of dedication, God Himself descended on the nation to dwell with His people. Martin Selman, remarks on the dedication of the Temple in his work *2 Chronicles, A Commentary.*

Priests and Levites were indicating through their unity, commitment, and praise their desire to worship God, and the Chronicler clearly intends this to be seen as an example to be followed. When God's people set themselves apart for him to express heartfelt worship and praise, God will surely respond with some sign of his presence.

Both the Old and New Testaments are rich with references to the community of God's people. God is a seeking God. His purpose for humanity is to bring each of us into fellowship with Himself. Paul speaks of the body as having many members (I Corinthians. 12), and uses the phrase "one another" in establishing Christlike conduct in the church. We recall passages that urge us to "love one another, teach and admonish one another, edify one another, build up one another," or to "pray for one another." In a larger sense, more than one-seventh of the entire revealed word of God, the book of Psalms, was intended as text for corporate worship.

So we conclude that God's purpose for his people is to call everyone to a relationship: a relationship with the Almighty and with each other in community. Further, we are called to embrace an artistic medium—corporate worship—as the means of expression for the divine relationship. But while we might agree that the act of worship is both corporate and artistic, we must also recognize that, as the body is made up of many members, some among us are gifted in artistic means. This was true of Oholiab, Beniniah, Asaph, David—men that we would consider artists. By looking closer, we see that artists themselves are members of smaller communities: musicians, sculptors, writers, dancers, or painters. We can begin to appreciate the scope and breadth of the corporate artistic body as we consider those individuals who aspire to these individual communities. As we examine the lives of individual artists—and here I will be speaking of performing artists—and observe their function within an individual community, can we discover a design for the Christian life that may have its origins with the master Creator?

Solitude

One would think that, (upon seeing a production of a Wagner opera or another large work) the life of a performing artist is largely spent in rehearsal and preparation of great musical events. In reality, the opposite is true. The amount of time allotted for complete rehearsal—even for the largest of works—is very little. The majority of the artist's life is spent in solitude—and the artist is acutely aware of this. For in these times alone the performer learns his craft and the composer seeks inspiration. Beethoven sought the quiet setting of the Vienna woods to gather strength. Mahler built a "shed" for himself in a remote part of Bavaria where he could compose in silence. Josef Haydn would schedule a specific time of day to compose alone in his studio, and if he didn't receive any ideas in the allotted time, he would pray for them. A 1996 study of young musicians has stated that "up to the age of 21, a talented pupil will have spent about 10,000 hours of purposeful practice."

One of the first characteristics of the artist and community is a budgeting of time spent with others and times spent in solitude. A performer knows what it means to practice: taking at times only incremental steps on a path that will eventually lead to true artistry. But he also knows that he can't do it alone. He is equally committed to the discipline of practice and an inner drive to be heard by others. Practice leads to performance, and performance is almost never alone. The performer is in an unending search for collaborators—singers need pianists, guitarists need a band, and all are vitally linked to their communities. And after the performance, on to more practice ... and so it goes. Each gives strength and purpose to the other, and both are held in perpetual balance in the life of the performing artist.

For the Christian, quiet times alone with God are preparatory to the times when we are bringing His message to a lost world. It is in these times of communion with Him that our faith is honed and our strength restored. But His spirit convinces us that we can't live our lives cloistered from those Jesus died to save. In the quiet hours when we are "still and know" that He is God, we are empowered to

act. And in the heat of the struggle for men's souls, our energies are depleted and we need to return alone to the source of all power. Jesus' ministry is nothing more than the perfect balance between times spent feeding the masses, and hours alone with his heavenly Father.

• • •

Unison singing has a symbolic significance. The singing of only one melodic line signifies unanimity of spirit and is the symbol of ultimate fellowship.
—German conductor Wilhelm Ehmann

Artistry and Unity

Arguably the most significant concert of the 20th century occurred at the Schauspielhaus in Berlin, Germany, on December 25, 1989. To celebrate the collapse of the Berlin Wall and the reestablishment of a united Germany, musical artists from around the world met to perform Beethoven's Ninth Symphony conducted by an American conductor of Jewish descent—Leonard Bernstein. Rich in symbolism, the event included orchestral musicians from the countries allied against Germany in the Second World War, along with a large chorus of German singers who came from both sides of the fallen Wall. Peoples who were at one time enemies in the greatest conflict in human history were united in the music of one of Germany's greatest musicians. This remarkable project was achieved with the collaboration of the Bavarian Radio Chorus, Dresden Philharmonic Children's Chorus, the Berlin Radio Chorus, the Dresden Staatskapelle Orchestra, the Orchestra of the Kirov Theater in Leningrad, the London Symphony Orchestra, the New York Philharmonic, the Orchestre de Paris, and Deutsche Grammophone Recordings.

One can only imagine the number of communities represented by those entering a concert hall to perform a masterpiece such as this. Yet a "community of communities" is a familiar occurrence in the performing arts. Look at the credits at the end of a major

motion picture, or read the names of the participants in the program of a theatrical production. Each individual participant in a corporate work brings an artistry and a humanity to the work that is critical to its achievement. In a symphony orchestra we find accomplished musicians who are not only performers, but prominent members of their individual fields, including the guilds and intelligentsia of every orchestral instrument. A chorus may involve professional vocalists, teachers, students and some whose professions are outside of music altogether. A dramatic production requires technical expertise—lighting and sound technicians as well as backstage assistance, costuming, and makeup. Each individual arrives at a different stage in his own artistic development, but all have something specific to contribute. In a very real sense, the work becomes a functioning organism, with activity from the smallest atom to the expressive whole.

Unity and Submission

At the beginning of a live performance we see a single person enter the hall and assume the podium: the conductor. His task is to bring all the musical and expressive forces together. Under his direction the next hours will be spent bringing a specific work into existence with order and meaning. He is a guide in the purest sense, navigating through a musical score using wisdom and refinement. He knows that this work, as with all performing arts, must be recreated in time for it to exist at all. The performers are unified in purpose and desire, and they also submit their own interpretative ideas to that of the conductor. The conductor channels the common spirit and human energy to bring to life the unified ideal.

Unity in any aspect of serious music making is a difficult and frustrating pursuit, yet almost every aural concept is connected to unity in some way. Unison, ensemble, rhythm, octaves, timbre—these and many other terms are intertwined with unified musical expression. I would mention here one of the musician's favorite

nemeses: intonation, or performing in tune with another instrument. Intonation may well be the determinant between music and noise. From the simplest solo line to the most complex harmonic structures, each individual pitch from each performer must have a center, and it must align with the pitches of those around it both melodically and harmonically. This is no small pursuit, it is a way of life. A performer never stops critically listening and making adjustments for the sake of intonation.

As community is significant in the mind of the Almighty, so also is unity. Both the Old and New Testaments present this as a distinctive of God's people. "How good and how pleasant it is for brothers to dwell together in unity." (Psalm 133). The idea of koinoneia (fellowship) is a New Testament idea. Paul wrote to the Philippians: "then make my joy complete by being like-minded, having the same love, being one in spirit and purpose." (2:2). Jesus' final prayer with the disciples in the upper room reads:

> I have given them the glory that you gave me, that they may be one as we are one: I in them and you in me. May they be brought to complete unity to let the world know that you sent me and have loved them even as you have loved me. — John 17:22-23

Jesus prayer is that "perfect unity"—through koinoneia—will be not only the impetus for bringing His message to a lost world, but also proof that He came to earth at all.

Unity is paramount in the Christian life on two levels. God desires that we be bonded with Him in the unity of the Holy Spirit. ("That they may be one just as we are one.") Also, God desires that we be united together in community. Closer examination of the ideas of unity and "oneness" in the Bible brings us into the presence of God Himself—the Father, Son, and Holy Spirit, three in one. Deuteronomy 6, the text of the Hebrew Shema, begins, "Hear, O Israel! The Lord is our God! The Lord is one!" In the New Testament, "there is one God and one mediator between God and

men, the man Christ Jesus" (I Tim. 2). After Pentecost, the Spirit, (paraclete) is one with the Father and the Son.

At this juncture, I would point out a distinction in meaning between the Biblical use of the words "oneness" and "unity." Oneness refers to a state of being—a Gestalt—in the character of God or of his people. "That they may be one just as We are one." "The Lord is our God. The Lord is one." "The one who joins himself to the Lord is one spirit with him" (I Corinthians. 7:17). Unity among believers, on the other hand, is one-ness played out in time—a purposeful act of pursuit. The brothers "dwell together in unity," and Paul entreats the Ephesians to be "diligent to preserve the unity of the Spirit in the bond of peace" (4:3). We are one in who we are, but we are unified in what we do.

Our lives spent in community with other Christians should embrace a consistent passion and attention to unity that an artist brings to the performance of a great masterpiece.

• • •

"There are different kinds of gifts, but the same Spirit. There are different kinds of service, but the same Lord. There are different kinds of working, but the same God works all of them in all men. Now to each one the manifestation of the Spirit is given for the common good. "
—I Corinthians 12

His The Spirit

As indicated earlier, art is inescapably linked to the human spirit. In the performing arts we can actually watch a living laboratory of communities functioning under a "leader" for the realization of a common ideal. In this venue we know that many function together to create something greater than any individual can achieve alone. Performers are dependent on this. They bring their craft to a level of artistry over a lifetime of balancing community interaction with the solitude of training. And they are willing to subjugate their artistry to another of their community, the

conductor , striving for a unity that is necessary for the art to exist as an integrated whole.

Human nature being what it is, we would like to think that we are capable of achieving great artistic and expressive heights on our own. But let's not kid ourselves. Anything that is so unmistakably joined to the human spirit can only get its life from none other than God's Holy Spirit. Here we must give credit where it is due and recognize that a unified functioning body works at all because the Spirit gives it its life. So before we go any further, we must consider how the Holy Spirit plays a role in the community and the artistic process.

More has been written on the ministry of the Holy Spirit in the last 30 years than in any other time of history. At this point, we leave our discussion on community to briefly look at three attributes of the Spirit: His regenerative work, His redemptive work, and what the Bible calls the "gifts of the Spirit."

His Spirit at Work

First, we must reaffirm that the Holy Spirit is a person, and that He is God. He is everywhere, and in Him all things coexist. The apostle Paul, in speaking to the Athenians stated, "For in Him we live and move and have our being" (Acts 17:28). R. C. Sproul has written "In the sense of creation, everybody participates in the Holy Spirit. Since the Holy Spirit is the source and power supply of life itself, no one can live completely apart from the Holy Spirit." He is present as a creative force today, and continues to be as active as when the earth was first created. Sinclair Ferguson notes in his book *The Holy Spirit*, "from the beginning, the ministry of the Spirit had in view the conforming of all things to God's will and ultimately to his own character and glory." In the Holy Spirit we encounter the administrator whose role is to "order and complete what has been planned in the mind of God." This is an ongoing, creative work.

Second, we must realize that since Pentecost part of the Spirit's ministry is to call all people to redemption. It is the Spirit that moves in men's hearts to bring them to the knowledge of Christ and His atonement. In his book *The Mystery of the Holy Spirit* R. C. Sproul writes, "Just as nothing can live biologically apart from the power of the Holy Spirit, so no man can come alive to God apart from the Spirit's work." This is the function of God's Spirit in this age—with Pentecost as the "beginning." As Ferguson puts it,

> The inaugural outpouring of the Spirit creates ripples throughout the world as the Spirit continues to come in power. Pentecost is the epicenter, but the earthquake gives forth further aftershocks. Those rumbles continue through the ages.

Further, we must concur with theologians who contend that these two aspects of the Spirit are essentially the same. The redemptive work is at once a regenerative work. In his conversation with Nicodemus, Jesus explains the meaning of being born again, "That which is born of the flesh is flesh, and that which is born of the Spirit is spirit" (John 3:6). In the work of redemption, something entirely new is created—a new spirit literally comes into being with eternal significance. Something has come from nothing, and this is creativity in the Godly sense. Also, we know that our spiritual life is dependent on the Holy Spirit for the renewal of a proper relationship with God. The Spirit convicts and leads us to confession, forgiveness, and restoration. In David's petition of Psalm 51, he cries out; "Create in me a clean heart, O God" (a creative act), "and renew a right spirit within me." (regenerative). Later he writes "Restore to me the joy of my salvation (redemptive) and uphold me by your free spirit."

In addition to His regenerative and restorative work, we briefly examine the activity of the Spirit in the giving of spiritual gifts. This is an issue of intense dialogue in the Christian community and an arena in which the arts flourish. Nowhere is diversity of human gifts more universally celebrated and significant to a

populace than the artistic community. Sinclair Ferguson comments that: "In pursuing his purposes among his called-out people, God's Spirit also granted gifts of design and its execution to men like Bezalal and Oholiab. The beauty and symmetry of the work accomplished by these men in the construction of the tabernacle not only gave aesthetic pleasure, but a physical pattern in the heart of the camp which served to re-establish concrete expressions of the order and glory of the Creator and his intentions for his creation."

God's Holy Spirit is alive and working in both the creative process and in the community of artists. He is both the giver of gifts, and the impetus for causing them to resonate. On one hand, diversity of gifts is a perfectly acceptable dogma to a performer— not only acceptable, but embraced! Recognition of the Giver of the gifts, however, is an entirely different matter. In the context of an artistic medium that is so dependent on creation and recreation, reverence of the Creator Spirit is not the universal norm. Like all of fallen humanity, the performing community has looked to human energies to achieve its goals. And considerable these energies are! No one could doubt that the great musical works of history are, by human standards, enormous in breadth and scope. In contrast, Jesus said in John 6:23, "It is the Spirit who gives life; the flesh profits nothing."

Man's Creative Spirit

While performing artists in recent centuries have been ardently joined to the human spirit, they have been either unaware of or uninterested in the Holy Spirit. The great composers, visionary organizers of human energies, brought artistic expression to new heights with their innate creative gifts. But, like the Russian cosmonaut who launched into orbit around the earth to exclaim, "I didn't see God," so also is the performer who might give his audience a glimpse of heaven, but has not known God.

Beethoven and Mahler both saw in music a gateway to a higher plane, but couldn't "find" God in it. On the other hand, J. S. Bach's music overflows with devotion to the Redeemer whom Bach knew and loved. The story is told of conductor Robert Shaw rehearsing his choir for a Bach masterwork; the glorious Mass in B Minor. In this opus is one of the great expressions of the human soul to a personal, relational God. Julius Herford, Shaw's friend and mentor, was present at the rehearsal. At a particularly climactic moment of the piece, Shaw, with his legendary ego, turned to Herford after the cutoff and asked, "Well, how was that?" Herford's reply: "It was perfect, Bob, just perfect. But you missed the whole point."

Sadly, the artistic community has been missing the point. We have been quick to recognize the creative gift, but not the Creator. We have applauded the grand musical event, but have not recognized the Spirit that infuses life. While the greatest minds have shown genius when called to orchestrate the collective voice of humanity, they have not been able to evoke the presence of God, even though some have claimed to do this. And, sadly, we would rather it be this way, because at issue is Lordship. We applaud the human spirit because it's a chance to applaud ourselves. We have experienced the Spirit in regeneration and in creativity, but we are strangers to his work in redemption. Art cannot redeem, only God can.

• • •

If you sing in a choir, the question is not just if you're on your note; it's why you are singing at all.
—Jim Cymbala, Pastor, The Brooklyn Tabernacle

Worship in Community

My family and I have traditionally spent our vacation at the beach, but we avoided July 4 because of concerns for crowds and traffic. One year, though, we found ourselves on vacation at the busiest time of the tourist season. We stayed in a small town, noted for its lovely beach—no boardwalk or large resort—and the townspeople publicized their annual July 4 parade. What a festive

day it was! Almost every house on every street was decorated and visitors were cheerfully welcomed. Some of the tourists even marched in the parade wearing the appropriate red, white, and blue. The patriotism was contagious. Walking back from the parade we remarked at how our national pride had been bolstered, and how we had felt a kinship with people throughout the country who were doing the same thing that day. Later that evening, as we sat on the beach, we could see fireworks from three different cities, affirming that we were part of a truly national celebration.

Similarly, when we enter the church sanctuary on a Sunday morning, we are part of something bigger than ourselves: a global celebration. We don't generally think of the community outside of our own congregation, although we might allow denominational differences or forms of worship to cross our minds. But the global community has set apart the day for gathering and worshipping God corporately, and the sounds of praising God are continuous each Sunday. We are part of this. We are mankind representing every tribe of every nation, every language, all involved in an artistic process for the purpose of glorifying God. We are the earthly counterpart of the vision of Isaiah where cherubim surround the throne continuously saying "Holy, Holy, Holy is the Lord of hosts. Heaven and earth are full of His glory" (6:3). Like the July 4 fireworks, the songs of God's children are lifted up on the same day as an affirmation that we are part of a universal chorus of praise.

There is another dimension to our acts of worship as the assembly of God's people. The Spirit that unifies all Christians today is the same Spirit that has been at work through the ages. We are part of a spiritual heritage, and our worship is filled with the artistic works of those who have gone before us. In our "songs, hymns, and spiritual songs" (Col 3:16) we connect with Christ's life-giving work in our spiritual forefathers. Jesus' redemptive work is as relevant today as when the words of "Amazing Grace" were penned. Consider these things as we raise our voices together in praise and we get a glimpse of the greatness of our God.

Could it be true that our worship is connected in some way with God's people throughout the world, and with the Spirit of the ages? Is the praise of men in some way a microcosm of the angelic praise that eternally surrounds the Almighty? Before we allow our thoughts to carry us away, we need to be reminded of Paul's words in I Corinthians 13: "If I speak with the tongues of men and angels but have not love, I have become a noisy gong or a clanging cymbal." Lofty as we imagine our praise to be, God is not interested in our Herculean efforts. God looks at the heart. Man asks what we are doing, God asks why. If we think for an instant that our praise is acceptable to God in and of itself, we are no better than the Pharisees. God looks down in compassion on the one who beats his chest and cries out "Lord, be merciful to me, a sinner." The Spirit visits those who humbly pray and seek Him, knowing that they deserve His judgment. And to those who gather in kiononeia, united in purpose, He comes in power and revival. Our worship, our art, is a process of preparation, refinement, and then an emptying of self to be used by the Spirit that gives all things life.

So let us return for a moment to the two significant musical events previously examined: the Beethoven concert in Berlin and the dedication of the Temple in Jerusalem. At the performance at the Schauspielhaus in 1989, an international collaboration of artists met at a historic moment to present a living work of art in the name of one of the great themes of humanity: freedom. Israel's dedication of the Temple under Solomon's rule was no less an historic event. Similar in size, with multiple choirs of Levites and 120 priests blowing trumpets, the entire nation of Israel met to express gratitude to the God of Abraham for his mercy and kindness. Both events were recorded for future generations. The Berlin recording by a renowned recording company captured the significance of the event to the German nation and the outpouring of human expression. The music was glorious. By contrast, in the Biblical record of II Chronicles 5-6, the Spirit of God descended on the Temple and stopped the music. God Himself was glorious.

Spirit-filled worship, as with Spirit-filled art can live in us only when we are willing to submit talent, practice, and purpose to the One who gives them in the first place. Also, we must also be willing to submit each time we pick up our instrument, or inhale to utter speech. The nation of Israel is our model. When we do this—with united hearts and minds, and for the glory of God alone—we can experience His presence and know that the words of our mouths and the meditation of our hearts are acceptable in His sight. "For just as we have many members in one body and all the same members do not have the same function, so we, who are many, are one body in Christ, and individually members one of another" (Romans 12:4-5).

• • •

Where there is charity and love, God is there.
The love of Christ has gathered us together.
Let us rejoice and be glad in it.
Let us revere and love the living God
And from a sincere heart let us love one another.

Likewise, therefore, when we come together
 let us be united as one;
Let us be careful lest we be divided in intention.
Let us cease all quarrels and strife.
And let Christ dwell in the midst of us.
—From a 10th century Plainsong

Devotion to Making

Having said all this, can we honestly admit that we are aware of such lofty ideals when we are in the midst of the creative process? Are we really in communion with men and angels when we join in worship to our Lord Christ on Sunday morning? Does our facility with movement or use of light show real inspiration and unique perspective? I suppose it is rare indeed that we think of these

things during a performance simply because we are up to our elbows in the creative process. Our thoughts don't belie the existence of a Godly presence, it's just that we are intent on the act of doing. We perform our art similar to the Mickey Mouse cartoon in which a tornado interrupts an outdoor band concert. The music, audience, instruments, gazebo, fences and trees are all swept away, but the musicians never miss a beat. As the tornado goes on its way, the music comes to an end and the musicians are frazzled but suddenly aware that something else had happened during the course of the concert. In artistic expression, something else is happening. Zoltan Kodaly, the Hungarian composer and pedagogue wrote: "While singing in itself is good, the real reward comes to those who sing, and feel, and think with others. This is what harmony means." So before we leave the discussion of the artist/community experience, we must consider the difficulties of community work, compound it with the difficulties of artistic process, and place both in the church environment.

It should not be surprising to us that (in a spiritual sense) when the house lights are dimmed and the spotlights come up on the artists, we are brought face-to-face with sinful man. Christian art is a battleground. Those who are gifted to interpret praise, joy, mourning, and other aspects of human experience, find it difficult to control their own emotions. The passion necessary to bring a great idea to life is also the stuff of criticism, quarrels, and strong opinions. The church choir can be a place of nurturing or of constant bickering and jealousy. Artists are also intensely competitive, and they are usually those who like attention. They are prone to create for personal gratification or to satisfy an inner need to be applauded. Their work is done at risk: risk of criticism or of poor performance, or of being misunderstood. It is no wonder that the mix of artistic "temperaments" and the unending issues of leadership are an ideal setting for the work of the Deceiver. Daunting indeed is the task of the artist/leader to bring the diversity of gifts to unity, particularly when these gifts are

attached to intense wills and opinions. At the center, it seems is the question of control.

For the musician, each musical phrase, each dynamic and tone, must be controlled. For the dancer, each movement must be brought under discipline. The representational artist controls color and light, even hammer and chisel. The words on the page, the volume of the instruments, the worship in song and prayer all play a part. And each participant has an idea of how it should be done. Who ultimately decides how or what is accomplished? After a time, it seems useless to attempt to do anything in love or unity of spirit. When we are ready as artists to throw up our hands at the church and take our gifts elsewhere, we are confronted with the disciples and their experience on the day of Pentecost.

Art Since Pentecost

Acts 2:42 tells us that after the Holy Spirit was poured out on the disciples "They devoted themselves to the apostles' teaching, and to the fellowship, to the breaking of the bread and to prayer. Four new disciplines characterized the new "community", the Church. First, the apostles' teaching in God's Word implies accountability and mutual growth. Second, the fellowship signifies the rich koinoneia or "common life" modeled by Jesus and his disciples. Third, the breaking of the bread represents the sacrament of communion. And fourth, prayer was not a shallow recitation of requests, but a deep intercessory prayer life immersed in the needs and knowledge of others. Even more convincing to us today is that the disciples devoted themselves to this new community way of life. The Bible makes no mention of these men's individual gifts, although they certainly had them. In their devotion to each other they fulfilled His purpose for the new church—a community so compelling that it would bear witness to the world that Jesus had come as the Redeemer of mankind. In addition, by devoting themselves to God's purpose, they placed their talents and gifts under subjection to the One from whom all gifts were given.

These are piercing words to us today as Christians and particularly as artists. Isn't it obvious in this postmodern age that the arts need to be brought into the church community and that Christ needs to be brought into the artistic community? Charlie Peacock-Ashworth reminds us in his essay that artists that are followers of Christ should "not consider themselves exempt from fellowship and church stewardship responsibilities. [Instead they should] love the church and do all they can to build it up ... "

So tomorrow—today—if we check our agendas at the door and devote ourselves to the community of others in unity for the glory of God, submitted to his purpose, He promises to send His Spirit to indwell us and give life to the work of our hands.

We'd better be careful—He may like it so much that He'll stop the whole performance.

WHY
we need
*A*RTISTS

In considering the place of artists in our world from a Christian perspective, we need to understand the answers to three simple questions. Why do we have artists? Why do we need artists? And, how are we to be artists? I may not give you all the answers in this short discussion, but I hope that my ideas will stimulate your thoughts with respect to these questions.

Why Do We Have Artists?

C. S. Lewis said that reason is the organ of truth, but imagination is the organ of meaning. When people talk about the difference between human beings and animals, they often conclude that one of the greatest distinctions is that animals do not do art. Why don't they? It appears to me that humans have art because they understand, perhaps at an intuitive level, that there is meaning in what we do. Our lives are filled with meaning that is greater than a simple factual evaluation of actions and consequences. We show that we recognize this when events touch our emotions and affect our behavior.

Consider how people react when a relationship breaks up. We could take a completely objective view of the situation with all emotions removed. Or, it is suggested that the only reason anyone experiences sexual attraction and the only reason that a person falls in love is because someone wanted to insure that his genetic code is passed on to the human race. Since that is all the "relationship" meant, we could admit that it didn't work, that it was a failed effort, and we could go find somebody else—another spouse, another mate. But that is not what happens. We feel pain at the loss of an important relationship. When we break up we want to think about why it ended, what it says about us. We do this because dating and marriage relationships mean more than genetics.

Think about the significance of a funeral. Animals don't have funerals. If we consider a funeral as an objective event, it involves the disposal of a decomposing organism. It would be wise to avoid the decomposing body to prevent the spread of disease. But that is not how we behave. People gather around the body. They sometimes hug or kiss the dead person. A funeral has more meaning than the disposal of a body. A funeral is art in and of itself and it is filled with art. Why? Because we deny that when a person dies it is no more important than a stone falling to the bottom of a pool. In an artificially objective way a funeral would be something we do to handle a particular type of inanimate matter. In reality, a funeral is a ceremony filled with meaning, so we must have art.

What this shows us is that art is always involved in events and circumstances that have significance and meaning. Arthur C. Danto, from Columbia University (by no means either a conservative or a Christian) said, "Art is getting across indefinable, but inescapable meaning." This is a helpful definition, because he is saying that if in your art you are getting your meaning across in a way that is too definable, it is really preaching rather than art. Of course preaching itself can be an art form, but it is an art form that is and should remain distinct from the other arts. Art has to have a place for the observer to explore and wrestle with the message. If

the meaning of a work is apparent, allowing the audience with little effort to say, "of course, that is what it means" and if the message can be simply stated in one sentence, the work is not art. You may have heard the famous statement by a dancer who was asked, "What did the dance mean?" She responded, "If I could have said it, I wouldn't have had to dance it." According to Danto, if an artist can enunciate the message in his work, perhaps saying, "Oh, that is Mary rocking the baby and putting him in the manger," then the work is not good art. Art has to be, in some sense, indefinable— but in another sense absolutely inescapable. What we say and do means something. We are not just chemicals. That is why we must have artists. Artists are people who know that, in spite of what we are told by our culture, everything is part of some bigger reality.

This raises an issue that I have been thinking about and that a number of people are constantly working on: What does 'meaning' mean? How do we define 'meaning?' Significance is really a synonym but it does not capture all that is contained in the word 'meaning.' Can we define 'meaning?' I believe we can. While it appears to some to be almost impossible to define, yet it is clearly something we know exists and understand at some level. Even people who insist that nothing has any meaning show that they don't believe their own words when they don't live as people who have no meaning. Many people do not know what it is that gives meaning to life but they know intuitively that life is meaningful. What I have found is that the meaning of life is the glory of God. All meaning is some aspect of the glory of God. If there is no God then nothing can have ultimate significance. The word glory means weight, it means significance—it basically means 'meaning.'

For those who want to deny life any meaning, the folly of their view is exposed by Christian artists who express the meaning, the glory of God, in a way that Christian non-artists cannot. C. S. Lewis in the *Weight of Glory* says,

> In speaking of this desire for our own far-off country, which
> we find in ourselves even now, I feel a certain shyness. I am

almost committing an indecency. I am trying to rip open the unconsolable secret in each one of you—the secret which hurts so much that you take revenge on it by calling it names like Nostalgia and Romanticism or Adolescence; the secret also which pierces with such sweetness that when, in very intimate conversation, the mention of it becomes imminent, we grow awkward and affect to laugh at ourselves; the secret we cannot hide and cannot tell, though we desire to do both. We cannot tell it because it is a desire for something that has never actually appeared in our experience. We cannot hide it because our experience is constantly suggesting it, and we betray ourselves like lovers at the mention of a name. Our commonest expedient is to call it beauty and behave as if that had settled the matter ... The books or the music in which we thought the beauty was located will betray us if we trust to them; it was not in them, it only came through them, and what came through them was a longing...For they are not the thing itself; they are only the scent of a flower we have not found, the echo of a tune we have not heard, news from a country we have never yet visited.

Lewis is suggesting that every artist recognizes the secret desire for the other country, whether he calls it by one of those names Lewis mentioned or not. A person who is not a Christian doesn't really know what to call the other country. It can be terrifying for one who is not a Christian to even begin to try to identify the other world. But whether he gives it a name or not, he senses that this greater reality exists and gives everything meaning. So Lewis is right when he says, "It is only through imagination that we really sense something has meaning."

It takes the imagination to sense something has meaning because we cannot cognitively grasp the glory of God. The glory of God is beyond our ability to understand or describe. The imagination goes beyond what we can think of and rises to lofty heights where it contemplates the glory of God. It is those elevated

thoughts that help us know that everything has meaning. We have artists to stimulate that imagination and to show us that things have meaning. Artists have a special capacity to recognize the "other country" and communicate with the rest of us regarding the greater reality. A good artist will reveal something about the greater reality in an indefinable but inescapable way. Having answered why we have artists, we now need to discuss why we need artists.

Why We Need Artists

Thinking specifically of Christians for the time being, why does the Church and why does Christianity need artists? While we have artists because they have the ability to see the greater reality, we *need* artists because, if Lewis is right, we can't understand truth without art. You see, reason tells me about the truth, but I really cannot grasp what it means; I can't understand it without art. Jonathan Edwards, the third president of Princeton University, probably the most important American theologian and one of the most prominent preachers in the First Great Awakening makes this point as well. Edwards said that unless you use imagination, unless you take a truth and you image it—which of course is art—you don't know what it means. If you cannot visualize it, you don't have a sense of it on your heart. We see this in one of Edwards' sermons called *Sinners in the Hands of an Angry God*. It is unfortunate that this sermon is one of the only sermons by Jonathan Edwards that people ever read. He has so many others that are quite excellent. Edwards, at one point in the sermon, looks at the congregation and says, "Your righteousness cannot keep you out of hell." That is a truth. You may not believe it, but there is the principle. While that is the content of what he is saying, he says it in a way that better makes the point. He says,

> Your wickedness makes you, as it were, heavy as lead, and to tend downwards with great weight and pressure towards hell; and if God should let you go, you would immediately sink

and swiftly descend and plunge into the bottomless gulf, and your healthy constitution, and your own care and prudence, and best contrivance, and all your righteousness, would have no more influence to uphold you and keep you out of hell, than a spider's web would have to stop a falling rock.

Now as soon as he said that, what has he done? He has used imagination, moving from truth into the area of visualization. As a result you have a clearer sense of what he means. Even if you don't agree with the concept, you begin to recognize what is going on. You may not have understood what he meant until he crossed over into another mode—until he put it in the form of a sense experience and showed you what it looked and felt like. This sensual expression of the truth allows you to hear the truth, to see the truth, to taste it, touch it and smell it. The more various forms in which truth is described, the more we understand and can then communicate truth. We can't understand truth without art. In fact, a preacher can't really express the truth he knows without at least couching it in some artistic form.

The Church needs artists to assist the body in understanding truth, but just as importantly the Church needs artists to equip the Church to praise God. We cannot praise God without art. Within the Christian art community there is frustration for visual artists who observe the important place of the musical arts in worship. Music is easy to use in worship. It holds a prominent place in worship that the visual arts do not. I believe we have to find ways to use all the arts in worship. But there are important differences between visual and musical art that make musical art a more natural element in public worship. It is impossible to get a thousand people together to do visual arts in worship on a regular basis. A large group can appreciate a visual art display in a church setting but they cannot *do* it. In contrast, a thousand people can create and do musical art in a worship service and it is both musical art and worship. Only recently I have recognized that God over and over in the Psalms commands people to worship through

music. He does not merely call on the congregation to proclaim his glory, he commands us to praise him with music, with the harp and with the viol. Now obviously he does not command us to worship with musical art exclusively rather than visual art. That is not what I am saying. But consider what the command requires. It is again what Lewis describes in *Reflections on the Psalms*. He says that when you experience the meaning of something, you need to praise it. One of the reasons why we non-artists have a lot of trouble praising God is that we can't enjoy the glory of God unless we praise it. When we praise God, we are not discussing our enjoyment of God, but the praising is the consummation and the completion of our worship as we glorify God. Therefore, one of the reasons we don't praise very well is because we are limited in how we bring forth what is in our hearts and minds. A great poem, an incredible piece of music or a marvelous painting—these are all ways to express our awe at the glory of God. Art is a natural vehicle for pouring out the praise we long to give God. Without art it is almost impossible to praise God because we have no means by which to get the praise out. We can't enjoy God without art. And even those of us who are terrible artists have to sing sometimes. We may not get God's praise out very well, but we have to do something because we have to praise God. So, without art we can't understand the truth, we can't enjoy the truth, and we can't praise God. But there is still another reason the Church needs artists.

The Church needs artists because without art we cannot reach the world. The simple fact is that the imagination 'gets you,' even when your reason is completely against the idea of God. "Imagination communicates," as Arthur Danto says, "indefinable but inescapable truth." Those who read a book or listen to music expose themselves to that inescapable truth. There is a sort of schizophrenia that occurs if you are listening to Bach and you hear the glory of God and yet your mind says there is no God and there is no meaning. You are committed to believing nothing means

anything and yet the music comes in and takes you over with your imagination. When you listen to great music, you can't believe life is meaningless. Your heart knows what your mind is denying. We need Christian artists because we are never going to reach the world without great Christian art to go with great Christian talk.

How to Be an Artist

Having explained why we have artists and why we need artists, we now need to explore how to be an artist, if you are a Christian. If you are wondering why I keep quoting C. S. Lewis, it is because almost everything I know about Christianity and the arts comes from him. When Lewis' best friend Charles Williams died, he thought that his other best friend J. R. R. Tolkien would fill the gap. Lewis felt that since the three friends were all together and shared so much with each other, the change once Williams was dead would result in his getting more of Tolkien. But he found to his shock that when Williams died he had less of Tolkien. Why? Because, he observed, "I'll never get out of [Tolkien] the particular kind of laugh that only a Charles joke could get." Lewis began to realize that no one human being could call the entire person into action. What happened when Williams died was that Lewis got less of Tolkien because he lost the part of Tolkien that only Charles Williams could bring out. This clarifies how much we need each other. The Christian artist needs to interact in community because of what he will bring out in others and what they will bring out in him.

If artists pick up some aspect of meaning and if all meaning is some aspect of the glory of God, things mean something only because they have something to do with the glory of God. This is true whether we are Christians or not. One artist can express only one little ray of God's glory. We all need one another because we cannot possibly see the whole thing. We need one another because only together do we get some idea of the multifaceted array of God's glory. It is incredibly frustrating to only see one part of the

glory and to never quite get it out. We need one another to help us express our part of the meaning.

This can be seen from an example in the life of Tolkien. Once, when Tolkien had a terrible case of writer's block, he sat down and wrote a short story. It broke through his writer's block, and he went back and wrote *The Lord of the Rings* very quickly after that. If you want to read this short story, it is called *Leaf by Niggle.* Go into any bookstore and find a Tolkien reader; it is in there. The story is very short. It is about a poor artist, a man named Niggle, who spent all of his life trying to paint a huge mural of a tree on the side of the post office in his hometown. Niggle had a vision but he was never able to get it out. Ultimately, all he ever did was draw one little leaf down in one little corner. Of course everyone in town asked, "Why did we commission you? We paid you all this money and what is going on?" Not long after, Niggle dies and suddenly finds himself on a train going to heaven. As he is looking at the landscape from the train he suddenly sees something off to the right and he tells the train to stop. When the train stops, Niggle runs over and at the very top of the hill is his tree. He looks up and realizes that this is the tree he had in his mind all of his life. He had been trying to draw it the entire time he worked on the mural and all he had ever gotten out was one leaf. For some reason, when Tolkien realized that the single leaf was all he ever would get out, he was able to go back to work. He realized that he would never produce the whole tree, the whole glory of God.

We get a leaf. But only together as artists are we going to see the whole incredible tree. We all have to "do our own leaf." Every one of us has something to contribute.

O the OLD
L D
STORY

(an afternoon's conversation)

The Story

I think that if artists are not dealing with the most profound subject and the most profound part of reality that they know, then they are playing in the shallows. For so long, artists in our time have played with the artistic means (the elements and principles of design) to the point that they have thousands of ways to say nothing. Christians should come to art-making knowing that the artistic means is not the highest we know. It is the language we use. How do we deal with that language? I remember from my college art history that the one thing Christianity brought to the art of the Romans and the classical world was a story to tell. In form early Christian art was seen as a degeneration of what had been. It doesn't really matter whether this decline was the decadence of the civilization that was Rome, or Christianity's untrained handling of the artistic means. The new thing that Christianity brought to the whole mix was that the Christians had a unique and compelling story to tell of God's sacrificial dealing with mankind, and they found a way to tell it. That is the mark of the

Christian worldview—the story we have to tell. We may tell it in all kinds of ways as artists. But Christian art, to be Christian, must at least assume that Christ has come in the flesh and is a living agent in our world.

If art is a poetic parallel to reality, then Christian art is a poetic parallel to Christ's presence in the world. This may be in a broad and negative sense as non-believing artists assume that they are making Christ's presence obsolete by attacking the evil in the world without reference to Him. They may even use their art to attack God's people for their real or perceived sins, but these artists' moral indignation can only have meaning in the context of a world created by a Righteous God. Then again, the art may be Christian in the more predictable sense of either openly or obliquely affirming His abiding presence and work in the world. In both cases the art is dealing with His presence and the truth of the Gospel. God uses whom He can to speak His truth. If He doesn't have his witnesses within the Church at a given time, then he will find them outside the Church.

Christ's immanent presence is the foundation of my work as a Christian artist even when I am not painting the Christian narrative. At graduate school I did still-life painting, as I was trying to find my way in a secular art environment. But how in the world can still life speak of the Gospel? The painting finally evolved from the borderline decorative into religious still-lives in which I was using objects on a table as a metaphor. Interiors became very unstable with objects in the roles of gods piled on top of each other. Chairs became little human thrones.

Even then I felt it necessary to make a link to past Christian art. I began to look at ancient illuminated manuscripts. I saw the possibility of a relationship between those ancient works on paper and contemporary watercolors on large buckled paper with borders that I began to make. The primitive nature of some of the manuscripts was even more interesting to me. The primitive, as the 20th Century has taught us, can translate into the painterly with rhythmic mark making creating pattern, which can create space.

Other realities presented themselves in the making of these works. I was finally striving towards a larger metaphor of how the world works. The theme of the place of humanity in the world ran through all the subject matter as the subject matter was serving the theme. Just simple still-life painting began to hold a human significance that I never suspected possible at the beginning. From this much else unfolded.

My paintings now are large biblical narratives that attempt to portray Christ's presence in the world in a different way. I tell people that the paintings are too large for homes (6' x 8' and 8' x 12'), too nude for churches, and too religious for public spaces. They don't seem to fit our society, but the size and the nudity are important to my Christian statement.

Edward Knippers. IDENTIFICATION (THE BAPTISM OF CHRIST), 1988 Oil on panel. 96 x 144 inches.

My calling is not necessarily to the Christian community. My paintings can and have benefited Christians and I hope that they will continue to do so. But Christians are not my target audience. Contrary to what many people think when they first see my

paintings, I am not making Sacred Art, which I would define as art intended for worship and the sanctuary. My art is religious, but why should that exclude it from the public square? I see my job as an artist as making an art powerful and engaging enough that the society at large must deal with it.

Reformed Art, Schaeffer, and the Color Blue

In the Christian community there are many people who love to talk about art theory, but far fewer who love to look at what artists make. Could it be that the reality of what is made too often makes theory obsolete? The art object is "incarnational," and incarnation is messy. A parallel might be that God Incarnate was subject to the need for sleep, yet the God of Heaven " … neither slumbers nor sleeps." In somewhat the same way, the intellectual pursuit of the artistic ideal has a self-contained purity that is soon sullied in the studio. The philosophy of art has its place, but it should grow from the heart and head of the artist as he goes about the artistic endeavor in its symbiotic relationship with a given age, or from the aesthetician and art historian after the fact. Theoretical prescriptions may be interesting games for the classroom, but they can easily become useless, or even detrimental in the studio. The studio is a delightful place for deadly serious play. Theory too often is simply deadly serious.

The Reformed community likes the theory and the intellectual pursuit of the ideas in art, and despite what I have just said, their writers have been helpful for me in forming my ideas about art. Calvin Seerveld and William Dyrness have been particularly helpful. Francis Schaeffer and H. R. Rookmaaker have caused countless useful conversations in the Christian arts community. Yet, the love of 17th Century Dutch painting in the Reformed community, particularly in the writings of Rookmaaker, I fear, has clouded the vision of a number of young artists who are serious about their faith.

The Reformed emphasis that the whole world is fair game because God created it and said it was good is the essential point

that was championed by St. Francis of Assisi at the nascence of painting in the Western world. That painting as we know it began in the early years of the Franciscan movement is no coincidence. The theological idea of the goodness of God's creation, even though marred by sin, is a concept fundamental to the whole development of Western painting. To hold that 17th Century Dutch art is the purest Christian expression of this idea is as limiting in its way as to say that all painterly expressions of the faith since the icon have been false. The Dutch Golden Age was truly golden, but 17th Century Holland had a common understanding of salvation history that would read a fallen tree in a painting as alluding to the fall of mankind in the Garden of Eden. It would be wonderful if we had such common understandings today, but nostalgia will not bring it back. As Christians, one image that holds something of our situation is that of homeless people hawking the shards of a fallen cathedral to a tourist in designer shorts and headset tuned to the latest Dow Jones averages. We are truly at the end of an age.

Edward Knippers. THE STONING OF STEPHEN, 1988 Oil on panel. 96 x 144 inches.

A middle-aged women came to my studio and was standing in front of my *Stoning of Stephen.* I told her the title. She seemed intrigued by it but looked at me with no registration at all. I thought she hadn't heard me so I repeated the title and added, "That is an account in the Bible." She said "Oh yes, the Bible. Is that Old or New Testament?" I said it is New Testament, the first Christian martyr. Then she said, "Now I know why you used so much blue. That is the color I see when I meditate." I said, "No, that's sky." That is indicative of the society in which we live; we do not have the luxury enjoyed by the artists of 17th century Holland of living in a world with common understandings, and common readings of visual things. I think that this is what Cal Seerveld was saying when he warned us, "Christian culturing must not generate museum pieces." Not all theorists are as clear-sighted.

Pre-Raphaelites

We had a big show recently of the Pre-Raphaelites in Washington. Victorian painters have never been my favorite, but I tried to go with an open mind. The Washington gallery-going public was excited about this show. As usual, I was glad I went. A few pieces were wonderful paintings, but also important (even though my prejudice against Victorian painting was generally confirmed), I was forced to clarify my thinking about literature and painting. These are painters who extensively use literature—and I very much find them wanting. I am a painter who uses the written word extensively. Is my work essentially like theirs?

No, there is an essential difference. What I finally could articulate was that much Victorian painting is obscure in meaning because of its love of literature over painting, and emotionally false because of its prim and thoughtless romanticism. The Victorians seem to have forgotten that there is much that words can say that painting cannot, but paint can speak in its limited way in that silent realm beyond speech. "What is the distance between the eye and the heart?" my fortune cookie recently asked. One might say that painting is entertained in that silent knowledge of

William Holman Hunt. THE HIRELING SHEPHERD, 1851
Oil on panel. 30 x 43 inches.

the heart and then in the mind, whereas literature is first entertained in the mind. The Victorians too often chose the path of the literary. A case in point was William Holman Hunt's *A Hireling Shepherd.* In it, a shepherd boy is having a dalliance with some woman while in the field, and the sheep were wandering off. The museum's explanation was that this painting was a criticism of the Church of England because the Bishops were playing around with new theologies and the sheep of the Church were being scattered. Such a reading was in no way readily apparent in the work itself. I realized that much Victorian painting used literature as a crutch outside the aesthetic consideration of picture making. Appealing to the mind first of all, literature in much Victorian painting was used as a *deus ex machina* for weak painting—it was hoped that a worthy moral would add the necessary depth of meaning and emotion to an inadequate art.

In my painting *Massacre of the Innocents* [see color plate 4], there is a biblical narrative, but the scriptural account isn't needed in

order to look at it with some understanding. If a painting does not embody its meaning in visual forms that address both the heart and the head its visual presence will soon become dated and stale because of its irrelevance to the declared meaning of the work. The great art of the past has dealt with universals of what it is to be alive and functioning in this real world—the way it functions spiritually and emotionally and physically. When dealing on that level, there is plenty of room for the creative spirit. What is more universal than the Gospel? Calvin Seerveld, in *Rainbows for a Fallen World* says that,

> the Pre-Raphaelite art ... was out of date as soon as it was finished because they were wrong-headedly struggling to recast painting into modern icons, albeit of a subjective, introverting sort that mirrors or stimulates the viewer's piety. Art and all cultures worthy of Jesus Christ's living name must not have the cachet of what is structurally obsolete or be stigmatized by wishful thinking for bygone days.

What does it take to make a significant visual impact so that you are engaged as a person? Our visual world today is dominated by a need for information. Once we have the information, the visual is disposable. Because of our long history of painting in the Western world, a work of art makes one look for meaning—emotional and/or intellectual meaning. Therefore, contrary to our visual age of information, a painting demands that one not turn off the heart when one starts to think, nor does one turn off one's mind when one starts to feel. If you can produce art that is on the razor's edge between the two, then your work will have impact. The meaning engages in a symbiotic relationship with the visual object—you can never quite separate them, and the viewer is engaged. Otherwise, the art becomes propaganda or becomes so dependent on the literature that the literature is really the point, and therefore it becomes illustration. There is nothing wrong with illustration as long as it is good, but illustration should not be confused with fine

art. The Victorians often did confuse the two. They produced some wonderful period pieces, but on a whole their art lacks the universality that is the hallmark of great art.

Biblical Narrative

In a pluralistic society how does the Christian artist communicate at all? Communication is exactly why biblical narrative has become important to me as a Christian artist. I'm trying to couch my artwork within the history of Western painting, which is a noble expression that one can learn about. I'm also working from a Christian worldview by using the biblical narrative. The viewer has at least these two threads that he can follow in trying to decipher what I am trying to say visually. My job is not to lean too heavily on either of these coordinates of meaning, but to make the painting as rich and powerful as it can be, so the viewer might want to find out about those things. But once they want to, if I have done my job well, then they have a place to go and find out about it. They can look at the narrative in my painting and say, "Oh the Scriptural account is this way, and yet he has done it that way. Why would this difference be?"—and perhaps they'll find themselves intellectually curious enough to investigate exactly what the claims of Christ are. That's the problem that I am afraid Schaeffer and Rookmaaker perhaps did not take into consideration as they should have—the possibility of the 17th Century Dutch painting speaking to our world about the Gospel. It is wonderful that all of 17th Century Dutch painting is imbued with the Christian faith. They are wonderful paintings but postmodern man does not come away from a 17th Century Dutch show of landscape paintings or portraits thinking Christianly. I am not sure that I do, and I know better. The paintings are simply landscapes and portraits.

In my biblical narrative paintings I am not trying to make an illustration of the text but a poetic statement on the text. This, I think, is an entirely different thing, and I think it is very much the stuff of good art—the poetic statement. Illustration is not

necessarily good art. For us moderns, illustration = propaganda. We have the solution to the whole problem, so we are just being propagandists when we point to our answer.

What is propaganda as opposed to fine art? I would say that we are handed much propaganda in the political correctness of the current 'performances' and 'installations.' The object that carries the meaning is a disposable thing, as we said earlier in talking about our information age. With propaganda I can look at the art object, get the idea, and then have the idea with no further reference to the art object. There is no longer any symbiotic relationship between the idea and the object. I think fine art has a symbiotic relationship with the object. You cannot have the meaning totally separate from the object at hand.

I like to use, as an example, Rembrandt's portraits of Christ. I never have anyone challenge me when I talk about 'portraits' of

Henry O. Tanner. DANIEL IN THE LION'S DEN, 1859-1937 Oil on paper on canvas. 41 3/16 x 49 7/8 inches.

Christ. Of course, Rembrandt never painted a portrait of Christ. What he has done is create a form, and his paint and the reality of Christ somehow have a symbiotic relationship. So if you really come to grips with a painting of Christ by Rembrandt, you can't quite think of Christ in the same way again. It is not that I look at it and say, "Oh, a good man," and I can run with that idea of Christ as a good man and I no longer need the painting—that would be propaganda. After seeing the painting, I somehow need the painting to complete the idea of that particular goodness of Christ that Rembrandt has shown me.

A lot of the politically correct art today is simply propaganda. Although the object is made to be destroyed after the exhibition, it is thought that the idea will live on. Propaganda is what it is no matter how correct or true its message might be. Christian artists must remember this. The importance of the object and its rightness in embodying the idea is our defense in the making of non-propagandist art, even while we proclaim the great truth of the Gospel.

The Body

When dealing with biblical subject matter, I do not go back to archeological sources, as did Henry O. Tanner. He wanted to go back to the Holy Land and find out what the dress was like, as well as the vegetation. I am not interested in all of that botany, anthropology, and sociology. What I am intrigued with are the people and the events, which is a whole different thing. I paint the nude. The nudity allows me to have a timelessness in my narratives that will not quite be pinned down to the specifics of the biblical era. The nudity allows me to show that God truly dealt with those people and at the same time to establish our human commonality with them. Nudity establishes a universality. They had bodies in the same way we have bodies regardless of our contrary sociology. The body is the straight line—the common element—through human history. If God could talk to them then, then God can talk to us now.

I get in trouble with the nudity in my work. One guy actually attacked my paintings and tore three of them down in Tennessee. In an interview, he claimed that I made the Old and New Testaments into a nudist colony. I got to thinking about it—and he's right. That's exactly what God does. He strips us of all our pretenses. The Spirit isn't hidden somewhere behind our bodies. It's all one—we are spirit and flesh all wrapped up in something we call a human being.

The human body is at the center of my artistic imagination because the body is an essential element in the Christian doctrines of Creation, Incarnation and Resurrection. If Christ didn't come gender-specific, then He didn't come in the flesh. That's pure and simple. I think that a sort of gnosticism has kept American Christianity from the arts. We must rethink the physicality of life.

Disembodiment is not an option for the Christian. Christ places His body and His blood at the heart of our faith in Him. Our faith comes to naught if the Incarnation was not accomplished in actual time and space—if God did not send His Son to us in a real body with real blood. "...if Christ be not risen...your faith is also vain" (I Corinthians 15:14).

A lot of the meaning of the work comes from the emphasis or the unction brought to it by the art of the artist. When a person comes to a painting—and I think this is one of the most important parts of painting as a continuing art form in the 21st century—it is an object in a room. Yes, it has virtual space, but it is always in a real space. A painting truly exists only one place, and you have to go there to see it. Something about that physicality reminds us of our physicality, and that is something we can never escape. Some of our thinkers are playing around with the idea that someday we will have computers perfected to the point that the body will be dispensable. How arrogant and how stupid! When reality is denied to that extent, we end up with death camps—if the body is not necessary, let's destroy it. Ideas that ignore God's creation and laud man's creation are destructive. In professing ourselves to be wise

we have become fools. The fact is, we are stuck with the body. We must deal with it. We must explore the mystery of its meaning.

We are in an age that denies the body in two ways. In one way it denies it through its extreme emphasis on sensuality and the worship of the physical as seen in contemporary sexual idolatry, including pornography. On the other hand we deny it by resorting to a kind of gnosticism, prudishly rejecting the physical creation's importance and disdaining as evil what God Himself called good. Neither response is Christian. Some say that the real essence of mankind is found in the computer when we are sending back and forth messages to one another in some little chat room. That is not the essence of humanity. No, coming and sitting together in conversation is a different thing entirely than chatting on-line. The computer denies humanity because it denies the flesh. If we get too far from the body and the blood, either our body and blood or Christ's, we are in trouble. Deny our body and blood, and we are in a fantasy world. Deny the body and blood of Christ, and we are heretics. The body is therefore at the center of our faith. That is the reason John said, "These things are Him who we've handled and touched and felt," which gave weight to his observations, his insights, and his inspired words.

As Christians, we believe that God paid the ultimate price for our redemption. That would not be true if He had given us only His mind (and thus been merely a great teacher), or only His healing (a great physician), or even only His love (a compassionate friend). Without His body broken for us, His sacrifice would be incomplete, and we would be lost. For without the broken body there can be no redemptive resurrection.

Having a body is a prerequisite for being human. For us, as inconvenient as this fact can be, it is a constant reminder that we are human and not God—that we are a part of the created order. Yet even as part of creation we are able to make our bodies a living sacrifice to God because of Christ's real and complete sacrifice for us.

Subject is the Point

Don and Christie Forsythe had a dinner for Philip Pearlstein to which I was invited. Later Pearlstein spoke at Messiah College, and he talked about how he wished people would stop talking about his subject matter (the nude) and start talking about his art. I realized that for me, the subject matter is the point. I use all my art in order to clear the way to my subject matter.

The fact is, when you have something to say, you want to find a clear way to say it. If you don't have much to say then your statement, as Pearlstein was saying, is the artistic means. It goes back to what I was saying at the very first, that we have a hundred thousand ways of saying nothing. That doesn't mean that just because an artist is concerned with technique he has nothing to say. Some new techniques and materials are exciting. After all, this is our language. I firmly believe, though, that the material should express a larger meaning than itself. Poets can enjoy sitting around talking about metaphors, but talking about metaphors is not writing poetry.

Ted Prescott pointed out to me a long time ago that we can't do without narratives. When we threw narrative out of painting what happened? We started talking about the artists' lives. There is the narrative; it went from inside of the work and to the artists' lives. Today it seems the artist with the best biography gets the press. Keith Herring and Jean-Michel Basquiat died young. Vincent Van Gogh had bouts with insanity according to some, or temporal lobe disfunction according to the book *At Eternity's Gate: The Spiritual Vision of Vincent van Gogh*. If the life story is interesting, then that must mean the work is all the more important. I don't know about that. Van Gogh is interesting to me, and I think he is a fine artist, but I really like his contemporary, Camille Pissarro [see color plate 6]. We don't hear much about him. Pissarro is every bit as good a painter as Van Gogh. He was a hard worker and was the only artist that had work in all the impressionist's shows. Pissarro was a plodder. How can a plodder stand up in the modern court of art opinion to self-mutilation? The best biography wins. Yet Pissarro did wonderful paintings.

Theme, Audience, and Prayer

I love to quote the fact that one journalist asked both Mattisse and Rouault whether they would continue to paint if they never had an audience again. The pagan Mattisse said, "Of course not;" the Christian Rouault said, "Of course." There is such a thing as an audience of One. God may call us to work simply for His own pleasure. What greater privilege could there be? For now, though, He has given me another audience for my work. What I am doing is setting the stage. Maybe that is why I am interested in the Baroque. Baroque is pure theater. Space of course is a key element, whether the space is open or closed, or whether there is a way out or in. Is it pushed to a shallow space? Or is it pushed farther and farther and farther out to you? Or are you able to go back in? All of that has a very direct relationship to our emotional response. Therefore that 'in your face' presentation (which I think grows out of my earlier interest in German Expressionism), as well as that encompassing of the viewer in an extension of the pictorial space, is to confront the viewer as powerfully as possible and force him to deal with what he is seeing.

When we deal with scriptural themes we are addressing much of Western painting—we are in a dialogue with the past. When I start a painting I don't research how the theme has been done, but often other treatments of the theme will come to mind. Instead of research, I will ask, "How many characters do I need in order to get this across clearly? What kind of space do I want? What are some of the predominant colors that will make the theme clear? How much light? How much dark? What kind of light? Direct? Soft? Harsh?" All of these questions are basic questions that any painter would have. These things will hone the meaning of the work so that the viewer comes away with a clear emotional impact. This is what I mean by using all of my art in order to clear the way to the subject matter. Because I am dealing with the large themes of Western culture as well as our faith, my responsibility to present them with everything I can is heightened. A work of art has to

stand on it's own feet. It is my job to give the work a firm 'understanding.'

A major painting of mine is *The Interrogation Room*. It has two diptychs and two triptychs that form a small room. One viewer told me that was "awfully site specific" and wondered where it was going. I said I didn't know but I felt led to paint it. Then Howard Fox, a curator from the Hirshhorn Museum and Sculpture Garden saw it. He remembered it after he moved on to the L.A. County Museum in Los Angeles and put it in his first show there called "Setting the Stage." It was as sight specific as the visitor to my studio had said, so Fox had a room built to house it for the show. This was a great affirmation that I was moving in the right direction. The Lord had directed me and had answered prayers that I didn't know how to ask.

Edward Knippers. ASH WEDNESDAY *in progress*, 2000
Oil on panel. 96 x 144 inches.

I pray about what the Lord would want me to do. A recent series I did is a good example. I was reading through Acts and came upon that long chapter of Stephen's sermon. The chapter was so long that I left it for a while. I started reading the shorter Psalms for my devotions. When I finished the series of paintings on which I was

working I didn't know what to do next. I prayed. My devotions brought me back to Acts, and as I read through Stephen's sermon I realized that I was reading a condensed version of the Old Testament. It was an unbelievably rich thematic ensemble. I did one large painting of the stoning of Stephen, and then I did seven smaller works dealing with themes from his sermon—*Jacob Wrestling with the Angel, The Gift of Circumcision, The Rejection of Christ, The Killing of the Prophets, The Golden Calf,* and so forth.

There are things through which we see the world, and there are theological presuppositions that I, of course, hold. I have tried to get back to the large themes, theologically, such as in my early works of the *Prodigal Son.* The theme of the prodigal gets at the very core of the Gospel. It encapsulates, theologically, all that we are about. The lostness of mankind. The coming back to God. Grace. All of it is there. The prodigal son is truly one of the large themes.

I have just started a painting called *Ash Wednesday.* We perform the imposition of ashes at our church on Ash Wednesday. This year as I looked around I was shocked once again to see friends and family with the mark of our mortality on their foreheads. There with the rest was my sweetheart—my dear wife. My painting, *Ash Wednesday* is an image of Christ and the wild man at the tombs. This seems to be a metaphor for who we are—the demon-possessed among the dead. The sacrifice of Christ is our only hope in such a world. His stripes truly do heal us. I hope that the painting will poetically be able to carry such a powerful meaning.

Calling

I think that the beginning and the end of artistic life for the Christian is God's calling. If He has called us to this work, then we can give it all we have to give. If He has not called us, then we are stealing time from God. Once our calling is settled there is an unexplainable freedom in which we live and do our work. There is also a strength available in those difficult times that we all have in the studio. If we have a true calling, a true vocation, then we have

Him as our major resource. "Lord you called me to this. I am having trouble. Please help me." It is very interesting when this happens periodically in my studio. I have thrown some brushes at my paintings and get very frustrated when I can't see something clearly. Finally I'll say, "Lord, help me see this, I can't see it." Time and time again He will be immediately there. This is very sad in one sense because it is as though God was standing there beside me the entire time and I wouldn't ask for His help.

One of the clearest examples of this happened some time ago when I was doing a large painting of an angel floating over a desecrated land. Something was wrong, and I didn't know what it was. In frustration, I prayed, "Lord help me to see this, what do I need?" Immediately I knew that I should go down to the National Gallery and see Poussin's *Holy Family of the Steps*—a neoclassic painting. Then I got angry because I thought, "Lord what are you doing to me? I am not a neo-classicist." I stomped onto the Metro and went downtown. I wandered around the gallery until I was exhausted. I was looking at wonderful things, but then I knew I had to see the Poussin. One second in front of this canvas, and I knew what was wrong with my painting. I had not been using clouds as structural elements. I had used them simply as a backdrop. I would have never thought to look at that painting on my own, but there it was—God had answered prayer. Other times it is being able to see a hand, or some particularly anatomical proportion and develop it as I should, or of being unable to break free of being trapped in a vicious cycle of not being able to see past what I have done. Since He has called me to the work of painting pictures and my art is in His hands, to the point where He could ask me not to paint and I would stop, then I can go unashamedly and ask for His help. I must add, I do not claim that God is painting through me in any magical way. I don't blame my paintings on Him. But He is a very present help in the time of trouble.

We are called to sacrifice ourselves to His will. So often when we are looking for God's will for our lives, what we really want to know is God's option as a possibility—we want to check His will against

our other wants and desires. Even more, we want Him to rubber-stamp our choice. Neither one will work. If you are just looking for God's way as another option or to validate what you have already decided to do, you will be looking for the rest of your life. But if you say, "Lord I want your will, period. I am going to do what you want no matter what it means and where it leads." Then He truly will give you the desires of your heart. The Lord has used that. Howard Finster has gotten God's message out [see color plate 7]. He had something to say, and God gave him a way to say it. Not only that, he has been called the most exhibited American artist.

Georges Rouault. **ARISE YOU DEAD,** *from the* Miserere Series.

Finster's popularity because he is a primitive can sometimes hide the message, but it also allows the message to get planted. People like him because he is this crazy guy in Georgia that paints on the top of his sausage cans. They like that crazy off-centered-ness of his, but his message is clear. He was readily criticized in the Christian community for painting a Talking Heads album cover. But he wanted the kids that listen to rock music to have an album cover in their world that says "God loves you." I think that is what he is about. He had a story to tell and a call from God that visually sent him on a quest beyond what anyone could have dreamed.

I think the same thing of Georges Rouault. Rouault was also on the cutting edge although he did not care about being *avant garde*.

He was a painter and a printmaker. At the core of his process for these fine art prints is a photography technique. This was unheard of then in fine art prints, although quite common now. People said that he cheated but considering what has come since, he was on the cutting edge. The *Miserere* suite was a large set of powerful drawings that he had done early in this century. Vollard, his dealer, wanted to publish them in book form. He had them shot onto copper plates, a technique called photogravure. They were printed. Upon seeing the proofs, Rouault would not let them be published in that state. Over the next ten years he reworked the copper plates with aquatint and other intaglio techniques. Rouault incorporated a photo process in fine art printmaking thirty years before it was accepted. He was not concerned about being *avant garde* in technique. He was simply trying to get his message clearly across to the viewer.

The Story/Meta-Narrative

I think 'the story' is at the very core of what Christian artists are to do one way or the other, though it has to be more than a personal story. It has to be *the* Story—Creation, the Fall, Incarnation, Sacrifice, Resurrection, and Redemption—the meta-narrative. Nigel Goodwin asks, "If the meta-narrative has left the stage because its tellers no longer know how to tell the story, how might the Word find flesh again?" But we have abandoned the story and isolated the Truth to such an extent that it comes down to be 'my truth' and 'your truth.' I think we have to talk about *the* Truth. It is unpopular, but I think that is what we have to do. We have to say that there is not just *a* truth, but *the* Truth. That leads us to universals. Then we can express universal truths that transcend the provinciality of multicultural concerns.

Reclaiming Our Art History

There are some encouraging signs. One is a major exhibit that was at the National Gallery in London called "Seeing Salvation: The Image of Christ." Bryan Appleyard in the Sunday Times of London (13 February 2000) started his review by proclaiming,

> Western art was Christian, is Christian and, for the foresee-able future, can only be Christian. Believers or not, we cannot evade the Gospels' continuing presence in our culture. Their meanings, their imagery, have determined the way we think, the way we create.

He called that exhibit " … London's most accurate celebration of the millennium as a period since the birth of Jesus," contrasting it with the Millennium Dome which he called " … empty—in every sense—because it is in embarrassed denial [of the centrality of Christianity to our culture]."

Christian artists must connect with this visual heritage of the Christian tradition. Seerveld says it this way:

> Distill a fruitful Christian art historical tradition in your own blood and pioneer its contribution in our day. Christians have no right to be ignorant of history just because they stand in the truth. As guardians of culture Christians should explore omnivorously whatever men and women have done in the Orient and Africa, Europe and the Americas, in ancient times and today, not to paste bits and pieces eclecticly together and not to assimilate a nondescript "best" that has been artistically done throughout the ages, but in order to know surely the consis-tency and contours of one's own particular Christian tradition …

In the "Seeing Salvation" article Appleyard recounted the statement of Jonathan Miller, who is an atheist,

> If, ... there is a God, then He could have thought of no more powerful, creative and imaginative way of expressing His presence than through His incarnation in Christ, an 'ordinary' man. For, of course, from this ordinariness springs the entire western way of making art. The novel, with its dependence on the material drama of human life, and the emotional repertoire of the old masters were inspired by the intense significance of everyday objects and activities in the story of Christ. Without the physical detail of the Gospel story, there would have been no novel; without the face of Christ, there would have been no coherent fine-art tradition.

I think Christian artists need to steep themselves in art history and find out how Christians have done certain things—what has worked and what hasn't worked. We have a 2000-year history that we need to know. This is the tradition out of which we work whether we like it or not—whether we are coming from Asia or America. As Christians this is our way of getting at the Faith, visually. For instance, one can do the biblical narrative as though it were right out of the biblical time and research every little thread of Palestinian dress. Or one can use a more generalized approach as I am trying to do, merging East and West by getting at the timelessness of the icon through the nudity, yet with the sense of place and time and action through a western sensibility. Another approach to biblical narrative is poetic extrapolations of the world from a Christian viewpoint, as the 17th century Dutch painters. As we have said, this is harder to do now because of our pluralism, but the record is there, and as Christians we should know our heritage. The Dutch idea is carried forward by Flannery O'Conner when she says, "My faith is not what I write about or what I paint about but it is the light by which I see." In other words, we don't paint light bulbs but we paint what is in the room with that particular,

peculiar light of which is our Faith. But as our society gets more pagan, the language options become narrower (O'Conner's Christian point was often missed even in her day). Or, perhaps they become broader. We are in a time in which we can retell the biblical narratives in a fresh way because nobody knows them. We are like First Century Christians; we have a fresh story to tell everybody. They think that it is a wild, intriguing story. And it is.

Conclusion

A viable Christian art is one that will communicate with our time. If it can communicate clearly now it might be able to speak in the time to come. But regardless of whether or not it will speak to the future, if it speaks well now, it can bring the gospel alive for today. This is what I am trying to do. People look at my paintings and say, "That has been done; it's in museums." But if we leave it in museums then we are saying that the Faith is no longer a viable faith. In reality I can't redo what has been done in the past—my experiences and ideas can never be a perfect match. I can work from the same foundational milieu but what I do will be different from the past. It is the way that the animal style led to the Romanesque. Charlemagne was trying to rekindle Classicism in the 9th century, but of course all that was available in vocabulary was animal style and some classical examples that were theoretically misunderstood. When he tried to go back to the glory of the earlier age, he failed. But his artisans, in trying to fulfill his dream, created a whole new language, which we call Romanesque. I think that is what we do. We go back in order to move forward. As artists, we plow fresh ground in our time by trying with God's grace to be true to the vision He has given us, not in trying to be new. We must remember that our chief aim as Christian artists is to glorify God and to make His Truth plain for all to see.

MAKING ART
like a
TRUE
ARTIST

Making Art Like a True Artist

The artistic journey begins with a simple desire to create. But this is only the beginning. This seed to create will in time grow into a full blown philosophy of art-making. And like plants themselves, these philosophies come in all shapes and sizes, from weeds to roses to lilies. All practicing artists whether Christian or non-Christian are driven by some philosophy of art-making whether they are able to articulate it or not.

In what follows, I've tried to articulate a philosophy of art-making that is both practical and spiritual. Christians making art need to be concerned with two main things: excellence in their craft —offering our work to God for His glory; and an imitation of Christ—the prime artist, for by Him the Scriptures say "everything was made."

Excellence in Craft

Artists pursue excellence in their craft for a variety of reasons. First among them is the responsibility to develop skill and ability on par with the talent given them. This responsibility is all about response.

Artists are called to live in response to the talent that God has given. They are to cultivate it responsibly and to pray for the Holy Spirit of God to fill them with skill, ability and knowledge. In short, they work hard as men and women doing their work before the Lord, for as the wisdom of Proverbs reminds us, "All hard work brings a profit, but mere talk leads only to poverty." They study models to learn why some things work and others don't—why some work is compelling, lasting, and excellent. They form opinions and cultivate taste. Though imaginative and innovative, they don't waste valuable time reinventing the wheel when it's simply not necessary. They get on with it.

Often 'to get on with it' involves letting your taste or aesthetic sense guide you to some work you admire. Once the work is before you, you can both enjoy it and ask questions of it. In my work, which is music, I find myself practicing this all the time. If I hear a song or a particular production style that I enjoy I want to know what it is about the music that intrigues me. Why do I find it to be excellent? Not only do I always learn something new about music by analyzing various pieces, but I add to my understanding of what excellence is. The process helps me to define a standard with which to measure my own work. It's worth noting that the culture around us (beyond the Christian subculture) has standards of excellence that are often very high and worth reaching for.

Though there are also notable exceptions to this, Christians should take the artistic standards of culture seriously. Seriousness will mean admitting that people who do not profess Christ often do excellent work worthy of our attention and study. And, it will also mean being serious enough about the disciple's life that we don't let supposed standards of excellence that are incongruent with Scripture pollute our own good definitions of excellence.

Christians ought to be able to recognize and name various models of excellence found in the fullness of reality, never forgetting that God has shown great genius, skill and imagination in Creation. As little creators made in the image of God we should do likewise with whatever talent we have. God has also shown great love to people through his plan of redemption. Following this good pattern, love should also be at the heart of all excellent art created by disciples of Jesus. This is the most excellent way. An artist filled with the Spirit, skill, and ability, asking what it means to love the Church and the watching world as one uniquely gifted, is likely an artist who is making the invisible kingdom visible.

Finally, regarding skill and ability, I'm reminded that Peter Kreeft in his book *Making Choices* wrote, "A ballet dancer becomes free to make beautiful moves only by conforming herself to laws and principles in disciplined practice. A scholar becomes free from ignorance only by conforming to truth, to data, to facts." The ideal for a Christian making art is to be one who is set free to imagine good and to create it. By dedicating yourself to acquiring skill and ability in your craft, to living by a standard of artistic excellence, you greatly increase your chances of actually being able to create all that you imagine. Good intentions will not do, but hard work might.

This is something that one of my jazz heroes John Coltrane knew well and lived by. Coltrane possessed an ability to make creative choices that others either did not know existed, were afraid to make, or simply could not execute because they had not prepared for such strange and wonderful possibilities. He stretched preconceived boundaries and erased limitations that many thought to be intrinsic to the instrument. In the world of jazz saxophone, Coltrane narrowed the gap between what a musician could imagine and what he could actually create. The pursuit of excellence to God's glory through practice and study, through the cultivation of God-given talent, for reasons of love, is the way that Christians can and should go about narrowing the gap.

Make the Most of Every Opportunity

True artists purpose not to live in a world of "if onlys" but instead make the most of every opportunity. They do not wait for a national platform to really apply themselves. They give their best to God in their home church, community or university—being seen as faithful in the little things that they might be found ready and prepared for the bigger. They recognize that contemporary tools are nice to have, but are no substitute for astonishing ideas.

Art is not simply a product of the mind and emotions, but rather the whole person. Therefore rest is just as important a tool to access in truthful art-making as anything. I maintain that true artists purpose to find balance between work and rest. Only a fool thinks he's succeeding because of all the chatter about how hard he is working. As Scripture says, "Better a little with the fear of the Lord than great wealth with turmoil." Rather than anxiety regarding basic provisions, true artists memorize and trust God's promises to provide. Endless cycles of trying hard to make things happen will only lead to the worst kind of poverty: ways of thinking and doing incongruent with faith.

Thus, true artists pray for humility and don't struggle endlessly against circumstances designed to humble them. Instead they see that even difficult circumstances can be a provision from God and an answer to their prayers. They welcome the discipline of the Lord because it is a testimony of His fatherly love and a sure sign that He is changing them incrementally into the man or woman He has designed them to be. Remember, God is working in you to make you like the prime artist, Jesus—not to give you your version of the perfect artistic life. Each day is a chance to decide afresh which outcome you are living for.

Still, the artistic life can be a very difficult one, especially when so few in the Church understand the role of the artist in church and culture. Given this, let me suggest that true artists commit to work against apathy and indifference. They purpose in their lives and their art to lead men and women away from such worthless

occupation of the mind and heart. To do so is to love the Church and the watching world in a tangible way.

Since loving well requires thinking well, true artists purpose to be good thinkers. Philippians 4:8 is their text. They meditate on what is lovely and truthful and desire such things in their art. They never stop thinking. They are curious to know how things work. They know the power of ideas and pray to use only those whose consequences produce fruit in keeping with the purposes of God. They cultivate the ability to distinguish good and evil (Hebrews 5:14). A good life is framed by discernment, and discernment comes through knowledge of the Word and the power of the Spirit. Study and pray. Great art is created in an environment of freedom, but the fuel of freedom is the substance of truth. The artist learns to watch both his life and his doctrine closely.

Know Mission and Destination

True artists know their mission and destination. They know where they are going and what they are called to do along the way. It's a panoramic vision that keeps them focused on the promise ahead as well as history behind. And when they begin to stumble about the road from fatigue or hunger or loneliness this same vision keeps them from falling into foolishness at either side of the road.

Years ago William Barclay wrote,

> It may be said that there are two great beginnings in the life of every man who has left his mark upon history. There is the day when he is born into the world; and there is the day when he discovers why he was born into the world.

In this Barclay is quite correct, and it's here that Christians have the advantage. We know why we were born into the world. We know the kingdom story and how it's meant to inform our own. We know that we are the Church, the *ecclesia,* the called-out-ones. We are called not to our own purposes but to God's. The words of

John Henry Newman add to this idea even further:

> God has created me to do Him some definite service; He has
> committed some work to me which He has not committed to
> another. I have my mission. Therefore I will trust Him.
> Whatever, wherever I am, I can never be thrown away. If I am
> in sickness, my sickness may serve Him; in perplexity, my
> perplexity may serve him; if I am in sorrow, my sorrow may
> serve Him. My sickness, or perplexity, or sorrow may be
> necessary causes of some great end, which is quite beyond
> us. He does nothing in vain.

This is the kingdom perspective. It is the perspective that God
has called all artists to take a hold of. The kingdom perspective is a
perspective fueled by faith, freely expressing itself through love in
response to the grace of God.

Imitate Jesus

True artists imitate Jesus in his serving and his storytelling.
They pursue greatness in craft in order to give the Lord the best
fruit of the talent he has given them, not to build themselves up.
They understand that true greatness is found in the heart of
the servant.

After Jesus had washed the feet of his disciples he told them:

> I have set an example that you should do as I have done for
> you. I tell you the truth, no servant is greater than his master,
> nor is a messenger greater than the one who sent him. Now
> that you know these things you will be blessed if you do
> them (John 13:15-17).

True artists purpose to love the Church despite indiffer-
ence or opposition to their work. Though indifference is
their enemy, they separate it from the brother or sister who
is seduced by it. They are eager to find their place in
the Body and do not consider themselves exempt from

fellowship and church stewardship responsibilities. They love the Church and do all they can to build it up, for how can you love Christ and hate his Church?

In Genesis 1:31 we find our subject matter for art-making defined: "God saw all that He had made, and it was very good." The whole of creation can and should be the subject matter and the inspiration for the arts. To imagine good things for the arts is a part of what it means to care for creation. In addition to subject matter, Genesis 2:18 instructs us in the need for community. We all need relationship for "It is not good for the man to be alone." You are made for relationship in all its variety. It is impossible for Lone Rangers to produce fruit of a comprehensive nature—they're too selfish. In addition to caring for the artistic needs of his or her community, a good artist will make other significant contributions as well, e.g., serving through prayer for others. In a natural way, prayer for others is a spiritual discipline that gives birth to good art.

Other-centered living (after the model of Jesus) is at the very heart of good art-making. The arts have the ability to serve people in a number of healthy ways, from worship to our need for beauty. Let me encourage you to care for others through your talent and be imaginative about what caring and serving might look like. The possibilities are wide, high, and long.

I believe that Christian art should be what Eugene Peterson called, the "observable evidence of what happens when a person of faith goes about the business of believing and loving and following God"—not "a rulebook defining the action" but instead "a snapshot of the players, playing the game." Good Christian artists make snapshots of all of us playing the game.

In his wonderful book, *Rainbows For A Fallen World,* Calvin Seerveld has this to say:

> . . . Christians of the historic Reformation will be wise if they understand art to be like clothes: a gift of the Lord to cover our nakedness, to dress our human life with joy,

to strengthen and enrich our labors of praising God, serving the neighbor and caring for the world.

Praising, serving and caring—these concepts should be as much a part of the artist's life as oils and brushes, guitars and word processors.

Telling a Good Story with Your Life

In making art that is glorifying to God, the Christian artist must imitate his Lord in story telling. Edward Knippers speaks to the centrality of the biblical narrative in his essay on "Subject and Theme." And central it is. Story is our doctrine! God has spoken in history, giving his people a narrative which not only frames our view of the truth, the Church and the kingdom, but reminds us that God acts in history on behalf of His people, and that these acts are stories worthy of being told again and again. He is still acting on behalf of His people today, and we should be telling today's stories (which is why all God's actions in history represent good and worthy subjects for art-making).

Scripture teaches us that Christians " . . . must learn to devote themselves to doing what is good, in order that they may provide for daily necessities and not live unproductive lives" (Titus 3:14). Or as Eugene Peterson puts it in *The Message,*

> Our people have to learn to be diligent in their work so that all necessities are met (especially among the needy) and they don't end up with nothing to show for their lives.

Or no story to tell. As my son Sam once said, "The way I see it, if you're old and don't have any stories—then something must have gone wrong." Wrong indeed.

The unproductive life is one in which you end up with nothing to show and nothing to tell. One sure-fire way to reach such an unproductive end is to give little credence to the life of the mind, the imagination, or holy, kingdom-perspective living. Live to tell the story as only you can tell it. Don't miss your cue.

Remember, the storyteller of good imagination seeks to leave the world and its inhabitants tangibly better than they were before the storyteller arrived on earth. Make this your goal.

The good story is never about the wisdom of the world. The kingdom is absent when the whole of your work remains within the range of human competence—especially so when it bets on it alone.

Telling a good story with your life is about faith that gives birth to action. It is about the object of your faith inspiring you to love responses or love actions. According to Dallas Willard in his book *The Divine Conspiracy*, telling a good story with one's life involves living "a life in which the good laws of God eventually become naturally fulfilled."

Some part of a good story is about imitation. It's doing the Father's business. As Jesus said,

> But love your enemies, do good to them, and lend to them without expecting to get anything back. Then your reward will be great, and you will be sons of the Most High, because he is kind to the ungrateful and wicked. Be merciful, just as your Father is merciful (Luke 6:35-36).

In addition, heed Paul's advice and "take note of those who live according to the pattern laid out by the apostles" (Philippians 3:17).

Live your life in the context of what God is doing and you will live a life that tells a good story, an eternal story. Rise every morning to talk with God about what He's doing on that day. Have what Willard calls an "intelligent conversation about matters of mutual concern." Ask God where the kingdom is being advanced, where the invisible is being made visible, where the battles are being fought, and ask Him to let you be a part of what He's doing in kingdom history. Ask this with great confidence "for we are God's workmanship, created in Christ Jesus to do good works, which God prepared in advance for us to do" (Ephesians 2:10).

What does each day require of you? The goal of life on a daily basis should be to live up to what you have presently grasped, understood, and lived through in the disciple's life. Paul understood this (Philippians 3:12-16). It is—in fact—all any of us can do.

Let the measure of success in the artistic life be how well you have loved. "Dear friends, since God so loved us, we also ought to love one another. No one has ever seen God; but if we love one another, God lives in us and his love is made complete in us" (1 John 4:11-12). "The only thing that counts is faith expressing itself through love" (Galatians 5:6).

Here's what I've figured out for myself. My life and my art are going to tell a story whether I try to or not. They will tell a story that says: "This is what a follower of Jesus is. This is what he is about. This is what he believes. This is what he thinks is important." Because this is going to happen and can't be stopped, I had better make sure I know my role and my job description: *a Christian is a living explanation.* As I go about living I will either make the teaching about God the Savior attractive or I won't. I make it attractive by living out what it is. It's attractive without me. My life and artistic work is to represent it accurately and not do violence to its attractiveness. That doesn't mean that the answer is to simply do every specific thing that Jesus did. That would be far from simple for someone not God. I'll be doing well if I can become the kind of person He's teaching me to be. That's some big work right there. Big work indeed. But work is beautiful. It's what we do. Gratefully, there is immeasurable freedom in Christ as we work and play. I am free to be who and what I am—a prepared and active participant in God's universe. My freedom serves to remind me that an heir does not live like an orphan; a subject in the kingdom does not live as if there is no authority higher than himself; an object of affection does not live as if she is not deeply loved. These things are true, as true as shadow and light or melody and rhythm.

Be who and what you are. There is no truer starting place for making good and true art.

who do you SAY I AM?

ARTIST & CHRISTIAN: Two Identities, One Person?

Introduction

One of the truisms of our culture is that art somehow reveals the artist. The roots of this belief go back to the Renaissance. At that time artists began to promote and be celebrated for the idea that "art" came from the soul, imagination, and poetic invention of creative geniuses. These rare individuals, whose art is distinct from the mere skilled work of craftsmen, are to be cherished for their unique gifts. The idea that art is an expression of the sensitive genius got a tremendous boost from the Romantic movement of the nineteenth-century. The Romantic artist was typecast as an outsider who suffers estrangement and privation for the sake of his art. One only needs to listen to the words of Don McClean's classic ballad "Starry, Starry Night," about Vincent Van Gogh, to hear a portrait of the Romantic artist. One refrain repeats, "… how you suffered for your sanity, how you tried to set them free … " ("them" being the insensitive audience of Van Gogh's time), and a bit later the singer opines that " … this world was never meant for one as beautiful as you…" So these accumulated ideas of personal

vision and expressive genius are the foundation upon which the vast majority of contemporary artistic culture is built.

I encounter these beliefs about art and artists in discussions with my students. When we are talking about what visual art does, I often hear ideas like, "you can see the feelings of the artist," "art is an expression of the artist," or "art allows people to be themselves." There is much that could be explored in these ideas, both in terms of what they say about art, and how we think about human uniqueness and individuality in our society. But my purpose is different. Ideas about the inherent relationship between the character of the artist and the content and quality of his or her work suggest that the *identity* of the artist is a critical component in the way we think about the arts. And the concept of identity is no less important for Christians as they think about their life before God. Indeed, identity is simply central to being and doing. Our concept of our identity answers questions about who we are, and what characterizes our life and work.

It is my experience and my observation that there is usually a substantial gap between the way our culture thinks about the identity of the artist, and the way the Church thinks about a Christian's identity. Thus artists who are Christians find they have membership in two subcultures, and participate in two institutions that have markedly different views of how to order one's life, and determine what counts for the good, the true, and the beautiful.

I believe that the actual gap between the two subcultures has narrowed some during the last decade, with changes taking place in both. Today there are many more Christians active in the visual arts than twenty years ago, and it is not that unusual to find churches that have started to use the arts for worship, outreach, or simple enjoyment. In the art world, postmodernism's critique of the monolithic and totalizing claims of modernity has sometimes had the effect of allowing religiously grounded belief a place at the table. And for about a decade the art world has had an interest in spirituality, which obviously has resonance with Christian belief and practice.

It is encouraging to see a narrowing of the gap. Nevertheless, the division is still substantial, particularly as each subculture defines and celebrates the characteristics of its important members. So I find that many artists of faith experience degrees of dissonance as they live and act in both worlds. At its extreme, the dissonance causes people to feel as though they can't be artists and Christians, and thus they opt for one group or the other. I have known people who have given up their art, or their faith, because they cannot reconcile the tensions between the two worlds. More often artists who are Christians tend to accommodate the ethos of the subculture they are in, or colonize one in the name of the other.

The colonizing impulse can be seen in some aspects of the "Christian Arts" movement. Colonizing occurs when the norms and standards of one area of life are used to shape and determine another area, without respect for the inherent character of that area. Thus "Christian Arts" movements can be narrowly prescriptive about content, moral tone, and audience impact when art is made by Christians. It applies standards developed by the Church for churches to art, even though the arts have a distinct place in culture outside of the Church. Christian colonizing dresses up the arts in acceptable Sunday clothing, and is akin to the early settlers "Christianizing" native Americans by having them dress as Europeans. It begs the question of whether appearance and use determine what is recognized as Christian, and ignores the legitimacy and integrity of art that does not have a Christian message, or is at least deemed uplifting in its effect.

What follows, then, is an attempt to shed light on complex questions about identity, as we live out our lives in two spheres—art and faith. I begin with a brief discussion of what constitutes identity, then move to a consideration of how both the arts community and the Christian community think about identity in light of their beliefs, and finish by offering some reflections on a scriptural understanding of identity. My goal is to help artists who are Christians find a way to fully utilize their gifts and be fully Christian, which is both our calling and our "reasonable service."

The Concept of Identity

Discussions about identity figure prominently in American culture today, particularly in the political realm, where questions of origin, ability, and orientation are being debated and legally proscribed. Thus, one way to think about identity is in terms of the socially and legally defined groups we belong to, such as Hispanic, single, dyslexic, and the like. Categories relating to identity can be enumerated endlessly, and in one sense the more categorically complete a description we have, the more we should know someone's identity. But this is misleading, because categories defined by one's inclusion in a group are always about *group* characteristics. Even fairly specific groups, such as "Greek Orthodox Christians with M.F.A.s who specialize in large-scale sculpture" are limited tools for understanding an individual.

Here it is useful to point out how general the terms "Christian" and "artist" are. They definitely mean something, but the shared beliefs and experiences may be less than the differences between an Anglo-Catholic artist who paints like Giotto and a Pentecostal commercial photographer. So it's important to acknowledge the limitations of identity as defined by membership in groups.

Another way to think about identity is in terms of the personal characteristics of an individual. These may include physical characteristics like left-handedness, personal experiences like serving in the Peace Corps, gifts such as the ability to conceive space three-dimensionally, and dispositions such as an optimistic outlook or a tendency towards anger. It is the interaction between our personal characteristics and our membership in socially defined groups that begin to create the depth and complexity of our identity.

But it's important to point out that neither our identities as members of a larger group nor our personal characteristics—which may roughly correspond to the way we are seen by others and the way we know ourselves—is the full picture. Our identity is grounded in and conditioned by the fact that we are created by God, bear His image, and are known by Him. That is to say, our

identity is circumscribed by our creatureliness, and charged by the capacity we have to know and interact with God.

Nothing I've said about group identities or personal characteristics is controversial. But the fact that we are made by God is of a different nature. It is beyond the realm of incontrovertible proof, and certainly not a place of easy consensus in our culture. Even people who entertain the idea may find the reality of God an abstraction, with little bearing on the subject of one's identity. Yet I would argue that this fact is of enormous practical importance. For Christians live in relationship to God, and have a rich and deep point of reference regarding their own identity. Knowing that we are made by God and known by God can give us courage to resist the tyranny of groups, and to act as corrective lenses for the myopia of our strictly personal viewpoint.

Another facet of identity that is raised by this possibility of communication, whether with God or fellow humans, is that much of our identity is *relationally conditioned.* This may occur in several ways, such as when someone is a wife, a mother, a teacher, and a friend. Different aspects of the same person are called forth by each relationship, which expands and enriches her identity. But that person's identity—and to a degree her being—changes depending upon which relationship she is involved in.

The relational aspect of identity extends beyond relationships with persons. Our doing is relational too. By way of example, Degas' failing eyesight is an important aspect of his identity in relationship to his late paintings and pastels. It helps explain the reduction of detail, blurred edges of forms, and emphasis on color found in his late work. Degas' eyesight is sometimes mentioned by art historians when they are discussing that work. But assume that Degas also taught a Sunday school class. (As far as I know, he didn't.) His failing eyesight would likely not affect the conduct of his teaching greatly, and thus not be an important element for understanding what he did in Sunday school.

It should be clear that our identities are complex, multifaceted, developing, subject to some change, and related to our circum-

stances and roles. But this is not quite the same as what is often asserted in academic and art circles, which is that our roles, characteristics, and beliefs are "socially constructed." One usually hears this phrase applied to questions of gender and sexual orientation. The concept "socially constructed" suggests that we are like silly putty, and receive our identities and characteristics from the ideas and images that are dominant in our environment. It also suggests that since our identity is the result of external forces, rather than internal predispositions, we may change our identity without too much cost. Much of our culture's imagery and commerce is also built on an idea of malleability and change. As one ad put it, you should "make yourself over." Would that it were so easy.

When I was in my senior year of high school, the headmaster of the school I attended wrote an assessment of my academic performance for my parents. When it came to mathematics, he wrote that my parents "would never have to worry about Ted amazing the world as a mathematician." It was a clever way to say that I was a poor mathematics student. And while I certainly could have studied harder, the fact of the matter is that I have very little aptitude for math. So while studying harder would have made me a better math student, my capacity to improve is circumscribed by my innate mathematical abilities, which are slight.

Our culture recognizes certain kinds of limitations, particularly physical and social ones. But it tends to project the idea that we have the power to invent ourselves, or at least radically change our circumstances, if we are not obviously handicapped. The idea of changing one's circumstances, and by extension oneself, is deeply imbedded in the American story. It is part of what it means to be free in the American sense. In the archetype of the American western, people move out West to start over again, "make something of themselves," or find a new identity. So there are powerful narratives, both in the art world and the larger culture, which promote the idea of ready change, or a tinker toy self made from various bits and pieces of those handy cultural conventions that are just lying around.

In my judgment, these ideas disastrously overstate the case for human malleability. I believe identity is developed as one's innate abilities and temperament interact with personal and social experience. So I would suggest that there is a core person who, though capable of growth, change, flexibility, and deceit, is bound by innate physical, personal, and cultural limits. My goal is not to limit any human's potential, but to suggest that human potential has limits. Thus there is a fixity we carry around, which can be expanded or contracted, concealed or revealed, but not jettisoned when something more desirable appears. Indeed, we do not make ourselves, though we are responsible for what we do with the gifts and abilities we are given. And although I have not quoted chapter and verse, I believe this play between fixity and change, limitation and possibility, reflects a biblical understanding of the human condition.

In summary then, when we think about identity, it is important to make distinctions. Since a person's identity is multifaceted, we need to recognize various aspects, such as both the personal and the social, or how temperamental inclinations affect innate aptitudes. We also need to distinguish what aspects of our character are involved in our identity *as* … an artist, or a believer, or a parent, or a friend. Some aspects are critical for our vocation, our faith, or our friendship, others are not. And we must be aware that our sense of how free we are to construct our identity has a great deal to do with what we hear and see in our own culture. While there is the possibility for real growth and change in one's identity, it is neither easy nor inevitable. And while will and effort are extremely important human resources, they will never adequately compensate for the capacities we lack—such as the ability to always do the right thing.

Identity Within Subcultures

By definition, subcultures are a piece of a larger picture. When people participate in one, such as playing a character in historical reenactments, they return to a more fully orbed life. Ordinarily

people do not make totalizing claims about the philosophy and benefits of belonging to historical reenactment groups, even though some people spend a great deal of time as reenactors, and may find substantive affirmation and satisfaction through their participation.

However, some kinds of subculture are more totalizing in their views and their claims. Clearly in its claims and its scope, Christianity is not a typical subculture. It tells us about the character of God, answers questions about why there is death, and explains how we may find peace and joy in this life. The Christian faith presents a complete world and life view, and in this sense is distinct from an ordinary subculture. Yet when we participate in the institutions of Christianity, which is typically the Church, we are located within one particular expression of the faith—with its own history, theology, and cultural presence. We experience this as a subculture, because it is a localized and temporal manifestation of the faith. If we change denominations, we find a different, sometimes very different, expression of the faith. So even though Christianity's claims are total, its expression is local. This is particularly true in post-Reformation, post-Enlightenment Western cultures, where the Church supports and interacts with much less of the total culture than did its predecessors.

The visual arts may seem more clearly like a subculture than the Christian faith. Artists do not have creeds or confessions, and they have no communal rituals equivalent to baptism or the celebration of the sacraments. Indeed, individualism and free thinking are cherished. Also, many visual artists would not articulate a clear overarching world and life view founded on art. But as the visual arts have developed in the last two centuries, they have progressively assumed a religious role for art's most devoted followers. This tendency towards religiosity has been observed and discussed by artists, historians, and critics—sometimes appreciatively, and sometimes with caution and concern.

I believe the most challenging and thorough study of art's religious pretensions is Jacques Barzun's *The Use and Abuse of Art*, a

compilation of the Mellon Lectures he gave at the National Gallery of Art in 1973. The wittiest analysis of art as religion I've read is *The Worship of Art: Notes on the New God,* by Tom Wolfe, which was first presented as part of the T. S. Eliot Lectures at the University of Kent, England, and published in the October 1984 issue of *Harpers.* In it Wolfe asserted that art today fulfills two "objective functions" of religion, identified by the great sociologist Max Weber. While I do not think art is an adequate religion, the fact that people see it that way means that as a subculture, the art world is not quite like the subculture of golf, corporate finance, or historical reenactment. Some of its members have devoted their lives to art, and make totalizing claims about art's role for the initiated.

Thus, when we look at the characteristics that each subculture esteems—that is, the things considered important and essential to the successful practice of art or the life of faith— we encounter values that give direction and shape to life. To the degree that the ideas are internalized and acted upon, they become building blocks for our identity, and an explanation of who we are and what we are about. My purpose is not to give an exhaustive description of the characteristics that lead to conflict when a person tries to internalize and act upon values and ideals from both subcultures. Instead I will describe what I consider to be two important and commonly assumed values from each subculture, which make it difficult to fully participate in the other group. I begin with the arts.

The Identity of the Artist

At the beginning of this essay I spoke of our culture's penchant to think of a work of art in terms of its maker, the artist. While a work of art may represent many things, our culture has a pronounced tendency to see it as somehow representative of the artist: "An artist expresses herself." Thus for many people the use of art, and its obvious goal, is *self- expression.* In this view, there is a kind of seamlessness between the artist's work and the artist's life.

The artist does not make art as one would work at a job, with set hours every day, and an entrance into and exit from a work world and a work consciousness. Everything in the artist's life may be part of the artistic process, or subject matter for the art.

Examples like this are not hard to find. One that recently caught my attention was in the *New York Times* "Styles" section, titled "The Artist is a Glamour Puss." The artists discussed were young feminists who were breaking free of the "Jackson Pollock image" of the artist, and moving towards a sophisticated fashion consciousness. One of the artists interviewed was Tracey Emin, who created quite a stir when she exhibited a tent which had the names of all of the people she had slept with on it. A lot of the publicity centered around the fact that one of the names on the tent revealed an incestuous relationship. Emin told the interviewer for the article, "If I was in denial about my sexuality, I'd be in denial about aspects of my work, which deals with *personal revelations.*" (New York Times, 4-18-99, page 6 ST, italics added.) My point in relating this is two-fold: that Emin is publicizing what many people would consider best kept private; and that her personal history constitutes the source and content of her art. As she defines it, her art is personal in the sense that it is about her. Keeping her life private would evidently impede her development as an artist.

Art historians have studied the lives of artists for some time now, as a way of understanding more about the artist's work. Freud wrote a famous piece on Leonardo in 1910, which was a psychobiography based on an analysis of Leonardo's iconography and working methods. In it he drew conclusions about Leonardo's Oedipus complex, which was suggested to him by the two mothers in Leonardo's famous painting of "The Virgin and Child with St. Anne." Today it is commonplace to hear or read that Van Gogh's nervous, edgy color and energetic strokes express his emotional turmoil, or that Picasso's distortions of women express his sexual anxiety or misogyny. People just tend to assume that both the process and the content of art *reveal* the artist.

So it was with some surprise that I once listened to the wonderful illustrator (*The Shrinking of Treehorn*) and sometime writer of children's books (*Amphigorey Too*), Edward Gorey, repudiate that idea. The characters in Gorey's books are often creating trouble for, or are in trouble with, the rules of behavior composed by adults. An interviewer said to Gorey, "Well, you must have been a difficult child to raise," or something to that effect. Gorey responded with a polite demurral, and pointed out that he was creating stories, not writing about himself.

Of course art does reveal something about the artist. One cannot make something without exposing his or her interests,

Leonardo da Vinci. *cartoon for* THE VIRGIN AND CHILD WITH ST. ANNE AND THE INFANT ST. JOHN. Charcoal with white on brown paper. Approx. 54 x 39 inches.

tastes, and skills in some way. But, as Gorey's response indicates, artists also make conscious choices, and have the capacity to create fiction. They may choose to conceal, exaggerate, distort, or fabricate. So I believe it is a risky proposition to think that you learn a lot about artists by simply looking at their art.

It is embarrassing to compare Leonardo and Emin, but also instructive. Whether or not Leonardo's "Virgin and St. Anne" actually reveals an oedipal conflict is open to question, but it seems beyond dispute that Leonardo did not consciously choose that subject to reveal conflicts about his mother. His

considerable intellectual and artistic prowess was directed elsewhere. Tracey Emin, on the other hand, has chosen herself as the subject of her work, and in that she is hardly a voice crying in the wilderness. She, and many others, are simply following the logic of the idea that art expresses the self.

The only systematic study I know of about the beliefs of artists was conducted by the sociologist James Davison Hunter, with the assistance of two graduate students, James Nolan and Beth Eck. Hunter is the author of the widely discussed *Culture Wars: The Struggle to Define America,* which was first published in 1991. Hunter is interested in the role that beliefs play in our culture, particularly the beliefs of our opinion makers and elites. In the late 1980s they conducted extensive interviews with twelve prominent artists, artists whose work would be considered progressive or avant-garde. Since anonymity was a condition for the interviews, we don't know who the artists are. But as described in the study, their accomplishments are impressive.

 All have received a notable level of prominence in their respective areas—some internationally and almost all on a national level. Collectively they have been the recipients of numerous awards. A majority have received National Endowment for the Arts (NEA) grants, several have sat on NEA panels, and one was, in fact, a Policy Panel Chair for Visual Arts for the Endowment. Several have published books and still others have been associated with well-known galleries. Their works have been featured in scores of publications both within and outside of the art world. For example, in the mainstream media, discussions of these artists' works have appeared in such places as the *New York Times, The Washington Post,* the *Wall Street Journal, U.S. News and World Report,* and the *Philadelphia Inquirer* to cite only a few instances.

For the authors, the interviews revealed a "remarkable consistency of attitude" whose "world view seems to be woven naturally

from the fabric of their participation in a community of like-minded artists; a community whose cultural identity is shaped, in large part, by its particular social location." The study suggested that there are a cluster of related beliefs held by these artists. For my purposes here, what is significant in the study is what the authors found about the relationship between art and self expression.

The authors concluded that for the artists expression "is a measure of our being—existence. To express oneself is to partici-pate in the creation of reality: a process co-terminus with life itself. Conversely, not to express oneself is not to exist ... " The study is peppered with quotations from artists. One said, "Art is merely a way of getting out stuff within yourself." Another declared that art "is an expression of someone's soul." And a third artist believed that "the value of the work is higher, the more personal it gets."

In the study the authors sought to determine what the point or end of self-expression might be. They concluded that there was no point, no end, no ideal, no *telos* that directed the artists' efforts. Hunter and his colleagues observed that "... change itself is sacred. Transformation is its own end. The canvas, as it were, remains blank ... freedom, expression, choice, and change exist in their own right and need no compelling justification." They also pointed out how at variance these views are with those articulated by traditional religious belief.

If I have established that self-expression is widely seen as being the purpose of art, it in turn raises a question which leads to the second value or characteristic that shapes artistic identity today. If self-expression is so valued, how do artists, critics, and the art public determine what counts, or is worth engaging? Put another way, why are some selves accorded more status and significance than others? What standard and criteria is at work in the recogni-tion and ranking of artists?

The circumstances and mechanisms of recognition have changed in Western societies. In preindustrial and pre-Enlightenment cultures the artists with the best imaginative and

technical skills were afforded the most recognition. The recognition came from patrons the artists served and the communities they lived in. Artists might achieve international fame, like some cathedral builders, or Albrecht Dürer, but their reputations were communally and commercially determined, starting locally and spreading.

With the social changes wrought by the spread of democracy and the industrial revolution, critical success became less dependent on broad public recognition, or the financial support of patrons. It was at this time that the distinction between the fine arts and the practical arts became significant. "Artists" were fine artists, attending to beauty, or the sublime, while practical artists were tradesmen, selling a product. So artists and critics (who first emerged with a distinct voice in the nineteenth-century) began to determine which artists were worth looking at, or buying. The critic Hilton Kramer believes that today artists' reputations are first made among other artists, and then with critics, and then with the larger art public. Given this, it no longer follows that financial success or popular appeal lead to a critical reputation.

About two years ago, the painter George Wingate sent me a copy of a letter that a friend of his had received. George's friend is a painter and printmaker. He had gotten the letter from a curator who was interested in helping him with his career. The artist, Don Journey, is a realist influenced by the Dutch and American landscape tradition. His work has a self-evident mastery of technique and love of subject which places it outside of the main currents of "advanced" art. He is very successful financially. A number of years ago, George and I visited an exhibition of Journey's in New York. The entire show was sold out. But while he sells well, Journey has no critical reputation to speak of, and that's what the curator wanted to address.

The curator's letter was full of good, sound advice about placing works in collections and having the right collectors. But he made it clear to the artist that one thing was lacking. Though Journey is a very good painter, he isn't *interesting* enough to

command critical attention. Here are the curator's comments regarding critical reputations:

> The system is not corrupt but it is stupid. It froths enthusiasm—so transitory critical reputations are not difficult to create. More lasting reputations are made by critical consensus. Critical consensus is a general agreement of dealers, curators, academics, critics, and collectors. Nothing that makes critical sense is likely to make economic sense

A bit further on he continued:

> Critical consensus favors innovation and inaccessibility. It favors sensation: craftsmanship detracts. It is not so good to take your critic work too seriously. Humor in the art bespeaks a self-detached irony. Add Martians, George Bush in drag, pubescent nudes, and an overlay of chemical equations and you are on your way. But understand that you will be "misunderstood" and not sell. The making of reputations is a parallel but separate process from the making of art and is a form of art-making in itself.

At a later point in the letter, he actually suggests, tongue firmly planted in cheek, that the artist invent a fictitious personality. The purpose was to create *interest* for the circle of dealers, curators, and critics who would see, write about, and promote his work. My point is that being *interesting* is an important value within the art world. I believe that, like the concept "artists express themselves," the idea that artists are interesting people, lead interesting lives, and make interesting things is part of the popular identity of the contemporary artist.

The great French painter Georges Rouault must have been thinking of something similar to this when he announced in a statement in 1937, "I am a believer and a conformist." He is quoted in the book *Artists on Art* as going on to say:

Anyone can revolt; it is more difficult silently to obey your own interior promptings, and to spend our lives finding sincere and fitting means of expression for our temperaments and our gifts—if we have any. I do not say "neither God, nor Master," only in the end to substitute myself for the God I have excommunicated ... Is it not better to be a Chardin, or even much less, than a pale and unhappy reflection of the great Florentine?

It's logical that artists would want their art, and certainly themselves, to be interesting. Who wants to make boring art (though I must say I can think of some artists who seem to have been trying), or worse yet, be labeled a bore? But the interesting is not merely defined by a lack of boredom. In our culture "interest" has built into it the idea of arousing curiosity, standing apart from the ordinary, and having or doing something that attracts attention. In our media-saturated culture, where so many voices compete for our attention, arousing interest is the first step towards getting publicity. So to set out to make interesting art is to move in a very different direction than to pursue beauty, faithfully limn the visual world, seek to expose the soul's traces on the structure and expression of the human face, make art that exposes frailty and corruption, or any of the other myriad goals artists may set their hearts toward.

In the last chapter of *The Use and Abuse of Art*, entitled "Art in the Vacuum of Belief," Jacques Barzun describes "the interesting" as an inversion of the ordinary, the commonsensical, and the normal. In the search for the new angle, the interesting tends towards oddity, and the exploration of the anti-conventional. The interesting is the residue left after the "*avant garde*" has ceased to be a meaningful cultural distinction, but still functions as part of the apparatus of difference and promotion.

For Barzun, one mark of the interesting is found in audience response. He believes that to declare a painting or sculpture interesting reveals a superficial engagement on the part of the

viewer. It's as if viewers are saying, "this has caught my attention and diverted my thoughts for a few moments. How interesting. What's next?" There is no passion, either of embrace and surrender, or disgust and rejection. Barzun notes that

> As late as the Sacré du Printemps the audience howled when it was hurt, stomped out when it was bored. By the time, 50 years later, when Mr. Cage and his pupils performed ... the audience had become *uniformly interested.*

In the 25 years since Barzun wrote those words, it seems as if interesting art, with its low voltage shocks and fleeting gestures towards significance, has become more firmly embedded in our art institutions. The art critic Deborah Solomon, who could hardly be described as reactionary in her tastes, recently wrote a piece for the *New York Times Magazine* on graduate education in the visual arts. The schools she visited were all in California, and have booming enrollments. In fact, M.F.A. program enrollments are at an all-time high nationally.

Solomon's article explores the tremendous irony that "cutting edge art (has) become a lesson you learn at school." This betrays the *avant garde's* insistence that art is not learned in the academy, and stands outside of mainstream social institutions. According to Solomon, advanced art, at least as it's taught in California, is based on theory and intellectual strategy, and looks a lot like homework. Towards the end of the article Solomon remarks that

> At the moment there is no shortage of interesting new art, but that is not the same thing as important art, art that promises to last. One wonders whether the new-genre art favored in the 90's, will ever be able to compete with the epic achievements of this century

It's a pointed observation that underscores Barzun's insights about the rise of the interesting as a value in art. However, I believe the issue is not what kind of media or genre the artist chooses—after

all, there are plenty of "interesting" oil paintings around. Rather, the question is, who does the artist want to be and what does she want to do in her work?

I have sought to make a case that "self-expression" and "interest" are two important concepts of our culture's—our art culture and our broader society's—image of the artist. I have argued that these can shape the identity of the artist as they are perceived by others, or as artists think about their own work. My argument is not that all artists embrace these values. Many do not. But to the degree that they are culturally active, they are the kinds of things young artists must grapple with as they make choices about what they want to do, and who they would like to become.

It is my contention that if an artist embraces these as goals for her work, the relationship of the Christian faith *to her art* will likely become more difficult. This is not because Scripture or the Church teach that selves are negligible, or that they are best kept in check by hairshirts and constant denial. Instead, it is a question of ends. The biblical concept of self, and of vocation, is found *in relationship* to God and other selves. So it is not that we should not be expressive, but a question of what our expressions arise from, and what they ultimately serve. Self-expression as an end is solipsistic, and finally locked within the sparsely populated universe of the utterly personal.

In a similar fashion, it is not that we should shun what we find interesting. Rather it is that when the interesting becomes the *raison d'etre* for art, the development of an artist's gifts, including the necessary maturing of skills and vision, are stunted by continued efforts to be different. It is unlikely, then, that one's work will develop the kinds of passion, depth, and knowledge that art can offer, both to the artist and to his audience. If this is true, there is a delightful irony in the fact that artists may find their own voices and develop the gifts that are uniquely theirs without setting out to be self-expressive and novel, which are the signifiers of the personal for so much of our culture today.

Clearly, more could be said about how these values affect the practice of the Christian faith. But instead I want to turn to ideas that are prominent within Christian circles that may hinder artists of faith as they work in the world of art. My observations are drawn from my experiences as an artist, my discussions with other artists and with my students, and from reading and listening as Christians seek to articulate a Christian understanding of art. My church affiliations have been with the Evangelical Protestant wing of the Church, and a great deal of what I've read and listened to is grounded in a Reformed view of culture. So I am aware of the parochial nature of my remarks. While they may not directly correspond to the experiences of Catholic, Orthodox, or old-line Protestant readers, I believe they will be broad enough to stimulate reflection about other theological traditions' assumptions regarding the artist.

The Identity of the Christian Artist

In American Protestantism the visual arts have historically had a peripheral role in the articulation and practice of the faith. There are a number of reasons for this. Much of American Protestantism, particularly its "free-church" adherents, have been populist and pragmatic in nature. Also, the lingering Reformational doubts about the use of images within the church has meant that many Protestants have not encountered the visual arts within the church. And, with few exceptions, it has been only in the last twenty-five to thirty years that evangelical theologians, literary critics, and philosophers have sought to develop a Christian view of culture.

Since the 1970's there has been a growing stream of books, usually aimed at popular audiences, dealing with Christianity and the arts. The general purpose of these books is to introduce interested Christians to the arts, argue for the place and validity of art in the Christian life, and give the reader a sense of the kinds of critical distinctions one needs to make to think Christianly about the arts. Some books are more historically oriented than others,

and discuss styles, periods and movements. The late Dutch art historian H. R. Rookmaaker's *Modern Art and the Death of a Culture* is the earliest book I encountered on art from a Christian perspective. It was first published in 1970.

These books have been useful in stimulating discussion and helping evangelical Christians sort through issues concerning the arts. One of the recurring themes in these books is the distinction between the secular arts of our culture as it exists, and the values and characteristics of a culture animated by Christian belief, which largely doesn't exist. Embedded within this separation between secular and Christian is the idea of *Christian art.*

Some artists I know who are Christians are fairly leery of being categorized as Christian artists. This may be for reasons of modesty, or because to be so labeled has not been much of a career booster outside of Christian circles, or because "Christian" seems too small to describe the artist's body of work, or because the concept "Christian art" is the intellectual equivalent of a briar patch. "Christian art" can variously mean: 1) work with obvious Christian subject matter like biblical narratives; 2) work whose worldview or spirit is Christian; or 3) work that is made for a Christian audience, to be used in some Christian way—usually liturgically. If these possibilities aren't confusing enough, sometimes people simply mean that Christian art is art made by Christians.

Regardless of where the authors may come out in their discussion of Christian art (I think all the authors I list in Appendix 2 subscribe to some version of 2), the structure of the discussion indicates a belief that the visual arts have a capacity to express, communicate, or reflect a Christian viewpoint. This is a particularization of a tendency among Protestants that Nicholas Wolterstorff has noticed. Wolterstorff says in *Art in Action* that Protestants tend to think that ". . . a work of art is always *an expression* of its composer's religion . . . " He says that this is because Protestants tend to believe that humans are irreducibly religious in orientation, and have an "in-created" tendency to

substitute and elevate something else in the place of God if they do not acknowledge and worship Him. Wolterstorff does not think that all art is religiously expressive, because he does not believe that all people are irreduceably religious. He distinguishes nonbelief from misplaced belief.

But, if you believe that all art is an expression of a religious view, then it is natural to assume that *the Christian artist's art should somehow express a Christian view.* You can hear this in a passage from Leland Ryken's book *Culture in a Christian Perspective.* He affirms that "artists are free to portray the subjects they are best at portraying." But he almost immediately qualifies this by saying,

> Sooner or later, writers or composers or painters will say something about the things that matter most to them. If this is true, it is inevitable that the Christian vision in art will be characterized by the presence rather than the absence of such realities as God, sin, redemption, and God's revelation of himself in both Word and Son.

Others would be less specific about what constitutes a Christian view. For instance, Rookmaaker says in *Modern Art and the Death of a Culture,* " … what is Christian in art does not lie in its theme, but in the spirit of it, in the wisdom and reality it reflects." So I believe that one of the assumptions within Evangelical Protestantism is that *art by Christians will, or ought to, somehow communicate a Christian worldview.* It is important to notice that I have changed the earlier italicized "express" to "communicate." This is because many people view expression as a communicative act. It is also useful to see that Christians share with the larger culture an expressive view of art. It's what is being expressed that is different, though Christian expression might be conceived of as a form of self-expression.

Now many artists I know fervently desire that their faith be a constitutive element in their art. Some want to express their faith through their art, others want their faith to be the foundation for, or worldview behind, the work. But other Christians are content to

let their work develop without much reference to their religious beliefs, or perhaps they have explicitly a-religious ends in mind, such as that the work should enliven architectural spaces, or decorate visually impoverished places.

I want to note three problems with the idea that Christian artists will, or should, express/communicate Christianness in their art. The first is that this ignores two diversities. One is the diversity of purposes to which art may be directed. Certainly art can be used as a means of communication, but it is not only that. One of the most common uses of visual art throughout human history is frankly decorative. We recognize this when we speak of the *decorative* arts. And even though there are libraries full of dense critical books trying to prove otherwise, one of the primary uses of modern abstraction has been decorative. Indeed, as the arts have unfolded in human history, we have tended to qualify them according to their designated ends. The communication arts, which are a distinct discipline and practice, have communication as their central preoccupation. "Art" by itself signifies no end, though we are quick to associate it with exhibitions in museums and galleries, with their characteristic uses of appreciation and study.

In a similar fashion, to stress expression/communication also ignores the diversity of gifts that God has poured out on humanity. Some artists have the gift to express faith, or a world view, others don't. I have watched some believing artists struggle to do something "Christian," because they feel that this is their duty. But it was obvious to me that these artists have no real gift for that, and the results were forced, awkward, and self-conscious. Other artists, laboring to be Christian, will attach a Christian "reading" to work that doesn't naturally carry it.

While it is understandable that Christians would want to privilege Christian expression, particularly in light of the poverty of a Christian presence in the visual arts over the last two hundred and fifty years, this bias is not without cost. It may even prolong what we all wish would go away, the overabundance of bad art in the service of faith. I believe it is better to recognize and encourage

a diversity of artistic gifts that are fitted to diverse artistic ends, than it is to suggest that the test of one's Christian conviction is found in the ability to artistically express the faith.

A second problem with the emphasis on expression/communication can be found in a possible objection to what I've argued above, which is that some artists will express their faith in their work, but others will not. Some might argue that it is inevitable that what a Christian does will be tinged with a Christian view or expression. You can hear this when Leland Ryken responds to W. H. Auden's quip that "there can no more be a 'Christian art' than there can be a … Christian diet." Ryken responds in *Culture in Christian Perspective*, "For one thing, there is such a thing as a Christian diet: it consists of eating meals that are healthful, moderate, modest in cost, and delicious." What Ryken has done is to exercise a form of the "all truth is God's truth, hence anything true is Christian" argument. Of course we live in God's created order, and in one sense a good diet is Christian.

But is a diet expressive of a world view? Many Buddhists and New Agers whose diets fit Ryken's description would not be able to discern anything Christian about their eating habits. They might agree that their diet is godly, but not specifically Christian. There is nothing that necessarily leads to the Christian faith in the kind of diet described. The ability to recognize and choose a good diet is given to all people, and to the degree a good diet may be expressive, it is capable of congruence with differing convictions. Of course there are diets that are chosen for religious reasons, but those are prescribed and are beyond commonly recognized virtues like moderation and healthfulness.

A little later on in the same passage, Ryken says:

> Since art not only presents experience but also interprets it—since it has ideational content and embodies a world view or ethical outlook—it will always be open to classification as true or false, Christian or humanist, or Marxist or what not.

> In the long run, every artist's work shows a moral and
> intellectual bias. It is this bias that can be compared to
> Christian belief.

I disagree. I believe there are many areas in life where one's choices
and actions do not express or communicate the religious convic-
tions that generate them—even in the long run. When called upon,
we may articulate the convictions, and try to explain how they lead
to our actions, but other explanations may be plausible too.
This is particularly true in a culture that is as open, diverse, and
pluralistic as ours.

For example, I know of many landscape painters who are
painterly realists. Their work is united by the plein-air tradition of
quick response to the complex and shifting sense experiences
provided by vista, atmosphere, and light. Some are indebted to the
American painter Fairfield Porter. While these artists do not
constitute a school, they do have a common language and shared
concerns, including a love of and respect for the sensory experi-
ences provided by the creation. Some of these artists are Christians,
and know that a Creator made and sustains the creation. But others
do not. Apart from talking to the artists about their religious
convictions, I did not see a real way to discern them. It would be a
tortured act of critical exegesis to try to make the Christian's work
express a Christian view, especially to distinguish them from the
religious views other painterly realists might hold and potentially
express. Would it not be more honest and accurate to say that
Christian and non-Christian alike can respond to and affirm the
beauty and goodness of creation? This is not to argue that
landscape painting cannot express religious views (one need only
look to the American luminists, or to Dutch seventeenth-century
painters), but rather to assert that not all art by Christians will
express or communicate their faith in a discernable way.

The third problem with the expressive/communicative view is
that it tends to make the Christianness of art reside in content that
can be verbally apprehended. Now I think there is a great deal that

can be said about visual art, but at its heart it is irreduceably visual, and words necessarily fail us. At their best words can open avenues to visual experience that we might otherwise miss. If the Christianness of an image resides in content that can be articulated, dissected, analyzed, and "proofed" in some way, we may have the illustration of an idea on our hands.

I once heard a purportedly intelligent pastor argue before a group of artists that Lucas Cranach the Elder was one of the greatest Christian artists to have ever lived, because his work was so full of Lutheran theology. The artists were incredulous. Certainly Cranach is an important artist, with his gossamer pubescent Venuses and Eves, and his many pristine portraits of the doughty Luther. But who would seriously compare him to Grüne-wald, Michelangelo, or Caravaggio? Only a person who is happy when he can see words.

In discussing how Christian authors have thought about the arts, I pointed out that they have generally made a distinction between the secular and the Christian. One way to distinguish the Christian from the secular is through the expressive/communicative assumption I've been discussing. But there is another way that Christians often draw a line between the secular and the Christian. That distinction revolves around the moral vision or moral effects of art. This idea is sometimes expressed as *the Christian artist's work should embrace what is good.* Sometimes this will be taken a further step, to include the effect of the work on the audience. This idea might then be formulated as *the Christian should make work that morally uplifts the audience.* This makes the ethical content of a work of art an important consideration in determining its Christianness, as we heard in the last quotation from Ryken.

It is probably foolhardy to attempt to critique this assumption. Our culture is awash in a flood of degeneracy, both in popular and "high" art. I have no desire to argue on behalf of immorality. Nor do I want to suggest that thoughtful Christians have not grappled with the issue, and made no distinctions between work that may be disturbing and difficult, and work that is morally

pernicious. Some of the authors I've mentioned have addressed this complex subject, and do not advocate a world-denying, neutered, stained-glass, life-is-in-the-sky kind of art. But of course, there is a great concern that Christians should be morally distinct from the sinking morass around them.

I believe most of the pressure to be morally uplifting as an artist comes from the Church, and its results are manifested in much of Christian popular art. One can see those results in most Christian bookstores. The art, music, and literature they carry exemplify the problems with the notion of "Christian art" as it is conceived in popular taste.

My point in calling attention to the idea that the Christianness of a work can be discerned by assessing its ethical content is not to challenge it. Clearly art can carry and communicate ethical views through its content, and some Christians will have ethical dimensions in their work. Nor is my intent to locate and fix the line between what is acceptable or not acceptable for Christians to be engaged in as artists.

My purpose in calling attention to this assumption about the ethical content of art a Christian makes is the same as my purpose in discussing the idea that the Christian's art will express a Christian view. What makes these assumptions problematic for the Christian *as an artist* is not even that they are only sometimes true, and ignore the complexity and diversity of possible things a Christian may do. Rather, what really makes them problematic for the artist who is a Christian, is that *neither assumption acknowledges the way art is actually made, nor how art works in our cultural landscape.*

I have three observations about the way art is made, and its uses in the larger culture. I want to stress that these are based on what I've *observed,* both in my own life, and in the life and work of artists I've known. First, the idea that artists who are Christians will make something Christian can lead the artist to view Christian content as an element to be manipulated during the creative process. So while the intention is admirable, the goal can become an

impediment to art, because Christianity is incidental to so many of the particularities of the creative process. This is especially true for people that are not working with overt Christian subject matter.

The artistic process, even for highly theoretical artists, is characterized by stops and starts, intuitive gropings, the retracing of steps, the coaxing of recalcitrant details into a coherent whole, and the search for a sense of substance. Except through the resources of prayer, one's faith simply has little to say to the moment-by-moment choices the artist makes in the give and take of creation. And if artists try to assess the Christianness of their work as they proceed, they are treating the faith as material that can be added or adjusted, as one might put a bit more magenta into a color mix. Christian expression, when it exists, suffuses the whole work, and comes from the insight and vision of the artist far more than it does from conscious decisions made in the process of creation. I am not saying that conscious decisions cannot be made about the content and direction of one's work. But I am saying that in the deepest levels of the creative process *what* an artist expresses cannot be managed the way one struggles with *how* it is expressed. Christian content is not a craft to be learned.

In our battle-weary culture, concerns about ethical standards can create special problems for Christians who are artists. Pressures from an imagined audience can be troubling. I believe that while artists are responsible for what they make, they are not responsible for what their audience perceives. It is useful here to recall Upton Sinclair's remark after the success of his famous novel *The Jungle,* published in 1906, which exposed the sordid conditions in Chicago's meatpacking industry. Sinclair hoped to outrage his readers with his descriptions of the low pay, danger, exploitation, and social injustices workers endured. He said, "I aimed for their heart, but I hit them in the stomach." What outraged readers was not the plight of the workers, but the disgusting and unsanitary ways meat was processed. Their revulsion helped stimulate reforms in the industry.

This anecdote is relevant to questions of morality in art. Christians who are artists may offend the moral sensibilities of their local church, or a particular audience, even though in their own minds they have worked within the bounds of morality. This is especially true if audiences are looking for a certain position as an indication of the Christian commitment of the artist. There is no easy way out of this dilemma. To the degree that the artist tries to guess an audience's response and adjusts the work to appease sensitive sensibilities, the likelihood increases that artistic power and expression will be diminished. So while artists must care for their works' audience, they cannot be controlled by it. In the final analysis, no one can aim art so well as to be assured of audience response. This is true even for advertisers, who spend billions of dollars trying to manipulate audience reactions. And art is hardly advertising.

Finally, I think both the assumption that Christians will somehow express something Christian, and support Christian morality, flow from a desire to create a Christian culture that is distinct from a secular culture. I believe the desire is based on two things: the belief that at one time Western culture was predominantly Christian in its arts with Christian concepts of the good, the true, and the beautiful; and on a longing for the arts to be a redemptive agent in contemporary culture. So, Christians may want to try to recover a former position in the arts, and see the arts as a possible way to change our culture. But we need to attend to what area of the past we look to, and understand how our art affects people's minds and hearts.

In my judgment, the past that we should be looking to for guidance is not the glory periods of Western art, but that of the early Church. This is because the contemporary Church's position relative to its larger culture seems more like that of the early church than like the Church in the later, more thoroughly Christianized West. This means that the Christian who is an artist works in a culture that is oblivious to, indifferent to, amused by,

afraid of, or perhaps somewhat curious about the religious dimensions of his work. But usually the audience is not informed about the faith, or disposed to embrace a work because of faith's presence. So the recognition and critical reception that Christian artists receive will not be due to their giving form to faith, unless the artists specifically address a Christian audience. And the Church—at least the Church I know—while beginning to use the arts again, simply does not have the theological imagination, artistic sophistication, or financial resources to call forth an aesthetically significant and emotionally charged Christian expression that will engage the hearts and minds in our art's culture. Thus the individual Christian artist who tries to create a Christian art *distinct from* the artistic concerns and idioms of our culture is shouldering a very, very heavy burden.

While it is understandable that Christians think a Christian expression may act redemptively in culture, this idea founders on our culture's actual uses of art. For many years, when I've visited the Metropolitan Museum of Art, I've stopped to look at Van Eyck's exquisite and terrifying depiction of the *Last Judgment.* I always watch other visitors, trying to fathom what they are experiencing. Does the painting move them religiously in any way? Does it predispose them to wonder who this Christ is, or make them meditate on the possibility that one day they will be judged? I'll never know, but I suspect that's usually not the case.

It may be that since Van Eyck painted in the fifteenth century, the contemporary viewer may see the Christian subject and content as something from the past, and not relevant today. After all, it was once in a church, and now is in a museum. However, we can ask the same question about a twentieth-century artist like Rouault, or a contemporary painter like Tanja Butler. The fact is that many people see, appreciate, and experience their work without being religiously stirred, because art as we know it is bound to the aesthetic, the expressive, and the personal. People moved by Rouault's pictures of Christ will likely see them as

Rouault's personal expression of belief, and not as an image whose purpose is to communicate religious truth. So while viewers may sense the depth and authenticity of Rouault's belief, that is part of the *aesthetic* experience of his work. It is an uncommon viewer who will be moved by Rouault's belief to examine her own religious convictions.

The art historian Bruce Cole has noted that somewhere in the thirteenth century Western paintings and sculptures began to lose their iconic power (the capacity to communicate and shape religious belief) and made the first steps towards our idea of "art" (*Italian Renaissance Art 1250-1550*, p. 17). I suspect that many Christians long for art to regain some of that earlier iconicity. But

as long as we participate in our culture's institutions of art, that iconic power will always be tantalizingly beyond our reach. Our culture's arts are very effective at mediating experiences of beauty, passion, mystery, intellectual engagement, or cultural challenge. But they are not capable of cultural redemption, unless society as a whole shares in the Christian longing for signs of the kingdom.

I have spent a longer time discussing Christian assumptions about who the Christian artist should be

Tanja Butler. THE ANGEL AND THE WIFE OF MANOAH (*detail*). Oil on canvas. 12 X 12 inches.

than I did discussing the art world's assumptions about the character and identity of the artist. This is because I assume that Christian expectations will be more normative for the readers of this book than the art world's assumptions, not because I believe the Christian subculture is more detrimental to art than the art world is to faith. My concern in both instances is to show how the values and expectations of each subculture may affect our thinking about our identity as artists. I believe that if we sort through and understand the pressures to *be* a certain way, we can more thoroughly develop our gifts, and determine our calling.

What remains is the question of whether we can live within both worlds, be true to our vocation and sense of God's call, and develop identities that allow for the integrity and flourishing of both our art and our faith. I will close by considering identity in the scriptural narratives, and suggest that we need to look at our identity in light of its engagement with Christ.

Identity in Scripture; Identity with Christ

One of the central acts of the Christian faith is the confession of Christ's identity. He is the Son of God, the Savior, the Redeemer, the Mediator between God and man, and the author and finisher of our faith. Christ's identity is revealed to us in Scripture, and enshrined in the creeds and confessions of the Church. Our identities as Christians are dependent on recognizing who Jesus of Nazareth is, and for most Christians the distinction between Christian orthodoxy and its various deformations rests on correctly identifying the character, role, and work of Jesus, the Christ. It's hard to exaggerate the importance of His identity.

The effects of continually confessing Christ's identity may mislead us, though. We may reduce the character of Christ to a few codified phrases, or we may make the recognition of Jesus seem easier than it actually is. Clearly the scriptures paint a vivid picture of the difficulty people have in grasping Jesus's identity. It's possible to dismiss that difficulty as a result of His audience's hardness of heart, because they belonged to a "wicked" and

"faithless" generation. But there is value in trying to imagine what it would be like to hear and see Jesus through all of the mixed, confused, and competing cultural assumptions that clamored for attention in a Middle-Eastern outpost of the Roman Empire during the first-century. Recognizing Jesus is no sure thing—and He doesn't seem too concerned about making it easy. He speaks in parables, disappears at strategic times, aggravates powerful people, and in general, doesn't act like someone who's working at developing a large following. But He spoke with authority and told people things they knew were true; He healed people, and they responded by flocking to Him in great numbers.

In the sixteenth chapter of Matthew there is an exchange between Jesus and His disciples that may shed light on the way we think about identities. In the thirteenth verse, Jesus asks the disciples, "Who do people say the Son of man is?" The disciples' response, "Some say John the Baptist, others say Elijah, and still others say Jeremiah or one of the prophets," indicates that there are multiple perceptions about Jesus's identity, all cast in light of earlier great Jewish figures. Then Jesus turns to the disciples. "But what about you, who do you say I am?" Peter, always quick to speak, says, "You are the Christ, the Son of the living God." Jesus affirms Peter's answer, but tells him that he wouldn't have understood this, unless God had revealed it to him. A bit later on, Jesus warns His disciples "not to tell anyone that He was the Christ."

Peter must have been feeling pretty proud about his recognition that Jesus is the Christ, the Son of the living God. So when Jesus went on to explain that He must suffer many things, be killed, and raised from the dead, Peter was sure that those experiences were entirely inconsistent with the role and identity of the Christ. He took Jesus aside and began to rebuke Him, saying, "This shall never happen to you (v 21)!" We all know Jesus's response, "Get thee behind me Satan!" Poor Peter, so right and so wrong.

What an intriguing story. Peter had confessed the "true" identity of Jesus. He understood that Jesus was not Elijah II, but the Son of God. Yet he didn't have any understanding of what that

meant. For Peter, and for Jesus' audience, "Son of God" was incompatible with suffering and death. That category simply precluded those experiences.

Then there is the question about Jesus' self-disclosure. Why did He not want people to know He was the Christ? Certainly a great deal of His reticence can be explained by sheer disbelief. "You are who? The Messiah? Yeah, sure!" But as Peter's attempts to dissuade Jesus from talking about pain and death show, what Jesus knew awaited Him was unthinkable to his followers, even for the disciples. In his little book *On the Incarnation,* St. Athanasius explains, " . . . He did not offer the sacrifice all immediately He came, for if He had surrendered His body to death and then raised it at once He would have ceased to be an object to our senses." So Jesus' work as the Christ had to be slowly unfolded as He set his mind and heart towards what lay ahead. It could not be simply announced, but had to be lived out through space and time to make it comprehensible to people.

In a similar fashion, our lives *as* artists, *as* parents, or *as* followers of Christ have to be lived out for our identities to have any meaning. And our conceptualization about that identity is always in dialogue with our moment-by-moment experiences. Our concepts are necessary to order and understand our experiences, but they also are modified and reconfigured to the degree that there is dissonance between what we think we know, and what we actually experience. Peter thought he knew that the person who was the "Son of God" would reign with majesty, power and glory. But his subsequent experience of Christ radically reconfigured his ideas about God's nature. Over time he came to see that indeed, suffering and death were taken into the very heart of God, and that God's power over pain and death was not exercised remotely, or without cost to Him.

Thinking about our own identities is particularly difficult for us, because we possess such clouded self-knowledge. As Walker Percy points out at the beginning of *Lost in the Cosmos,* a book that has a great deal to say about identities and why late-

twentieth-century Americans have such a tenuous hold on their own, " ... it is possible to learn more in ten minutes about the Crab Nebula in Taurus, which is 6,000 light years away, than you presently know about yourself, even though you've been stuck with yourself all your life ... " Scripture is full of examples of people who don't understand who they are, or who are unable to do what they know they should (think of Paul's great anguished cry in Romans), or who are fearful of the consequences of some aspect of their identities.

Peter's denial of Christ is one of the most clear and wrenching examples of someone unable to understand himself, and unable to bear the consequences of his identity. When Jesus tells Peter that Satan will sift him like wheat, Peter replies that he is ready to go to prison for and die with Jesus. Jesus responds that Peter will deny ever knowing Jesus three times that very night. Subsequently, Peter did as Jesus predicted. We can only wonder about the change in consciousness at the critical moment when Peter was caught between his desire to be faithful to Jesus, and to stay out of the troubles he'd said he was ready to face. While the stakes are rarely so high for us, we play out this drama over and over again, as we adjust or suppress one aspect of our identity to make present circumstances more "comfortable."

Though this is a limited look at a large subject, I believe that Scripture shows that our identities are unfolded in the acts of living, and that there will be degrees of dissonance and brokenness between how we know and identify ourselves, and what we actually do. That dissonance, whatever its nature, is always a particularized instance of the great and original rupture that separates us from ourselves, from others, and from God. So just knowing what the pressures are to be a certain way will not by itself give us the freedom and courage to act consistently.

The dean of the college where I teach sometimes jokes that the solution to many of the difficult personnel issues she deals with could be found if she had the ability to do "personality transplants." Don't we all sometimes long for personality

makeovers, especially at difficult junctures in our lives? But as Walker Percy noted, we are "stuck" with ourselves. And contrary to what is offered by a lot of religious purveyors today, the Christian faith never promises a personality transplant.

The Christian faith's uniqueness lies in the way God relates to individuals. We are not subsumed by God, but co-joined with and to God. Our identity is not erased or obliterated, as desirable as that might seem at times, but instead is involved in a deep and complex exchange with Christ's identity. Christians seem most clear about this exchange at the point of the atonement, in which Christ dies that we might live. But this is only one aspect of a relationship that extends into all areas of our lives.

The English author Charles Williams has called this state of being "co-inherence"—the opposite of incoherence. He sees it permeating both the natural and supernatural worlds, as when a child is conceived and carried in its mother, and godparents stand in for a baby about to be baptized. Christians "partake" of the life, death, and resurrection of Christ in that they share in the *identity* of Christ. The exchange between the believer and Christ is at the heart of the Christian life, and the believer's motives, thoughts, and acts can be renewed and transformed in this "being with" Christ.

Herein lies the ability to be one person with two identities. It is in fact already a permanent condition of the Christian. Just as the Church confesses that Christ is one person with two natures (or identities), both fully human and fully God, the Church acknowledges that the individual Christian is joined to Christ through the Spirit, and carries Christ's identity as well as his own. So our identity is enmeshed and intertwined with Christ's in ways that are beyond our knowing, and unseen. Nonetheless, Christ with us is a "real presence."

The action of Christ's identity in us, with us, and through us is neither automatic nor easy. It can be thwarted or displaced, and must not be confused with the cultivation of the Christian "personality" that is the preoccupation of so many churches. *That* personality may or may not reflect the character of Christ.

But to the degree that we live in the knowledge of and communion with Christ, we have the potential to resist and transform pressures to conform to someone else's idea of who the artist is, or what kind of art the Christian should make. All kinds of ideas and experiences affect our identities, but they cannot overshadow the foundational identity we have of being with the living Christ.

For a large part of this essay I have argued that our culture's ideas about the institutions of art will shape what is possible regarding a Christian expression in the arts. I have argued this because I've found that Christians tend to have expectations about what art can do, and what it will look like when Christians do it, that ignore the real terrain of art. But I have not argued, and would not want to suggest, that the contours of art today are permanent and immutable. It is possible that the way we think about and do art, and how we experience it, can change. It may be that thoughtful and dedicated Christians will have a hand in that, and help create a world where the words Christian and art coincide more easily, more naturally, and more fully.

CREATOR
CREATION
and
CREATIVITY

Our society puts a high premium on creativity. Businesses look for people who think "outside the box." Artists defend their work on the basis of innovation, not tradition (or the Modernist tradition of innovation). Technology has unleashed the imagination of researchers in medicine and science to achieve what was literally "unthinkable" only a decade ago. And teachers give credit for creative answers, even if the correct answer remains at large. Indeed the very idea that there is only one "correct" answer leaves some concerned that this might stifle this precious but elusive characteristic. This anxiety that creativity could be extinguished is an indicator of how important it is to us and how little we can understand or control it. Creativity, like spirituality, is an intangible and mysterious quality that defines us as human. One description of creativity is that it is like moonlight. In some cultures, the moon is worshiped as a god. A lunar eclipse is enough to provoke a frenzy, even sacrifices. In other cultures, the moon is understood as a large rock that orbits our own planet. There are even some among us who have walked on its surface. However, this

cerebral understanding does not prevent us from taking long walks when the moon is full and bathing in its luminous magnetism which evokes within us an indescribable warmth and romance.

Without certainty of the source of their creativity, many artists have rituals and objects that they hope will maintain their powers, and a creative "block" or eclipse is enough to send them into turmoil. Conversely, a biblical approach to human creativity seeks to understand it as the reflected light of Divine creativity. This neither overestimates the glory nor underestimates the magnificence of creativity by affirming the value of those things which act as reflectors of Creativity: nature, language, reason, love, faith, art. The moon is no substitute for the sun, but if it were not for the moon we would not have any contact with the sun for half of our lives. Similarly, our human creativity can be a manifestation or revelation of God, even when it seems like He is on the other side of the earth.

How is it that human creativity reflects its divine source? In *The Mind of the Maker*, Dorothy Sayers wrestles with the meaning of Genesis 1:27, "Then God said 'Let Us make man in Our image, according to Our likeness … '." Despite the fact that God is often represented as an old man with a long gray beard, there are very few who actually believe that God resembles us in appearance. Sayers asks,

> How then can [we] be said to resemble God? Is it [our] immortal soul, [our] rationality, [our] self-consciousness, [our] free will, or what gives [us] claim to this rather startling distinction? A case has been argued for all these elements in a complex nature of man. But had the author of Genesis anything particular in his mind when he wrote? It is observable in the passage leading up to the statement about man, he has given no detailed information about God. Looking at man, he sees in [us] something essentially divine, but when

we turn back to see what he says about the original upon which the "image" of God was modeled, we find only the single assertion, "God created." The characteristic common to God and man is apparently that: the desire and the ability to make things.

Sayers goes on to describe a Trinitarian understanding of God as Creator and a corresponding understanding of human creativity in terms of Idea, Energy and Power. She notes that the Trinity may be the most remote of all Christian doctrines from the common experience. However, an understanding of the Trinitarian relationship, is very close to the common experience of many artists.

The Holy Trinity describes one God in three persons. The Nicene Creed affirms faith in this Trinity as follows,

> I believe in one God the Father Almighty, Maker of Heaven and earth and of all things visible and invisible; And in One Lord Jesus Christ, the only-begotten Son of God, begotten of his Father before all worlds, ...by whom all things were made; Who came down from Heaven and was incarnate by the Holy Spirit and was made man. And I believe in the Holy Spirit the Lord, the Giver of life, who proceedeth from the Father and the Son...

Each of the persons of the Trinity is described in creative terms and each relates to a particular aspect of the creative process. Works of art are the product of three elements: the concept, the material, the meaning. There is one work and three elements. Each is separable in art theory but no work can succeed if they are not in a balanced unity.

The work of art first exists as an idea in the imagination of the artist. This is an aspect of the work of art that relates to the Father, the Creator of heaven and earth who commanded creation into existence from his creative imagination. Sometimes the idea comes to the artist as he is engaged with the material, but the idea

is the point from which the creative process toward a work of art begins. The idea conceptually encompasses the whole work from beginning to end yet it is abstract and formless.

Without form, the idea exists only in the artist's creative imagination. The artist must proceed through a creative struggle with his materials for the idea to be incarnate in the art object. This physical nature of the work of art is very important to its being, just as the incarnation of Christ was important to his purpose. The suffering, death and resurrection of Christ were not a conceptual suffering, death and resurrection; they were necessarily physical— physical, but with spiritual meaning. On a smaller scale, works of art are physical but they are also nonphysical. Not only does the physical work of art give form to the nonphysical idea of the artists, but it conveys nonphysical meaning to the viewer.

The result of the creative process is a unity of idea and form from which meaning proceeds, as the Spirit proceeds from the Father and Son. This is the power of the work of art over the viewer, that which connects the work to the creative spirit of the viewer. This is the spirit of the work speaking to each viewer in its own way and renewing itself in each new context.

Just as the Trinity cannot be completely grasped cerebrally—it must be taken by faith and known personally by the believer—so the concept, material and meaning of a work of art cannot be understood by theory, but rather requires that it be experienced through an actual work of art. The fresco cycle by Michelangelo Buonarroti on the ceiling of the Sistine Chapel makes for an appropriate study of creativity from a Trinitarian paradigm. Not only is this work undisputed as a successful work of art but its success both illustrates and demonstrates Trinitarian creativity. The subject of the fresco cycle is the creation of the world as described in the first chapters of Genesis, and Michelangelo intentionally used this subject to explore the creative process itself.

The Sistine Chapel and its Liturgical Function

The famous detail of the commanding finger of God as he gives life to Adam, his most spectacular creation, epitomizes our understanding of creators, creation and creativity. For both obvious and elusive reasons, the nine scenes from the Genesis narrative that span the chapel ceiling make a valuable study of human creativity as it attempts to reflect and represent the origin of all creativity.

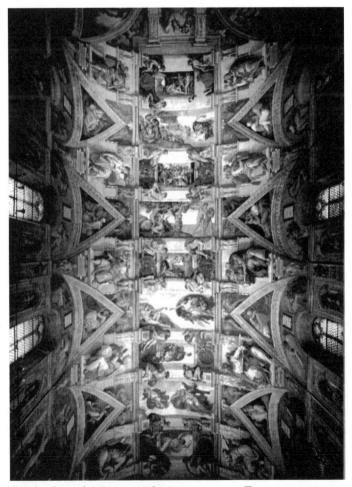

Michaelangelo. SISTENE CHAPEL, 1508-12. Fresco. 40.93 meters long by 13.41 meters wide.

In his book *The Christ of Michelangelo,* John Dixon argues, "The Sistine Chapel is one of the best known, the most studied and the least understood of great works of art." The problem according to Dixon lies in fundamental assumptions about the program and purpose of this work of religious art and its relation to Michelangelo's faith. The questions of the subject and function of Michelangelo's frescoes are interrelated and both derive their power as much from the artist's faith as his creativity. These two factors cannot be separated.

James Beck, one of the preeminent scholars of the Italian Renaissance, illustrates Dixon's point when he states, "A basic feature of the chapel itself, so obvious that it is sometimes ignored, is the papal function, as the pope's chapel..." However, like so many others, he goes on to discuss the ceiling frescoes divorced from their liturgical context.

Before and after its double duty as tourist attraction, the Sistine Chapel functions as the pope's personal chapel. In addition to being the place where each new pope is elected, it is a chapel in which he can celebrate Mass. With ceremonies that stretch into several hours, the Pope and his elite ecclesiastical and secular officials have had ample time to contemplate the complexities of Michelangelo's work.

Perhaps more than any other scholar, John Dixon has contemplated the complexities of this fresco cycle in relation to the liturgy of the Mass and the context of the chapel. His discussion of the liturgical nature of this work deserves to be quoted extensively, not only because it opens Michelangelo's work, but it also has wideranging implications for understanding the spiritual in art.

> The fullness of true liturgy requires full participation in the transforming action; the principle of the true liturgy is the same as the enterprising principle of so much art.... It is in this sense that Michelangelo's work in the Sistine Chapel is participant in the liturgy, an instrument of the liturgy. As the true art work requires a participation of the sensibility

of the spectator in the structure of the work, so these paintings are a means for the total liturgy that is not exhausted in the service at the altar but is in the whole, requiring participation.... Every painting of whatever style is an element in such a transaction and, in ways we are only timidly beginning to understand, great paintings shape the imagination of those who participate in them.

Though he effectively elucidates the liturgical reading of the chapel, Dixin does not adequately connect this structure to the subject it represents. What is the relationship of liturgy to the creativity of the Genesis narrative?

Michelangelo's frescoes on the ceiling of the Sistine Chapel represent the Genesis narrative of Creation, Fall, and Redemption as an epic history of divine action. The program is constructed of nine scenes divided into three groups of three. In

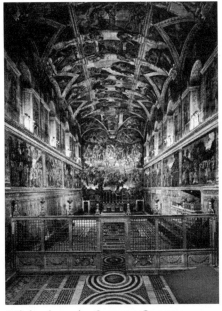

Michaelangelo. SISTENE CHAPEL

order beginning from the altar, these are: *The Separation of Light and Darkness, The Creation of Land and Vegetation and The Creation of the Sun and Moon, The Bringing Forth of Life from the Waters, The Creation of Adam, The Creation of Eve, The Temptation and Expulsion, The Faithfulness of Noah, The Flood,* and *The Drunkenness of Noah.* The nine scenes that run the length of the chapel break down thematically into three triads: God's creation of the world before man, the creation and fall of humanity, and the life of Noah.

The Trinitarian program of the Sistine Chapel ceiling is sustained by spiritual energy from the abounding power of the first moments of creation to the disaster of the Fall and the hope of salvation. The first triad of scenes focuses on the creative character of God as he shapes the universe into being out of nothing. The second three scenes show how man was created for a perfect relationship with God and how that relationship was broken. These scenes represent God as active in the creative process and are also dominated by the most overt representations, literal and symbolic, of Christ presenting himself as the restorer of our relationship to God. The final triad represents the faithfulness, sinfulness, and deliverance of Noah. These works demonstrate how Noah's life and faith were supported by God who is no longer physically present in each scene but is an invisible actor in this final set of scenes, along with the Holy Spirit who sustains the faithful in worship, protects our spirits, and prepares us for facing death and judgment.

Each of the nine scenes is set in a horizontal rectangular frame. These frames act as stage sets for the dramas they contain. They are oriented to be viewed from the west end of the chapel where the altar is located and this should guide our interpretation of them. The frescoes of the Sistine ceiling bring the Genesis narrative into the liturgical function of the chapel to connect heaven and earth. The worshiper enters from the temporal end of the narrative under *The Drunkenness of Noah* (we must approach God naked, in awareness of our shame, and seeking his covering). The altar stands at the eternal end of the chapel from which Creation emanates. As the priest holds up the sacrament to enact the mystery of transubstantiation he sees above him the image of God initiating the mystery of creation. The placement of *The Creation of Light and Darkness* over the altar calls attention to its perfection in Christ's struggle and triumph over evil and death. Christ is the light of the world.

One of the themes of the ceiling is the Genesis creation narrative as grace foretold through the promise of the Messiah

[1] Sandra Bowden. LAW *and* GRACE. Collagraph and gold leaf.
14 x 18 inches each.

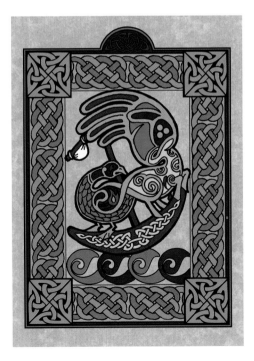

[2] Ned Bustard.
BLESS THE BOAT, 2000.
Ink and digital.
6 x 9 inches.

[3] Edward Knippers. **POTIPHAR'S WIFE,** 1998 Oil on panel. 96 x 144 inches.

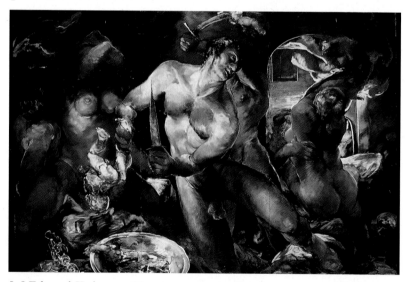

[4] Edward Knippers. **MASSACRE OF THE INNOCENTS,** 1987 Oil on panel. 96 x 144 inches.

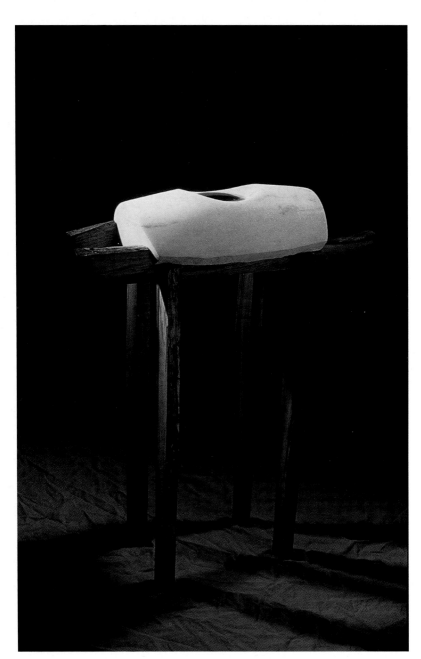

[5] Theodore Prescott. TASTE AND SEE, 1996-97. Colorado marble, hand blown glass, Tupelo Honey. 28 x 11.5 x 34.75 inches.

[6] Camille Pissaro **LANDSCAPE WITH FARM HOUSES**. Oil on canvas.

[7] Harold Finster. **SOUVENIR ANGEL**. Oil on wood.

[8] Makato Fujimura. **GRACE FORETOLD,** 1997. Mineral pigment and gold leaf on paper. 102 x 80 inches.

[9] Makato Fujimura. **MERCY SEAT,** 1999. Mineral pigment and gold leaf on paper. 102 x 80 inches.

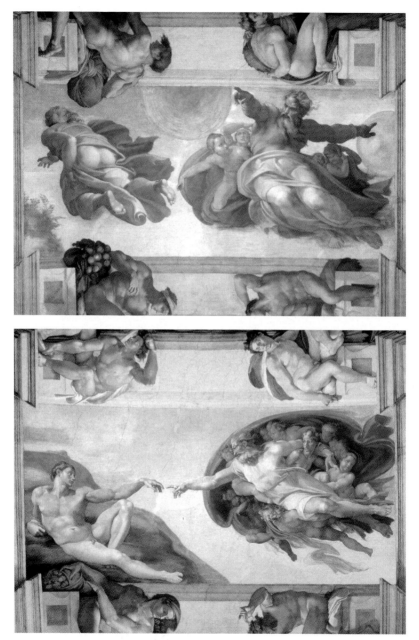

[10] Michaelangelo. **THE CREATION OF LAND AND VEGETATION/THE CREATION OF THE SUN AND MOON** *and* [11] **THE CREATION OF ADAM.** *from the Sistene Chapel,* 1508-12. Fresco. 40.93 meters long by 13.41 meters wide.

[12] Gaylen Stewart.
AGAINST CHANCE, 1996.
Ink, enamel, photos, crab,
velvet, x-ray and light.
12 x 10 inches.

[13] Gaylen Stewart. **ALL THINGS PASS**, 1997. Watercolor, oil, gold leaf,
aluminum, butterflies, photos, velvet, x-ray and light. 24 x 24 inches.

and prefiguring of Christ. This purpose of foreshadowing seems to have been a significant consideration in Michelangelo's selection of scenes—why he chose to represent lesser known scenes such as Noah's sacrifice rather than popular scenes such as Cain's murder of Abel and the Tower of Babel. Michelangelo's selection of scenes, their order, and how he treated his subjects suggests that his concerns were not to show all of the significant scenes from Genesis but to construct a specific structure of divine and human action through the creation, Fall, and redemption.

The Christ of the Sistine Chapel ceiling is the Christ of the cross. Each of the nine central scenes that span the ceiling and mark the liturgical procession of the Mass makes reference to His death and/or resurrection. As the redeeming sacrifice of Christ is celebrated in the Mass, the temporal reality of the acts of man in the present and the eternal reality of the acts of God represented above become one chorus of worship. The Mass completes the frescoes and the frescoes set the eternal and theological context for the Mass. This is the spiritual in art functioning at its highest level.

The Patron

The commission Michelangelo received to paint the ceiling of the Sistine Chapel was part of a larger program to rebuild, expand and strengthen the prestige and authority of the church in Rome. Pope Julius II was a prolific patron with an almost insatiable appetite for art and architecture. Although some historians have blamed Julius II's extravagance for precipitating the Protestant Reformation, his patronage was founded on a recognition, one that is largely absent in the church today, that the visual arts are a form of expression and debate that affect cultural and social change. Julius II wanted to impact his own times and shape his legacy; he did this through war and art, not war against art. Is it any surprise that what many consider the high point of art which reflects the Christian faith was the product of a period of outstanding patronage by the institution of the Church and individuals of faith?

Two years into his pontificate, Julius II called Michelangelo to Rome and commissioned him to construct his tomb. This ambitious project, which includes Michelangelo's sculpture of Moses, would take the majority of the artist's life. The pope soon became distracted with his total renovation of St. Peter's, carried out by Donato Bramante and then Michelangelo. Without the funds to complete what had became a stalled tomb commission, the pope devised another way to keep Michelangelo in Rome. That plan was to have the sculptor become a painter and decorate the ceiling of his private chapel. It had been Julius II's uncle, Pope Sixtus IV, who had commissioned the Sistine Chapel's construction and the frescoes on its walls. Julius II undoubtedly understood that commissioning Michelangelo to paint the ceiling was to complete a work begun by his uncle.

The original commission, according to the artist's own accounts, was for the representation of the twelve apostles. It was Michelangelo, probably with the help of a theological advisor, who conceived of the much grander program from the Creation of the world to life of Noah. While there is little to confirm or rebut Michelangelo's own account of the commission, the artist wrote in a letter that the pope "gave me a new commission to do whatever I wished..." Certainly one of the issues Michelangelo had to incorporate into his designs was Julius II's views of the Church's historical and theological place, as well as that of the papacy as the representative of Christ.

The Artist

Artistically and theologically, Michelangelo was a dominating personality of the High Renaissance and one of the few individuals allowed to deal with the pope as a near equal. Nevertheless, to say that Michelangelo could do as he pleased with this commission overstates his freedom. The very nature of a papal commission would mean that it had to be approved by the pope. That he was given artistic freedom in how he could treat the subject would be more accurate.

According to Robert Clements in *Michelangelo's Theory of Art,* "Michelangelo was one of the most devout men of the Renaissance, lay or cleric." His faith was central to his life and art; for him "religion was not a set of opinions about reality. It was … reality itself." In his biography of Michelangelo, George Bull states, "Religious faith was second nature to Michelangelo in every unguarded utterance...He had absorbed Catholic piety and belief almost through his pores..."

It is reasonable to suppose that Michelangelo intended his frescoes on the ceiling of the Sistine Chapel as a personal meditation on the creative process itself. By exploring God's creative nature and exercising his own creative nature, Michelangelo could have hoped to better understand the relationship between the two. There is perhaps no work of art in which the form is so appropriate to the subject. Michelangelo stretched his own creativity and the limits of his medium to develop an appropriately majestic visual vocabulary. This conveys the awe-inspiring implications of what it means to be an artist creating in the knowledge and faith that one's creativity reflects the image of God's sovereign power described in Genesis. Dixon notes:

> Few works are so immediately, overpoweringly, accessible to us as Michelangelo's … [It] doesn't fit our normal categories, something inaccessible to our normal procedures. Critics offer their solutions to these problems; these solutions are not only different, they are often irreconcilably contradictory. We should acknowledge the implications of this situation. Anomalies, ambiguities, contradictions, paradoxes, are an inherent part of Michelangelo's work and have to be dealt with as what they are. They are outside explanation or resolution.

Undisputed as the greatest artist of his day, Michelangelo was continuously in demand. Although as many as a dozen workers may have assisted Michelangelo in aspects of the project, their exact contributions are unknown. It is generally agreed that, considering the size of the project, Michelangelo did a surprising

amount of the work alone. Although one could, and some have, romanticized Michelangelo in ways that detract rather than add to his work, it remains that even in his own lifetime he was widely known as *Il Divino*, the Divine One.

The Genesis Cycle in Its Chapel Context

Michelangelo's designs for the ceiling chronicling the creation of the world through the life of Noah both complemented and surpassed the two cycles of frescoes on the life of Christ and life of Moses, by a list of artists including Pietro Perugino and Sandro Botticelli, on the north and south walls of the chapel. These two cycles parallel each other as the active presence of God through the Old Testament law and New Testament grace. Over the altar was a representation of *The Assumption of the Virgin* by Perugino emphasizing this chapel's, and Julius II's, particular dedication to her and the triumph of the Church, which her assumption signified.

Although Michelangelo's later commission of *The Last Judgment* would replace the chapel's original altarpiece as well as one scene from each of the cycles, his work on the ceiling theologically complemented, even completed, the works already in existence. The parallelism between the Old Testament law and New Testament sacraments sets the precedence for Michelangelo to represent the Genesis narrative of creation as a mirror of the New Testament and the contemporary liturgy. Both Christ and the apostles continuously referred to the Old Testament, emphasizing that the whole of scripture is meant to be understood as a progressive revelation in which every element contributes.

It is possible to read the three cycles of frescoes in terms of three eras of God's revelation to man: Creation, the Law, and Christ. Michelangelo's works, taken literally without the foreshadowing elements they contain, represent the Creation before the Law. This era began in Creation and ended in the judgment of the flood. The second period of time is that of the Law. It began with the deliverance of God's people from Egypt and ended with the coming of

the promised Messiah. The third age began with the Incarnation of Christ and continues through the Church and the papacy to the present. The frescoes on the wall and ceiling of the Sistine Chapel tie these three stages of revelation to the present time and space of the liturgical function of the chapel.

Before Michelangelo's frescoes, the ceiling itself was decorated with a deep blue sky studded with stars. This design would have been understood in terms of a tradition going back to antiquity of associating the ceiling with the heavens. Michelangelo's imagery of God's creation of the heavens also connects to that tradition.

In subject, style, and splendor, Michelangelo's work was a potent representation of the Church's enduring power and divine institution. The cycle of nine events represents the initial unfolding of history along a divinely ordained plan that unifies all of time and space from its beginning to its end. Each scene has literal and figurative meanings which must be read individually and as part of the whole cycle in its liturgical context.

Michelangelo began to paint the cycle in reverse of the Biblical narrative from the life of Noah to the Creation. Perhaps he knew that his inspiration would grow and the process of painting this narrative would prepare him to deal with the momentous and sublime subject of God's creation of light itself. Moving in the order in which they were painted, three of the first four scenes contain more than one event. The conflation of events which occurred at different times into one image was a common practice in Renaissance painting and served to give the viewer a greater sense of narrative movement. Michelangelo largely abandoned this practice in his painting of the final five scenes, four of which are dominated by single events.

The nine central scenes are framed by a circle of witnesses made up of Old Testament prophets and classical sibyls. As they progress toward the altar, the figures of prophets and sibyls increase in size until they begin to spill out of their niches. Only the precision of Michelangelo's line holds his forms in check. These prophets and sibyls balance each other in a number of ways.

The Old Testament prophets are male while the sibyls are female; this inclusion of so many woman, in such prominent places is typical of Michelangelo's art. Although Renaissance Italy, and the Vatican in particular, was a predominantly patriarchal society, women in Michelangelo's art, despite being created from live male models, were individuals equal to men in personal character and spiritual strength.

The Old Testament prophets and classical sibyls also balance each other as Jewish and pagan seers who anticipated Christ. They make an important link between the nine scenes of Creation and the rest of the chapel. Not only do these figures visually frame the Creation narrative, they act as historical and conceptual links to Christ, thus reinforcing the Christocentric reading of Creation as well as connecting that reading to the rest of the chapel, including the viewer. The prophets and sibyls are not prophesying the events of Creation since these events are already past. What these figures see (and what the viewer is meant to see), is that by reveling in the awe of these events we can see that the connection of God's work through Christ and the Holy Spirit in the Church are natural extensions of his first creative work.

These prophets and sibyls were vessels used by God to prepare the way for creation to be restored. The sibyls were named by St. Augustine as recipients of glimpses of truth which prepared the way for Christ within the Gentile world. That God would work through Jewish and non-Jewish, biblical and non-biblical figures to accomplish this task would have been an important statement in reinforcing Renaissance humanist intentions of uniting Christianity and classical antiquity. The prophets and sibyls are unified by a single light source, not the natural light from the windows along the north and south walls, but rather the spiritual light emanating from the direction of the altar. This light not only unifies the figures but it also suggests how the light of God that now flows out of the Church and the sacraments at the altar baptizes both Jew and gentile, East and West, man and woman—all who live in light of the Gospel.

The most monumental of these prophets and sibyls is the figure of Jonah enthroned directly over the altar. Jonah's three days and nights in the belly of a fish foreshadow the death and resurrection of Christ. He is the only Old Testament prophet who seems aware of the central cycle of the Genesis narrative as he turns in wonder at the sight of God creating the universe.

Michaelangelo. JONAH

At the corners of this gathering of spiritual visionaries are four scenes of salvation and sacrifice. Over the entrance at the east end of the chapel are scenes of *David and Goliath* and *Judith and Holofernes,* in each case the hero or heroine saves the nation of Israel. At the west end of the chapel, over the altar, are scenes of *Moses Raising the Brazen Serpent* and *The Death of Haman.* These two scenes more explicitly connect the theme of sacrifice and salvation to the redemptive sacrifice of Christ which is celebrated at the altar below. The connection between Moses raising up the serpent and Christ was made in the Gospel of John where Christ said, "And just as Moses lifted up the serpent in the desert, so must the Son of Man be lifted up so that everyone who believes in him

Michaelangelo. JUDITH AND HOLOFERNES *and* DAVID AND
GOLIATH

may have eternal life." *The Death of Haman* is a scene taken from the
book of Esther where the Jewish queen saves her people from a plot
by Haman by exposing him to her husband King Ahasuerus of
Persia. Although the connections between this narrative of the
salvation of Israel and the salvation offered by Christ are less direct
than that of Moses raising up the serpent in the desert,
Michelangelo has taken license with the story, by crucifying Haman
rather than hanging him. This visual link between the outstretched
body of Haman and the death of Christ is one of the most powerful
reminders of his redemptive sacrifice in the entire chapel.

The Christocentric theme of the Sistine Chapel continues on
the upper sections of the chapel walls in sixteen lunettes and eight
spandrels that depict the generations listed in the Gospel of
Matthew as the ancestors of Christ. Just as the ceiling represents
the first chapters of the Old Testament, the lunettes represent the
first chapter of the New Testament. The Old Testament prophets
and classical sibyls represented the spiritual or visionary connec-
tion between Creation and Christ; these ancestors represent the
human lineage from Abraham, the first prominent individual
named in Genesis after Noah, to Joseph and Mary. It is noteworthy
that although Matthew names mostly male ancestors of Christ,
Michelangelo has represented mostly couples of husbands and

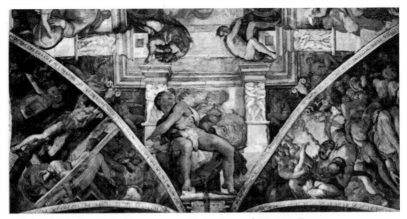

Michaelangelo. THE DEATH OF HAMAN *and* MOSES RAISING THE BRAZEN SERPENT

wives. It is significant that Michelangelo chose Matthew's lineage rather than Luke's lineage which lists only men. Furthermore, just as the prophets and sibyls represented both Jewish and non-Jewish ancestry to Christ, the lineage of Christ in Matthew included both Jewish and non-Jewish figures.

Perhaps because their magnificence is so dominating, Michelangelo's central fresco cycle for the ceiling of the Sistine Chapel has too often been taken out of its context. By intentionally connecting his work to that already in the chapel and creating layer upon layer of complexities through intricate relationships, Michelangelo was able to elevate his own work exponentially and bring nine scenes from the beginning of time into the present of the viewer.

The First Triad

The three scenes closest to the altar show God creating the universe. These scenes are dominated by God's physical gesture. Since his expression is often unreadable, our attention is drawn to movement of his body and the gentle power of his hands.

Michelangelo's representation of Creation begins with *The Separation of Light and Darkness*. As our eye enters the image from the lower right, we move across the powerful figure of God who

stretches across the entire frame as he turns in space. As he holds darkness in one hand and light in the other, they seem to have real substance. Light is the substance of life and art, darkness is the absence of that substance. The face of God is obscured from our view as he looks ahead in space and time directly into the gap he is creating between light and darkness.

Michaelangelo. THE SEPARATION OF LIGHT AND DARKNESS

One of the moods that characterizes the ceiling is struggle; as His fingers disappear into the dark and light clouds in *The Separation of Light and Darkness,* even God seems to turn and strain as he labors against the forces of nature that he created. Certainly, God's creative struggle was not physical in Genesis but it became physical in the incarnation. It was only through a physical struggle in the death and resurrection of Christ that Creation was redeemed. The raised arms of God echo those of the priest as he holds up the host. This connection to the Mass celebrated in the present with the very first moment of Creation impresses on us that God's plan for salvation and the Church was part of God's initial plan of creation. This scene has been symbolically read as

Christ's triumph over sin and darkness and/or the Last Judgment when God will separate the saved from the damned.

The Creation of Land and Vegetation and *The Creation of the Sun and Moon* [see color plate #9] are among the most dramatic scenes of the ceiling. In fact they are two scenes in one frame. As we read the image from left to right, we first see God creating land and vegetation on the third day, and then we see him again in the creation of the sun and the moon on the fourth day.

The immediately more engaging of the two creative moments is the latter, in which God's power is unleashed as he creates physical matter and commands the celestial spheres into their orbits. The other half of the image is dominated by a figure of God creating dry land. Considering the plethora of discussion regarding the program of the Sistine Chapel ceiling, there is a remarkable silence regarding why Michelangelo chose to represent God from the back. One explanation for representing God from behind may be that since God is represented twice in the same image performing actions done at different times, Michelangelo might have desired to show this figure in radically different poses as a way of distinguishing the two scenes for the viewer. The view of God from behind has the effect of emphasizing his action in relation to our space.

The only place in the Bible where God is described as seen from behind is in Moses' encounter with God during which God passed before Moses while he was in the cleft of the rock. Moses saw God in that moment, but only God's back. This connects Michelangelo's work to the cycle of the life of Moses on the chapel wall below, although Moses' encounter with God is not represented. Moreover, the outstretched arms of God in *The Creation of the Sun and Moon* [see color plate #9] foreshadow Christ, whose life is represented in the other cycle below, on the same right/north side of the chapel as *The Creation of the Sun and Moon.* This would further connect the image of God in *The Creation of Land and Vegetation* on the left/south side of the image to the life of Moses on that side of the chapel.

In the third scene *The Bringing Forth of Life from the Waters*, the majestic figure of God soars above a boundless space as he commands life from the deep. The focus of our attention is on the creative energy evident in his imperious hands as they seem to break through the plane that separates his eternal space from our temporal existence. The work of art is the point of contact between heaven and earth.

Michaelangelo. THE BRINGING FORTH OF LIFE FROM THE WATERS

There has been considerable disagreement about this third scene. Beginning as early as the 1550's, Vasari and Condive—the two biographers of Michelangelo who knew him personally—respectively described it as the separation of land and water and God bringing forth life from the water. The absence of both dry land and marine life requires us to look outside the scene itself to identify it. The fact that Michelangelo had shown God creating dry land and vegetation in the second scene undermines the argument that this is also the subject of the third scene.

Furthermore, no convincing argument has been made to explain why Michelangelo would intentionally disrupt the order of creation by representing the separation of water and land (day 2) after the creation of the sun and moon (day 3). The focus of scholars on which day of creation this scene represents is in fact a distraction from the central point of this image. In this third scene the palms of his hands in fact are not turned down towards the water but are open and active towards the liturgical Mass that would pass beneath it. (More than any of the other eight scenes, this one depends on its physical context in which the viewers stand beneath the fresco and look up over their heads at the image of God bearing down on them.) This work could be read in terms of baptism of the Holy Spirit and it creates an immediate intensity, emphasizing God's life-giving energy as still present and moving in the chapel's activities.

Michelangelo's focus in this third frame, as with the two preceding it, was upon the creative energy of God, not the physical creation. The first triad represents the trinitarian character of God's creative imagination. The first scene shows the sovereignty of God's power as he created matter and order out of chaos and nothingness. The second scene shows God's creative touch as he crafts the earth by molding the land into shape and forming the sun and moon. The third scene demonstrates the life giving power of God, which the Nicene Creed attributes to the Holy Spirit, as he calls forth life from the sea.

In the Image of the Creator

Artists are not theologians; they are creators of images and forms. However artists, who wrestle intimately with the creative spirit, can sometimes more plainly reveal aspects of the Genesis creation as a revelation of the divine Creator.

The first triad of scenes on the ceiling of the Sistine Chapel represent three significant moments of creation before man. The creation of non-matter: time and space itself; the creation of physical matter; the creation of living things. In each scene the

figure of God emanates power that creates light and life wherever it radiates. Michelangelo was attracted to the subject of the Genesis narrative because it touched him as a Christian and an artist; it laid out a biblical, trinitarian understanding of creativity that he found necessary for his art-making. An encounter with this divine Creator has to be awe-inspiring as well as terrifying, even for an artistic genius known in his own day as the "divine Michelangelo."

The Genesis account of creativity emphasizes it as an act of personal expression by a previously unknowable, invisible, and infinite being. Too often, the theological debate surrounding how or when God created blurs the simple fact that he did. The emphasis of the Genesis narrative is that God created order out of chaos, light out of darkness, life from the void.

God's separating light and darkness is a particularly significant moment for artists since all of the visual arts depend on the rendering of light. Artists do not create matter; rather they use matter to create meaning. Artists use light and color, which is light broken up, to mold forms in space. The very energy of the image is constructed from the rhythm of alternating light and darkness.

Michelangelo represents Creation in terms of a process of relationships: light and darkness, night and day, heaven and earth, land and water, deliverance and damnation. Likewise, art-making finds significance in relationships. Meaning in works of art proceeds from the internal unity created by the tension and fitting-ness of content and form. Michelangelo was very conscious of this relationship between content and form. Frederick Hart notes,

> Moreover he was able to find in each of the scenes and each of the figures a content so deep and a formal grandeur so compelling that it is generally difficult to think of these subjects in any other way.

Hart is right in pointing to Michelangelo's equal dedication to form and content. Recognizing that meaning emanates from the union of these two, Michelangelo was able to create a truly commanding magnificence, sometimes awe-inspiring and

sometimes terrifying, appropriate to his subject. Hart continues, "Michelangelo rose to heights from which he alone, among all Renaissance artists, saw the Creator face to face."

The Second Triad

The central triad of the Sistine ceiling represents the creation and fall of humanity with an emphasis on relationships. While the first three scenes dealt with the creative character of God, these images represent who we are as created in God's image.

The Creation of Adam is one of the most complex of the entire cycle and is open to some misreadings. As our eye enters the scene from the lower right, we immediately find ourselves standing on solid ground. This allows us to imagine ourselves in the drama. We are meant to identify with the figure of Adam and experience the rest of the drama of this scene from his vantage point.

The figure of Adam has been fully and wonderfully formed but his limp body still stretches across the earth from which it was made. God Himself is about deliver the final touch and give Adam life. This will cause Adam to stand up, distinguished from the

Michaelangelo. THE CREATION OF MAN

material from which he was formed and from the rest of creation. (This gift is the inverse of the curse that God put on the serpent by condemning it to spend the rest of its existence crawling in the dust of the earth.)

In *The Creation of Adam*, Michelangelo prefigures Christ as the second Adam by his incarnation, death and resurrection. The reclining figure of Adam echoes that of Christ in many representations of the Lamentation. As Adam comes to life, the image becomes a foreshadowing of the death and resurrection of Christ as they are celebrated in the Mass. Just as Adam is the first man created, Christ is the first man resurrected in a restored relationship with God. All those who participate in the mass celebrated in the chapel find themselves in between these two creative acts. The Creation of Adam is a picture of the origin and end of man.

One of the complexities we have to contend with in *The Creation of Adam* is the fact that Adam appears to be alive before God has endowed him with the power of life. If Adam already has a living body, what is he about to receive from God? This problem has troubled many scholars who have even faulted Michelangelo for this seeming contradiction. It is more likely that Michelangelo was very conscious, even intentional, about not representing the physical creation of Adam but rather God giving Adam the creative power of life. The creativity we have already seen demonstrated by God in the first triad is now his gift to Adam. Michelangelo's representation of Adam as already alive before God has touched him is actually an ingenious way of solving a more subtle but theologically more important potential problem in this scene. What does it mean to be created in the image of God? A superficial reading of this image would concentrate wholly on Michelangelo's representation of Adam's physical body as the perfect human form. Is it his beauty alone that shows that he is created in the image of God? The figure of Adam represents Michelangelo's obsessive study of the anatomy, his knowledge of his art, his passion for the forms of antiquity and the yearnings of his spirit for God. Michelangelo's representations of the human

figure were so spectacular that we can become distracted by the body in a way that Michelangelo never was. While Michelangelo did use the visual vocabulary of physical beauty to express the dignity of man and his special place in creation, this needs to be understood in the proper context of his approach to physical beauty and spiritual perfection.

Michelangelo's approach to the human body is definitely a study in itself. It remains a difficult question for two reasons. First, Michelangelo's understanding of the human figure was anything but simplistic. It was at the center of his own identity and his relationship to God. A second difficulty we face in understanding Michelangelo's approach to the body is that his world view was radically different from many modern viewers. Our contemporary cultural vocabulary focuses more on the self-indulgence of sexual desire than on restraining the flesh in order to grow spiritually. It is not surprising then that we have often mistaken the spiritual dimension of Michelangelo's devotion to the human form as sexual in nature.

Despite an almost complete absence of solid evidence, popular myth has defined Michelangelo as a homosexual. The problem of Michelangelo's sexuality grows out of a desire to read this into his art. John Dixon notes that Michelangelo himself denied any homosexuality and puts the question to rest quoting Jean Paul Sartre, "If a man say[s] he is, he is. If a man says he isn't, he isn't, he isn't." Creighton Gilbert argues that it was because of Michelangelo's sexual attraction to women that he turned to representing the ideal human form as male. He argues that "The frustrating difficulty of reaching spiritual calm through excitement over beautiful women can be circumvented in one way. This is by loving a man, since sexual excitement there is not involved." He goes on to say that "Michelangelo's fears that people would apply their own standards to him are all too justified. The matter has been the center of sensational gossip..."

Michelangelo's focus on the beauty of the human form was based on a belief that this splendor was the most eloquent manifestation of God's order and glory. It was in the divine creation of human form that he saw the most complete revelation of God's creative character. Since all of life flows from this divine source, its beauty is not only a mirror but also a direct line to God. The artist, consumed by the brilliance of his art as though it were a mirror of heaven's glory, is drawn upwards through it to God. The body's beauty was an echo of the soul's splendor.

The Creation of Adam contains a curious mirroring of likenesses. On the one hand, we see God creating man in his image. At the same time, Michelangelo is representing God in the image of man. It would be wrong to think that Michelangelo believed that God, the Father, had a physical body. He represents God as an old man with a long beard, not unlike Julius II, but he knew that his image was only a symbolic representation of God. Michelangelo represented God in the image of man, because he had no other model. Our creativity as it is exercised in relationships, in faith and in expression is our means of extending ourselves beyond the boundaries of our bodies. Just now as you use your creativity to piece together these letters into words and words into ideas, you are extending yourself. But in every way that you extend yourself, you do so "in your own image." Your thoughts about this essay are formed in your creativity. God created us in his image so that we could be creative ourselves. Otherwise we would have no basis on which to relate to Him. This makes it even more important that Michelangelo does not show God, as a physical being, creating Adam as a physical being. If Adam seems already partly alive before God has touched his finger to Adam's, it is because Michelangelo meant to show God creating man in His own image, but this likeness is of a creative and spiritual resemblance not a physical similitude.

Art is always about making the invisible visible. *The Creation of Adam* has power not only because of what we can see in it but what we can see in light of it. Because he was able to create a sense that

the whole history of human creativity had been an anticipation of this one work of art, this single image, Michelangelo's representation of God's creation of Adam has remained the most vivid and lasting vision of the moment from which all human creativity has resulted. Through his composition and forms, Michelangelo conveys the reciprocatory love and longing between God and Adam through their reaching for each other. The Bible describes God breathing into Adam to give him life; we are ourselves breathless in anticipation of their touch.

Hart notes that the arm of God is naked as nowhere else on this ceiling or in any previous representations of God. It was as if God had removed all encumbering garments, rolled up his sleeves to free his creativity for this, his most magnificent creation. The absence of any garments allows the arm of God to visually match the naked arm of Adam. The fluidity of their forms, allows our eyes to move seamlessly across that small divide, which nevertheless contains within it all of eternity, between the limp hand of Adam and the thrusting gesture of God. We travel that distance to be face to face with the omnipotent Creator.

The sublime figure of God is surrounded by the company of heaven and several attempts have been made to identify these figures. Balancing the figure of Adam at the other end of God's outreached arms is a young child who stares directly at the viewer. He is held in the hand of God between the thumb and index finger just as the priest would hold the Host. This representation of Christ at the creation of Adam emphasizes both his divinity as being before man but also that his Incarnation was an element of God's original intention.

At the center of this company with God is a beautiful woman nestled in his arm. There have been those who have interpreted this figure as Eve. The supporting evidence for this reading is her intent gaze at Adam, as though she were yearning in anticipation of their union. However, this figure has few resemblance's with Michel-angelo's depiction of Eve in *The Creation of Eve*. They have different facial features and their body types are different. God

creates Eve as a fully grown curvaceous woman. The female figure in *The Creation of Adam* is a younger girl whose body is scarcely developed. There are more reasons to suppose, as other scholars have, that this teenage girl is the Virgin Mary. First, although this figure does not resemble other representations of Eve by Michelangelo, she does resemble the Virgin Mary who is represented with very similar facial features in one of the lunettes of the Sistine Chapel where Michelangelo depicted the ancestors of Christ.

Since the Assumption of the Virgin was the central scene of the chapel when Michelangelo began his work, it is more likely that the Virgin Mary would be present at this supreme moment of creative action than Eve. The fact that this figure of the Virgin Mary is between God the father and the Christ child with the Father's arm around her is a visualization and foreshadowing of the virgin birth. Her breasts are oriented towards her son whose arms wrap around her leg. Her gaze at Adam, whose creation is also a

metaphor for the incarnation, is in anticipation of her own role in that miraculous and glorious event. The presence of the Virgin Mary in this scene connects it to the chapel's altarpiece. This serves to reinforce one of the central themes of this fresco cycle, namely the connection of the Church to the initial creative plan of God.

The central scene of the second triad represents *The Creation of Eve.* The landscape that slopes down to the left suggests a proximity to *The Creation of Adam.* The sliver of

Michaelangelo. THE TEMPTATION AND EXPULSION

water that separates land from air in *The Creation of Adam* has become an expansive and tranquil sea. Eve is lifted out of Adam's side at the command of God's gesture. Although he is not physically taller than Adam, his form is given greater monumentality by the fact that he appears to be a column holding up the top to of the frame. Whereas God had reached out to Adam who remained more limp than active, the figure of God is the stable pillar of the composition and Eve is drawn to Him.

Michaelangelo. THE CREATION OF ADAM

Typical of Michelangelo, form and design serve psychological and spiritual purposes. As our eye enters the scene from the right, it passes over the body of Adam, by the visual bridge that his arm forms, and, like Eve, we rise towards a face to face confrontation with a benevolent Creator. Eve responds to her own creation as an act of devotion which we are meant to imitate. Worship is the purpose for which we were created and everything we do, including art making, should be part of that worship.

The reclining figure of Adam leans against a tree, partially cut off by the painted architectural frame, which echoes the form of the cross. This posture echoes the figure of the dead Christ in many representations of the Lamentation. *The Creation of Eve* could relate to the birth of the Church from the side of Christ though His blood. There is also a reference to the Virgin Mary as the second Eve. Eve was seen as a precursor of Mary, who, by her carrying Christ in her womb, prefigured the Church as containing the body of believers. It may have been Michelangelo's intention to set this scene in the center of his cycle as a way of giving it greater

prominence and connecting it to *The Assumption of the Virgin* represented over the altar. God is dressed in a violet mantle that matched the vestments of the priests and the coverings of the altar during Advent and Lent. This connects the priests to the figure of God and the body of God to the altar.

The last of the second triad, which contains two scenes, is *The Temptation and Expulsion.* As we enter the scene from the left, we find ourselves in the Garden of Eden. The lush vegetation extends across the entire upper regions of this half of the scene forming a protective canopy over Adam and Eve. Our eye travels across their powerful bodies as our eye is irresistibly propelled toward the temptation that awaits us.

Michaelangelo. THE TEMPTATION AND EXPULSION

Because there is no break in the form or action, our eye does not stop at the tree. Our vision is expelled from the garden as if we know that we cannot remain there. As an angel of God expels Adam and Eve, their anguish is palpable. One could go as far as to say they have become less physically attractive because of sin. This would certainly conform to Michelangelo's spiritual connection of

the human figure. The space between the body of Adam and the last edges of the garden creates a gaping space which seems as expansive as the space between the fingers of Adam and God had been intimate.

The scene the *Temptation* and *Expulsion* are often represented by artists as separate scenes. Michelangelo brings them together as cause and effect. In representing the *Temptation* alone, it could create the impression that sin has no consequence. Likewise, the *Expulsion from Eden* isolated might created an impression of God as unmerciful. Michelangelo has brought God's justice and his mercy together in this scene. It is not surprising therefore that Michelangelo has united these two scenes by a central device in the form of the Cross. It was on the Cross that justice was poured out on Christ and his mercy made available to us. That Michelangelo compositionally brought together the *Temptation* and *Expulsion* in one image is a statement about his powers as an artist. The way in which he has represented both the fall and redemption of humanity in one image—indeed symbolically representing the redemption through the imagery of the fall—goes beyond artistic talent and speaks of his spiritual inspiration.

The Value of Creation

The relationship between God's creativity and man's is an issue which continues to be debated among Christians of various persuasions. Not only are there differences concerning what it means to be created in His image, but also what the impact of the fall has had on this relationship. Richard Niebuhr's *Christ and Culture* lists five different approaches Christians have taken. Although each of these positions represents a sincere desire to know and follow the Creator, they are radically different approaches to creativity and different assessments of the continuing value of creation. The achievements of Michelangelo give us the opportunity to consider in what ways our human creativity is similar to God's creativity and in what ways it differs.

In *A Theological Approach to Art*, Roger Hazelton asks rhetorically, "Must there not be some continuity, some common denominator of meaning, between what man does in the arts and what God does in creation?" The narrative of creation in Genesis lays out a continuing paradox of contrasts and relationships between the Creator and the created.

As we have already noted, Sayers concludes in *The Mind of the Maker*, "The characteristic common to God and man is apparently that: the desire and the ability to make things." Sayers also quotes Nicholas Berdyaev saying,

> God created man in his own image and likeness, i.e made him a creator too calling him to free spontaneous activity and not to formal obedience to His power. Free creativeness is the creature's answer to the great call of its creator. Man's creative work is the fulfillment of the Creator's secret will.

If we are created in God's image, we reflect his light and glory. God's revelation of himself is in and around us; our creative impulse reveals God's divine mark on his creation. However, not everyone who has examined the Genesis account of creation agrees with Sayers.

In *Rainbows For The Fallen World* Calvin Seerveld argues,

> There are no biblical grounds either for the usual talk about artistic "creation." Comparisons between God as a capital A Creator Artist and man as a small, image-of-God creator artist are only speculative and misleading.

In his desire not to more fully come to terms with the implications of the Fall, something absent from many Modernist interpretation of creativity, Seerveld goes on to say, "Art is no more special (nor less special) than marriage and prayer and strawberries out of season ... art is not, therefore, suddenly mysterious or supernatural." However, many find art to be deeply mysterious and supernatural; no less than love (marriage), communication with

God (prayer) or nature (strawberries). In contrast to Michelangelo's visual display of monumental power and spiritual inspiration, Seerveld's description of creativity has almost lost all sense of having been formed by a divine imagination.

Perhaps Berdyaev's perceptiveness and Seerveld's reservations can establish a balanced perspective of our creativity. When talking of artists being God-like in their creativity, we should recognize the beauty of this analogy, but also its boundaries. Unlike God, human creators are bound by limitations of materials and talent. Genesis describes God creating from His sovereign will and free imagination, out of no obligation and under no confining circumstances. Artists do not create out of nothingness. In this way they are not sovereign as God is. However, by giving form to their materials, they are creating meaning. As the artist brings forth life from his art his creativity reflects the image of his Creator. The notion that humans create in the image of a divine Creator is one of the principal contributions of Christian theology to the Western understanding of art behind works like the Sistine Chapel ceiling.

The biblical account of creation is an ennobling view of mankind, placing us above the rest of creation, as beings uniquely created in God's own image. The Genesis understanding of the creative artist sets him between genius and craftsman. Perhaps better than both of those descriptions of the artist, is that of gardener. The vocation of the artist is an extension of God's mandate to Adam to cultivate the earth. The gardener neither destroys the ground he works nor leaves it as it is. Like the artist, he cultivates his material in order to bring forth its hidden potential. After the Fall, God did not revoke this mandate but he added that in this condition of sin Adam would eat by the sweat of his brow. The artist's creative struggle is an effect of the Fall. Any success in this process, however limited, is an echo of the nature of the artist in the image of God and a ray of hope that one day the full potential for which each individual was created will be fulfilled in Christ. His works of art are not in stone or paint but in the lives of

every believer. Vincent van Gogh, who was a preacher and evangelist before becoming an artist, wrote of Christ,

> He lived serenely, as a greater artist than all other artists, despising marble and clay as well as color, working with living flesh. That is to say, this peerless artist,...made neither statues nor pictures nor books; He loudly proclaimed that He made...living men, immortals. This is profound, especially because it is the truth.

And as an artist friend of mine is fond of saying "we are the project." A true artist, Christ loves his materials, those lives he changes. The human artist must know how to master his materials but this mastery is the result of knowing and loving that material. The painter must know what the character of paint, as a material element, can and cannot do. The artists works with intention, the idea, but he also has to work through the nature and will of the materials. If the artist works against his materials the result will be failure. The artists chooses his materials with their characters in mind, knowing how he will gracefully work this material to his intention.

There are times during the process of giving the idea form through the material elements of the work when the work takes its own direction. The artists who knows his materials will recognize this and patiently work what some would consider mistakes back into the art. We should remember that Michelangelo took a block of marble which had been badly damaged by several artists who had unsuccessfully worked on it and which had then been abandoned to the weather to create a figure of David which remains a standard of beauty.

Michelangelo found confidence and comfort in the fact that his creativity was derived from God. He does not show God forming Adam's body out of the dirt, rather he represents God endowing Adam with the spirit that is his creativity. Adam receives this spirit with an expression of adoration. God creates man,

before the Fall, not as a toiler but as a creative being. To exercise this creativity is to imitate and glorify our Creator.

Michaelangelo. THE FLOOD

The Third Triad

The final triad of scenes represents the life and deliverance of Noah through faith, protection and redemption. God is no longer physically present in these scenes but his Spirit is still active. In *The Sacrifice of Noah,* the aged patriarch stands at the apex of a powerful triangular composition made up of his wife, his three sons and their wives and some livestock. At the lower right, a sacrifice has been made and part of it is being passed towards the altar where a fire is being lit to make a burnt offering.

The Sacrifice of Noah has been described as a break in the narrative by several scholars who assume it had to take place after the Flood. There are two reasons to question this conclusion. First, why would Michelangelo hesitate in painting the beauty of the rainbow that God sent as a sign to Noah after the Flood. Its absence

has to raise some doubt about the scene taking place after the Flood. Second, there is no indication in the Scriptures that Noah sacrificed to God only once in his life. Therefore, if Michelangelo depicts Noah sacrificing to God before the Flood, then we can believe that this served a particular purpose in the function and meaning of the work. As he officiates this act of worship, Noah's upward gesture indicates the direction our eyes should take and connects this image to the one that follows it, *The Flood*. Noah's faith points to the reason for his deliverance. *The Flood* is a precursor to the Last Judgment—Michelangelo is showing the worshiper how to avoid damnation.

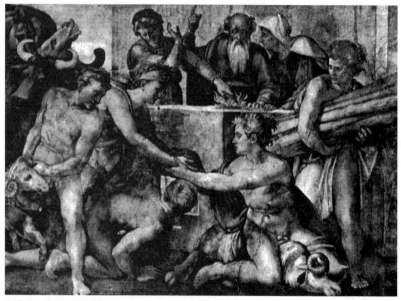

Michaelangelo. THE SACRIFICE OF NOAH

The eighth in order of the Genesis narrative, but the first of the nine scenes to be painted, *The Flood* is the most visually complex of the nine scenes with multiple points of action. While the other eight scenes are self-contained within the painted architecture of the ceiling, the action of *The Flood* is cut off by the frame as though it continued off stage. The turbulent landscape of falling and

broken-off trees and billowing winds embodies the emotion of the scene. Like *The Creation of Adam, The Creation of Eve* and *The Temptation and Expulsion,* the viewer enters the scene on a landscape that slopes from left to right. The tranquil waters of *The Creation of Adam* and *The Creation of Eve* have risen up against us as we find ourselves as refugees on what seems to be one of the last plots of dry land. The disorientation we feel as our eye wanders across the drama without finding a particular figure with whom we can definitively connect creates a similar experience to that of those who did not board the ark which floats away in the distance. The human drama intensifies as the waters rise and survivors begin to crowd onto hill tops and makeshift rafts carrying with them whatever belongings and loved ones they can salvage. Near the center, a father strains to carry his full grown son while others swim towards a boat only to be clubbed back into the water by its occupants; humanity with all of its compassion and violence is on display. As we know the frightful end that none of those outside the ark will survive, the scene is a reminder of the futility of depending on our own resources for salvation.

We should remember that, as Michelangelo painted the ceiling of the Sistine Chapel, he would have had no way of anticipating the future commission of *The Last Judgment.* He may have felt a need to use scenes from the life of Noah as a way of concluding not only his own cycle but all of human history. These three scenes intentionally play the double role of literally representing the life, salvation and death of Noah and symbolically representing the life, salvation and death of humanity.

Although we enter the scene as one of the damned, salvation remains within our view, symbolically represented in four ways, if we know how to read them. The most obvious of these symbols of salvation in *The Flood* is the ark itself. Along the central axis of this scene, Noah leans out of a window of the ark in a gesture towards God in heaven. The shape of the ark echoes that of the Sistine Chapel and could be read as symbolic of the Church. At the apex of this triangular composition, in one of the upper windows of the

ark, is a dove, which stands out even more prominently because it is the lightest form in the composition. This dove points to the hope of deliverance that awaits Noah and his family. However, it also can be read as a reference, at least as a foreshadowing presence, to the Holy Spirit, which is the hope of deliverance that awaits the faithful worshipers in the chapel. This connection between the Holy Spirit to the form of the dove of course derives its origin from the baptism of Christ. The inverse role of water, as symbolically life-giving in baptism and life-taking in the Flood would probably not have escaped Michelangelo's attention.

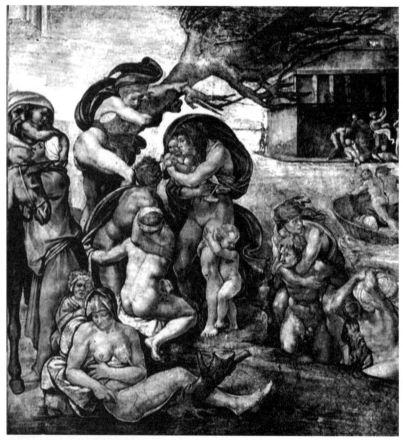

Michaelangelo. THE FLOOD

The third representation of salvation is a figure, scarcely participating in this drama, who may prefigure Christ. Having said that there is no one in *The Flood* with whom we can identify, this in fact is not entirely the case. There is one figure—only one individual in this crowded scene—who looks out at the viewer. This single point of connection is very easy, intentionally easy, to overlook. As we enter the scene from the left, we immediately encounter a family who are preparing to leave by donkey, something that might iconographically connect them to the Holy Family in the flight into Egypt. There is a remarkable degree of calm in the faces of this family who seem as though they are framed by the architecture into a scene of their own (indeed they are cropped out of the main scene in many reproductions). The child looks directly at us with a knowing expression. Given the Christocentricity of the entire ceiling, it would not be surprising to find a figure, even in *The Flood*, who foreshadows Him. The fact we are meant to relate with this child as the only figure in the entire scene with whom we can connect eye to eye further supports the idea that this child is a foreshadowing of Christ who is our salvation.

The final aspect of *The Flood* that needs to be recognized concerns two trees clinging to their respective rocks in order not to be blown away. Hart connects these to the Tree of Life and Tree of Knowledge. While this is a possibility, the fact that both these trees were in the Garden of Eden from which Adam and Eve had been banished makes it seem unlikely that they would reappear at this time. Throughout the frescoes of the ceiling there are several connections between trees and the Cross. It would be consistent if this were the case here as well. The presence of two trees may call their meaning into question. That is unless we recognize that the ark was also constructed of wood and stands in as the third tree and the third cross. The two trees that remain on dry ground frame the central ark which stands for the cross of Christ. This arrangement further connects the ark and the cross as means of salvation. In a final brilliant maneuver, Michelangelo's composition causes the tree on our left to seem, by the compression of space in perspec-

tive, to be reaching out for the ark. This may be a reminder of the final redemption of the condemned man on Christ's right who received this salvation when all hope of it seemed to be lost.

All three members of the Trinity are present in *The Flood.* The Father is the invisible subject of Noah's gaze, Christ's incarnation and death are both prefigured, and the Holy Spirit presides at the apex of the picture's composition. Through the presence of God in the Trinity and the hope of the ark (which Michelangelo connects to the institution of the Church), the artist turned the terror of the Flood (and the Last Judgment it foreshadows) back to hope by reminding us that it is never too late—at least while there are still a few patches of dry land—to call out to Christ and be saved.

Our helplessness to save ourselves is once again emphasized in *The Drunkenness of Noah;* we see a nude figure of the patriarch reclining on a mat, slightly elevated off the ground. His three sons stand over him in a hut which is barely taller than they are as they are about to cover him with a cloak. In the background, we see Noah planting the vineyard which would ultimately lead to his drunkenness. This digging is a representation of his toiling under the curse of the Fall and his eventual death when his own grave would be dug and his body would return to the earth. Here is an instance where there can be a definite connection between Michelangelo's work and the work of another artist previously done in the chapel. This scene which alludes to Noah's death is at the far east end of the chapel. On the east wall of the chapel, directly over the doors through which the liturgical procession would enter the chapel are the scenes of *The Archangel Defending the Body of Moses from the Devil* and *The Resurrection and Ascension of Christ.* These works point to the life after death that could be Noah's.

Noah is a mirror of Adam since he becomes, in effect, the second father of humanity. *The Drunkenness of Noah* shows not only his sin and shame but also foreshadows the fact that this sin will be covered over. The figure of Noah echoes that of Adam except that Adam's gesturing finger pointed toward God from

which his life came and Noah's gesture is down toward the earth to which he will return. However this is not where the Bible or Michelangelo's frescoes end. The means for that redemption begins with the prophets, sibyls, and ancestors of Christ with whom he surrounds the central narrative. What is significant to our discussion of the Noah trilogy is that Michelangelo shows how the judgment of God, through the Flood and Last Judgment, and the mercy of God, through saving Noah and Christ's sacrifice, are direct extensions of his primary creative act.

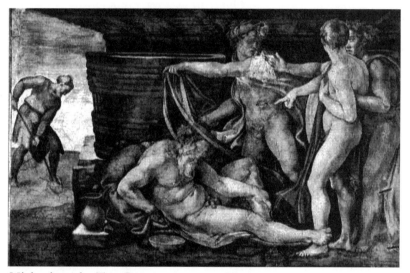

Michaelangelo. THE DRUNKENNESS OF NOAH

There may be some question as to why Michelangelo would end his cycle on such an anti-climactic point as representing Noah, and by extension humanity, in disgrace. First, as we have noted, the chronology of Michelangelo's cycle of frescos was faithful to the scriptures. Noah's drunkenness is the last episode in the life of the patriarch. Furthermore, this scene is meant to be the beginning of the cycle, not its end. Not only is this scene in that part of the chapel where Michelangelo began working on the project but it was also the first scene under which the liturgical procession would pass.

What we see in this image is Noah's shame being covered over. His sins are covered over just as the sins of humanity can be covered over by the death and resurrection of Christ which is being celebrated in the Mass.

As the pope's chapel in which he performed the Mass, *The Sacrifice of Noah* can be read as a foreshadowing of Christ's sacrifice celebrated in the Mass. Faithful to the Catholic doctrine which sees the Eucharist as central to our spiritual life, Michelangelo uses Noah as a precursor of the priestly sacrifice in the Mass and *The Drunkenness of Noah* could be read as a warning against abuse of the Mass. The same wine which, properly sanctified, is the cup of salvation can also be the means of sin. The wine is the same; the sin or sacredness of it depends on our use of it. The same could be said about the gift of creativity that God endowed us with.

Noah's planting of the vineyard was a fulfillment of God's command to cultivate the earth. The artist who cultivates his materials into forms that create meaning can look to this command as a creative mandate affirming his vocation. However, Noah overstepped the parameters of God's design. He allowed the fruit of his labors to take control of him and this led to his shame. Artists also have boundaries which they cross at their own peril.

The Gift of Creativity

Michelangelo's work on the ceiling of the Sistine Chapel traces the Genesis narrative of Creation, Fall, and Redemption as ongoing. This structure reflects an understanding of God's creativity as ongoing rather than finished (until the Last Judgment). The artist sought out very imaginative ways to connect his work to the liturgical function of the chapel. However, as I have already noted, the extension of Michelangelo's creative vision has radiated beyond his original ecclesiastical audience. Day after day, crowds of people pack into the Sistine Chapel to see Michelangelo's art. For many of them, this may be their closest encounter with God. The Holy Spirit is still alive and active in that space through the work of one man who used his gifts to honor the Giver.

God continues to work through his own imprint on our creativity. Every time an artist creates, whether or not he is conscious of it as Michelangelo was, he acts in the image of the Creator. This is an opportunity for the Creator himself to continue his own creative and redemptive work in that person. We arrive at a knowledge of God only through his revelations of himself interpreted by the Holy Spirit. The gift of creativity, understood as created, redeemed and sustained by the Trinity, is a gift to humanity that we may know him more intimately. It has been said that art-making is a form of worship. The inverse is equally true. The possibility of our having a relationship with God is our greatest creative potential. The fulfillment of this potential is the greatest work of art and the end of the desire which first caused God to create each of us.

Although not everyone would acknowledge the trinitarian source of our creativity, there is a recognition that this creativity is an important aspect of who we are as human beings. Created in the image of God, our own creativity is a ringing echo of his image within us. The Christian faith, so powerfully represented on the ceiling of the Sistine Chapel, names the source of this mystery of creativity which empowers every artist who creates in a way that reflects the fact that he or she is being lovingly created in the image of the Creator.

^A*SENSE*
OF PERMANENCE

Light and Photography

As a photographer I have been working with light for 25 years. Photography is about light, and its complement, darkness. I love light rushing into and juxtaposing itself with darkness. I love shadows contrasting with illumination. I love the contrast and drama of light wrestling with dark, invading the dark and challenging it. I love the ever-changing patterns of shadows opposing their twin structures of light. I love the power of light, its presence. When light meets dark, it has enormous energy. It rushes in, it fills the darkness, it takes over.

John Szarkowski wrote in the exhibition brochure for *Photography Until Now,* a show held in 1990 at the Museum of Modern Art:

> Toward the beginning of the 19th century it occurred to an undetermined number of curious minds that it might be possible to fix the enchanting, fugitive image on the ground glass of the camera not by drawing it, but by causing the energy of the light itself to make a print on a sensitive ground.

The negative film contains light sensitive silver halides that, when exposed to light, produce an invisible, latent image. The film must be inside the camera, in total darkness, before it is exposed to light. The light exposure, controlled by the lens opening (the F stop) and the shutter speed, is paramount in determining the quality of the photographic image.

The exposed negative film must be handled in total darkness until it is developed; then the silver halides turn into black metallic silver. In the darkroom, the light of the enlarger projects the negative onto the photographic paper, and the lens of the enlarger enlarges the image. With chemical processing during developing, the silver halides in the photographic paper turn again into metallic silver particles.

The darkroom is a place of mystery, solitude, and meditation. When I was a little girl, I helped my father, an amateur photographer, to print in his darkroom. I remember the darkness, the dim safe light, the smells of chemicals, being close to my father.

Now as a photographer myself, I find the process of working with light and darkness extraordinary. The spiritual aspect of photography—making the invisible visible—is close to miraculous. As Deborah Sokolove, Director of the Dadian Gallery in Washington, D.C., has written:

> ... the task of the artist is to make the invisible visible, to capture glimpses of a certain kind of truth ... to look with the eye of the soul ... to preserve the fleeting passage of something real in the shadows cast by an inner light

Sacred Light

I find working with light as a photographer to be the most incredible partnership with God. After all, God invented light. He said, "Let there be light; and there was light. And God saw that the light was good" (Genesis 1:3-4). Before God created light there had been "a formless void and darkness." Light is synonymous with life. In the Gospel of John, Jesus says, "I am the light of the world.

Whoever follows me will never walk in darkness but will have the light of life" (John 8:12).

The light-darkness theme can be placed in three major categories. First, Jesus Christ is the Light of the World, and the light-darkness contrast comes to signify the mutually hostile worlds of good and evil. Second, just as the sun lights us on our way, so anything that shows us our way to God can be thought of as light. And third, light is symbolic of life, contentment, and joy, as darkness is of death, unhappiness, and misery.

In the Gospel of John the word "light" is used to refer to a spiritual phenomenon. In his book *Mystical Christianity: A Psychological Commentary on the Gospel of John* John Sanford observes that the Evangelist uses light and darkness "metaphorically to signify the light of truth and spiritual illumination on the one hand, and the principle of moral and spiritual darkness on the other."

And Jey Kanagaraj writes in *"Mysticism" in the Gospel of John*:

[T]he light is perceptible to the mind ... and to the eye of the understanding. [It becomes] the source of enlightened consciousness [and transforms] the darkness of unbelief and sin to a life that will exhibit divine characteristics and deeds.

Even more important, the light that Jesus brings shows things as they are. It strips away the disguises and concealments. It shows things in all their nakedness. It shows them in their true character and their true values. That is why it is difficult to be in the light of Jesus. That light reveals our faults, our sins. When the light of Christ exposes who we really are, we may not like what we see. It may be pretty threatening. John speaks of the experience of sinners upon seeing their lives in the light of Jesus Christ (John 3:19-21):

Light has come into the world, but men loved darkness instead of light because their deeds were evil. Everyone who does evil hates the light, and will not come to the light for fear that his deeds will be exposed. But whoever lives by the truth comes into the light, so that it may be seen plainly that what he has done has been done through God.

Spiritual light is stronger than spiritual darkness, just as the smallest ray of light has the power to pierce the deepest darkness, and the darkness is unable to extinguish it.

What has come into being in him was life, and the life was the light of all people. The light shines in the darkness, and the darkness did not overcome it (John 1:4-5).

Spiritual light and darkness should not be confused with natural light and darkness. John Sanford writes in his commentary on the Gospel of John:

The distinction between light and darkness as natural phenomena on the one hand and light and darkness as spiritual principles on the other hand needs to be kept clearly in mind. There is nothing wrong with the darkness of night. . . . But as spiritual principles the light and the darkness struggle against each other, and constitute a pair of moral opposites that requires us to choose between them. As spiritual principles we cannot follow both the light and the darkness, for the darkness seeks to overcome the light.

When I follow Jesus Christ I cannot follow the darkness at the same time. Jesus Christ is our spiritual light which points to a truth inaccessible to sight and touch but apprehensible by the eyes of faith. Christ points to our Father, who can bring us from the darkness into light, from death to life, from anxiety to peace, from fear to love, from pain into joy, from our helpless poverty into the limitless kindness of God, to God's undeserved grace, God's sheer loveliness, God's awesome beauty. Jesus opened a window for us so

we can see God. As Rudolf Bultmann puts it in *The Gospel of John,*
Jesus points to God

> just as all the waters of the earth point to the one living
> water, and as all bread on earth points to the one bread of
> life, and as all daylight points to the light of the world.

The Light of the World

Several years ago, when I was working as a photographer for the
New York City Police Department, I was on the night shift at
Brooklyn Criminal Court making mugshots. The photo studio was
located in the sub-basement. I was next to a large cell containing
about one hundred arrested people in different stages of darkness
and misery. I was in emotional darkness myself at the time. Both
the place and my condition were extremely ugly.

Between photo sessions I was looking at an old magazine I found
in a desk drawer. As I turned idly through the pages I suddenly
found myself looking at a reproduction of Holman Hunt's famous
painting, "Light of the World." The painting depicts Jesus knocking
at a door at night. Jesus is alone. Strange, tangled trees loom against
the sky. Jesus holds a lantern that casts elongated luminous patterns
on his robe. A brilliant halo contrasts with his crown of thorns. In
the God-forsaken sub-basement of Brooklyn Criminal Court,
Christ, the Light of the World, visited me.

Hunt's "Light of the World" is not aesthetically sophisticated.
Calvin Seerveld claims in *Rainbows for the Fallen World* that Hunt
needs "a painterly lesson." But that painting brought light
and contentment to my heart then and there, something I will
never forget.

Light and the Face of God

My first in-depth explorations with the camera led to my series,
Masks. I had always been fascinated by human faces and even more
by photographs of human faces. There was a mystery behind the
face that I could not explain. At the time, I saw the face as a mask

Krystyna Sanderson. [l to r] INDIAN PRINCESS #3, SALLY #8
—*from MASKS*, 1981. Silver-Gelatin photographs. 11 x 14 inches.

that concealed rather than revealed the inner person. While I was working on a series of large portraits with moderate success, I realized I wanted to include only the face and exclude hair, ears and neck. I wanted to stress the essentials of the face: eyes, nose and mouth. I designed a board, cut a hole in it just big enough to frame a person's face, and covered it with black fabric. The Texas light— very bright, hot and piercing—was an excellent vehicle for portraying the drama of the human face. To further heighten the topography of the face, I underexposed one F stop and then overdeveloped the film. I was using Kodak PlusX Pan film ASA 125 at ASA 250. The result was that the skin of the little girl was almost transparent and glowing ("Melonie"), the skin of the elderly black woman shone like a black diamond ("Sally #8"), and the furrows of the Indian woman's face showed magnificently against the pitch black background ("Indian Princess #3").

I photographed all the faces straight on from the front and at the same level as the camera lens. When I printed the photographs, I enclosed the image of the face within a rectangle or square which

I placed on a white or, occasionally, a black background. The visual order and clarity of this arrangement served to counterbalance the emotional aspect of the photographs. A.D. Coleman described the portraits as using "light and silver in a highly sculptural fashion, emphasizing the plastic, dimensional characteristics of each ... subject." The faces of people of all ages, sexes and races—in some cases because of lack of hair it became impossible to tell their gender—became archetypal and iconic, exemplifying Paul's words in Galatians that "there is no longer male or female, for all are one in Christ Jesus."

The series consisted of twelve persons and each series consisted of between four and ten poses. The images in each series were sometimes similar to each other, with only minute changes. The viewer had to make a mental comparison and contrast among them. The individual images also produced motion as if the photographs were individual frames in a motion picture film. A.D. Coleman continues in his foreword to *Masks:*

> Think of it as a soundless dream, a vision—or what you would see in your mind's eye as you come out of the ether. This peculiar succession of faces—all ages, races, and sexes—alternately receding and advancing, expressions constantly changing (but sometimes recurring) ... they seem to be on the verge of telling us something, seem in fact to have messages to deliver. Their lips shape words we will never hear, their frowns and smiles inflect inaudible sentences.
>
> On this level the book becomes an act of the imagination, with an almost cinematic structure: it has rhythms and tempos, pacing and movement. Scale and juxtaposition are employed adroitly, yet never obtrusively; even if we stop to admire the craft involved in their making, these images always return us to their subjects, the faces, the masks. That they seem by and large benign—or, at least, not overtly threatening—is small consolation. Their muteness is what creates our compelling urge to add a soundtrack, to project

personal histories upon them, to put words in their mouths. What we want to know—and what [Sanderson] makes clear we will never, in any case, know—is: Who is behind all this?

At that time I did not know who was behind the faces. I did not know who was behind each human being. All I knew was that I felt alone and starved for a human connection and that I was drawn to the beauty and mystery of the people I photographed. The camera became a carte blanche for that connection.

Before photographing *Masks* I talked with each subject, usually for several hours. I asked about them, about their lives. My deep interest in "who they were" fascinated the people. They saw me as an exotic visitor from another world who saw beauty in them and their lives. They reached out to me and talked. I opened up and talked too. The distance between us dissolved, and we connected.

While we talked the presence of the camera built an excitement and tension between us. We did not know exactly what would happen—an element of the unknown was always there. When I made the photographs I found myself under such emotional tension that my hands were trembling and I could not keep the camera steady. At the time I was so excited that part of me became part of my people. I would exclaim, "Oh yes, yes, you are great, hold it, hold it." The moments were so enchanting and hypnotic that they became for me timeless. I never knew how long it took—it could have been moments or maybe hours.

When I worked on *Masks* I was not a Christian. I had started to understand what it was to be an artist, and I began to taste the power of creating beauty. I was high on my creations. I knew I had created something bigger than myself. I thought that what I needed was the right recognition and glory. I envisioned riches and fame. After all, I was the creator. At the same time I felt enormous upheaval as far as my spiritual identity was concerned.

Three years after photographing *Masks* I experienced a conversion. I saw the faces I had photographed as revealing the

image of God in which all people are made. Ted Prescott wrote earlier in this book of our being bearers of the imprint of God when he wrote that we are "created by God, bear His image, and are known by Him." I found a tremendous sense of peace when I realized I was God's creature. Adam Gaymou, in *Images of God,* describes the human face as

> a mirror in which God appears, a mirror of the soul that bears the imprint of the invisible God. Perhaps there is no better way to have a vision of God than by looking in the eyes of our fellow human beings. In the gleam of joy, the wince of pain, the gaze of desire, there dwells the image of the imageless God.

Each face has a message to deliver—behind each face hides the Creator. Jesus Christ had a face very much like yours and mine. God used the physical light reflected from the faces of my photographed subjects through the lens and F stop of my camera to expose the film and to bring his sacred light to expose my narcissistic, proud, and isolated soul, to illuminate me with his love so I can love him and others.

> "You shall love the Lord with all your heart, and with all your soul, and with all your mind." This is the greatest command- ment. And a second is like it: "You shall love your neighbor as yourself" (Matthew 22: 37-39).

It is paramount for me to know that I am an artist and a Christian. They are inseparable for me. It helps me to put my life in perspective when I see that my art, what I create, is not for my own glory but indeed for the glory of God. Of course that is never so cut and dried. The temptation is always there. When I am disconnected from God I become my own creator and my art becomes my own creation. Then I must struggle to regain the truth that sets me free.

Places of Light

My series entitled *Places of Light* is all about light pouring through open doors and windows to illuminate dark places. My soul makes a parallel between my own darkness and Him who rescues me from my darkness. There are different kinds of spiritual darkness— the darkness of fear, the darkness of poverty, the darkness of self-hate, the darkness of hating another, the darkness of addiction, the darkness of self-centeredness, the darkness of loneliness. To be in darkness is to be without hope, to be desperate, to give up. But there is nothing more joyous than light when one is in darkness. Light means hope. Light means freedom. Light means life. How much more hope, joy and life there is if it comes in the person of our Lord Jesus Christ who is our hope, our joy, and our life.

There were places in my experience that evoked a certain feeling of peace, where I felt at home, where I felt joy for no other reason except being there, being with God. One of these places was the Cloisters in New York City. The Cloisters is a complex of medieval monasteries standing on a hill 250 feet above the Hudson River. It is a contemplative and meditative place not far from the bustle of the city. One sunny, crisp October morning I went there to encounter the Holy Spirit. I found myself in the Cuxa Cloister, reconstructed there from the Benedictine Monastery of Saint-Michel-de-Cuxa, founded shortly before 878 in the northeast Pyrenees. I could almost hear the plainchant of medieval monks. The light pouring through the arcade of columns casting repetitive shadows, forming a soundless rhythm, caused my camera to be more like a string of rosary beads, and my photography a meditation. The two worlds— the physical world of a real camera, my beloved Nikon FM2, with real film in it (Kodak TMY 400) and the world of the Spirit melted together into one. In my photograph "Light #1" the visitation of the Spirit in the guise of light was as real to me as the physical world of arcades and columns made out of stones.

The photograph of the deep and narrow window "Light #11" came from another Cloisters location—the Pontaut Chapter House from the abbey in Notre-Dame-de-Pontaut in Gascony, south of

Bordeaux, built in the twelfth century. The Chapter House, where Benedictine monks met daily to discuss the business of the monastery, was built in Romanesque style and was distinguished by fortresslike walls and enclosed dark interiors. The deep and narrow windows were designed to create a maximum concentration of light. The photograph shows the light rushing into the pitch darkness, exposing the rough texture of the stones. In the photograph the power of light "burns" into the stone the same way the power of the light of Christ burns into the darkness of humankind.

Another image from the Cloisters is the view of the Fuentidue, a Chapel from the Church of San Martin, about 75 miles north of Madrid, built in the mid-twelfth century with no aisles or transept. In "Light #12" the extremely narrow window of the majestic apse allows a beam of light to penetrate the massive walls and illuminate the Romanesque crucifix.

"Light #4" from *Places of Light* is the open door of the north aisle of Grace Church at Tenth Street and Broadway in New York City. The massive, tall wooden door with metal reinforcements is slightly ajar, with light gently trickling into the dark French gothic church. The door is a powerful symbol in Christian faith. Jesus describes himself as a door: "I am the door; by me if any man shall enter in, he shall be saved." (John 10:2) In another place the door signifies the opening to our heart: "Listen, I am standing at the door, knocking; if you hear my voice and open the door, I will come in to you and eat with you, and you with me." (Revelation 3:20)

Another sacred place that was photographed in the *Places of Light* series was the Friends Meeting House on Rutherford Place, New York City, a Federal style building with strong neoclassical elements. In "Light #2 [see cover]," light pours through the panes of the large windows, making rectangular spots on the floor and benches of the empty house of prayer, where the whole space has been saturated with prayer as light overcame the darkness.

Among the secular "places of light" that I photographed was the window of my beloved friend's apartment in Greenwich

Village, New York City. His home has been an oasis of love and tranquility for me for many years. "Light #7" shows the roofs and steeples of the West Village with the Hudson River and New Jersey beyond. In the foreground, on the windowsill, stands a lamp. It is an odd place for a lamp, right where the maximum light is coming into the apartment from outside. This circumstance accentuates the spiritual significance of the lamp. "Your word is a lamp to my feet, and light to my path" (Psalm 119).

Krystyna Sanderson. PLACES OF LIGHT #7, 1995. Silver-gelatin photograph. 11 x 14 inches.

Solitude: Light and Stillness

The inspiration for my latest photographic series, *Solitude: Light and Stillness,* came to me through the image of a painting "Interior" by the turn of the century Danish painter Victor Hammershoi. It depicts a solitary woman sitting with her back to the viewer in a sparsely furnished room, undeniably European, with door upon door receding into the background and a luminous window beyond.

This image has had an extraordinary effect on my life. One time when I was a young girl, my mother left me alone at home. For some reason she was delayed coming home, and I sat on the windowsill, my face pressed against the windowpane, in total terror and loneliness. I feared the darkness outside, and also the darkness inside, including my internal pain of emptiness and aloneness. The waiting seemed interminable. Something died in me. In the last seventeen years since I came to Christ, he has been healing me in many ways, gently bringing his light to my life with contentment, peace and beauty.

In the series *Solitude: Light and Stillness* I place a solitary female figure in an almost empty interior near a window. Poul Vad comments on the dynamic function of the window in his book on Danish art made around 1900:

> . . . the window [is] a connection between inside and outside, between the interior space's reassuring order and intimacy and the free, scenic space's boundlessness and light—with sensations of infinity.

My subjects range in age from ten to ninety. The light is either soft and reflective, gently illuminating the interior and bathing the figure, or strong and direct, flooding into the room through the window and producing a powerful chiaroscuro. The light casts shadows and produces the shapes of the windowpanes both on the faces of the subjects and on the floor and furniture. The light illumines the face and causes it to glow, and that contrasts with the dark clothes and interior. In one case a lace curtain leaves a patterned spot on a girl's neck. Light coming through the window into these interiors is like a gentle yet powerful visitor. It is like the visitation of the Holy Spirit to our spiritual interiors.

Light has immaterial presence, but at the same time it has the unique character of the moment. Poul Vad writes:

Krystyna Sanderson. SOLITUDE: LIGHT AND STILLNESS #14, 1998. Silver-gelatin photograph. 8 x 10 inches.

The light in the sense of a particular lighting is bound to the moment: a point in a stream of time whose continuity is never interrupted. The intense experience of the moment is the entrance into the marvelous: every moment the world is new, every moment is a unique locus in a never-ending coming into being. The camera gives these fleeting moments a sense of permanence. The action gets suspended in time.

The eight women whom I asked to photograph, all of whose lives are closely linked with mine, are usually sitting in a chair, some reading, occasionally standing. Most of the time they look away from the camera, looking out the window as if remotely aware of the presence of a viewer peering into their private worlds. Sometimes they look up from the book and stare out at the viewer. They are motionless. There is a spirit of stillness and tranquility. There is a tremendous tension and energy in just being.

As a photographer, but also strongly identifying with the photographed subjects, I see not only light streaming through the window into the dark interiors, but also light streaming into my heart and soul, for the first time being able to experience the contentment of being me, the stillness and peace that can only come from God, and the joy of beholding God's beauty. My soul soaks up the gentle and soft light that illuminates the everyday activities of being in solitude with God, being content doing simple everyday activities like sitting, reading, being . . . the profound miracle, mystery and beauty of human existence.

Light, Aesthetics and Faith

The beauty of light as it contrasts with darkness is one of the components of aesthetics in black and white photography. The major aesthetic consideration is actually in the making of an image itself. Adam Scharf, explaining the significance of the title of Cartier-Bresson's book *The Decisive Moment,* describes

Krystyna Sanderson. SOLITUDE: LIGHT AND STILLNESS #8, 1998.
Silver-Gelatin Photograph. 8 x 10 inches.

. . . the elusive instant, when, with brilliant clarity, the appearance of the subject reveals in its essence the significance of the event of which it is a part, the most telling organization of forms.

It is an optimal moment, when the photographed subject, the composition, the angle, what is included and excluded, the light conditions—all of these come into alignment with the inner eye of my heart and soul. A photograph made under these conditions it is the purest and truest expression of my artist's vision.

Finally, there is a region that serves, for some people, as a kind of interface between the aesthetic world and the world of faith, and that is the experience of the emotions. Our very human feelings can be a bridge between natural things—paper, chemicals, sunlight itself—and spiritual things—that opening of the inner eye to perceive the true Light of the World. A friend wrote to me that on first seeing my photograph "Light #1" from the series *Places of Light*, she wept. For her, this spontaneous response to a mere image on paper was a sure sign that the Holy Spirit was speaking to her through the language of photography. I know that my art is only a dim reflection of God's goodness and beauty. Yet as a Christian artist, I see myself in some small way in a priestly role. My faith and my art point to God, who is the ultimate Artist.

L no TIME KE N OW

"You Must Change Your Life"
 —Rilke
"We'll take the trail marked on your Father's map"
 —Sixpence None the Richer

I returned recently from an arts conference in the People's Republic of China, with many of the questions the students asked still ringing in my ears. We had sat together in the lecture hall, looking at the slides of Gaylen Stewarts' paintings, and talking about the gallery installation they were part of. The questions ranged from issues having to do with "modern art" to concerns with our fragile natural environment. All these concerns with culture and nature, for me, link in some way to our root questions and concerns with the idea of "Truth."

Accordingly, I want to talk about truth in art making and art observing in a number of different ways.

The following remarks break into three broad sections. The first focuses pretty much on my responses to other people's art.

Section Two deals a little more generally with some of the history and philosophy behind some trends in modern art, and also talks about "interpretation" as a central key to understanding our place in the modern world. The final section tries to take the insights of the first two and weave them together in a description of 1) my response to more art and 2) my own creative process from seedling idea through to performance. If you can read these remarks as a kind of collage of reminiscences, experiences, concerns and questions, then you'll not only experience something of my working method, but you'll also get a glimpse of some of "the truth" I am trying to describe.

Just after I became a Christian in 1967, a friend took me into London to see a film called "The Gospel According to Matthew." I knew very little about the director, Pierre Pasolini, or his other films. I knew even less about Italian cinema, "Neo Realist" or otherwise. The film, shot in black and white, had an almost rough documentary feel to it. There were shining angels and miracles to be sure, but also you could almost feel the parched soil and taste the dusty air. The skin stretched across the peasants' faces looked parched, and weather beaten too, almost like maps to a place that few of us ever visit. The exception would be the almost childlike Virgin Mary. It was nothing like any greeting card or even "high art" painting I had ever seen. And the music! Folk music, country blues mixed in with classical, the combination as rough-edged and rich on the ear as the images on the eye. The film, as I remember it, offered a multidimensional marriage of form, content, material, medium, and message in which the realities and limitations of the chosen media were somehow harnessed and harmonized with the underlying "truth" of the story.

When I came to the USA for the first time in the mid 70s, I spent a few days in New York soaking up as much of the richness and vibrancy as I could. This involved not only hanging out in Greenwich Village, but also frequenting the Museum of Modern Art. It was here that I saw the fabled *Guernica* by Picasso. In order to view this famous painting—with its distorted forms and muted

colors—I had to make my way through an entire room of prepara-
tory sketches by the artist. I could see how the painter tried
variations on theme and form and painstakingly hammered out
the logic of the composition. One might say that some exposure to
Picasso's experimentation, plus a passing acquaintance with the
genesis of this (commissioned) composition played a role in my
overall response to the finished painting. But there is more to it
than that, isn't there?

How can we best describe or analyze what happens when we
experience art? And how does this experience—however we define
it—link back to "truth?" Aesthetic theorist Arnold Berleant talks
about an "aesthetic field" (Berleant 1970, 1991). Berleant adopts the
"field metaphor" to locate and articulate the components that go
into making up the experience of art. Berleant's model is one in
which object, viewer, viewing environment, and historical
background all weave together to create a single experience. The
aesthetic experience (or what we designate as such in our culture)
occurs in the overlap of those four categorical fields. The Polish
psychological theorist Czikszentmihalyi, most known for his work
describing the phenomena of "Flow," writes of "the Art of Seeing"
(Csikszentmihalyi and Robinson 1990), and maps some of the
historical and educational factors that play into the process of our
reception of art. This is less about "demystifying" art, and more
about helping us to grasp the different dimensions of our aesthetic
field. He goes on to suggest ways in which museums can best
curate and display art in a way sensitive to the many dimensions of
how we see. Obviously art is more than the object in front of us. It
is also more than just a subjective experience. How are we
supposed to build a bridge between Art and Truth in today's world?
Does "truth" reside in the object, the individual experience, or the
artist's intention? Or somewhere else entirely? Surely not the
object. Everything from the invention of photography to the
unfolding of the world wide web has contributed to the ongoing
erosion of the cult status of the art object. Walter Benjamin
theorized about how the technological developments in image

reproduction and duplication would strip the "unique art object" of its power and aura. For Benjamin and the theorists who followed him, the power base shifted from the aura around the object (and the guardians who controlled access to the object) to the technology of reproduction (and therefore whoever controlled reproduction and distribution) or more succinctly "from ritual to politics." Objects, art objects, are important, to be sure. The evident power of Picasso's *Guernica* is unavoidable. But surely there is more to the truth of art than the object and its aura. For example, I wasn't watching the only print of Pasolini's film. It still spoke to me as an individual. It still spoke truth. And the truth it spoke was linked to another kind of power than that of the governing interests behind the reproduction and distribution of images.

Some would suggest, given the recognition of different overlapping factors that help us define the shifting boundaries of an "aesthetic field," that it is not so much the "object" that has a singular aura, as the experience—and we know that many elements play into how we experience what we experience. I am suggesting, with our complex theories of "the aesthetic field" and "the art of seeing" in hand, that it is possible to talk and think about art and truth in ways that are not entirely dependent upon privileged objects. Nor do I believe that we have to link the artwork to some mystical realm or conversely reduce its truth quotient to technologically driven power plays. However, I believe that it is possible to link this experience to some sort of conviction about the nature of truth in the mind and the hands of the art maker and the faithful expectation of the public. If the critics are right, however, and the factors involved in appreciation are local, historically and culturally relative, what happens to our understanding of any "truth" that art may intend or convey? Is what is "true" for you, "true" for me, also? These questions have deep and somewhat tangled roots, as the variety of learned treatises on Modernism, modernity and postmodernity are only too eager to point out.

Ship of Fools?

At this point we have to push off into some deep waters. Please bear with me. Some thinkers, responding to the subjectivist and skeptical intellectual trends of their day, proposed an almost transcendental realm of artistic experience, in which the value of the aesthetic experience was pure, self-sustaining and not reducible to any explanation that might claim to reveal its underlying social or moral agendas and interests. At first this realm was argued for by Idealists who wished to talk about the Beautiful and the Sublime as universal categories of human experience. Such categories had to be protected against the skepticism and the overbearing rationalism of the day. This same category, according to one thinker, was refined and reinterpreted by succeeding philosophical and social schools of thought, until it became the potentially subversive "aesthetic dimension"—a refuge from the world of alienated consumption, commodities and kitsch (Bernstein 1987). These ideas, in all stages of their development, conceivably, touched on elements of "truth" that we need to consider in relation to the arts. They all made vital contributions to what is called Modernism in the arts. Modernism in the arts can be looked at as a combination of several strands— both conservative and *avant garde*—that argued (variously) for the purity of the art object, the sanctity and prophetic dimension of the artistic vocation, the authenticity of raw artistic expression, and the ongoing questioning and challenging of previously established cultural categories in the name of "new art" or even "anti-art." This Modernism drew upon artistic theory and cultural practice to wage war upon the linear-minded and technologically driven modernity (Calinescu 1987). Modernity, as understood by these cultural theorists, was dominating, alienating, dehumanizing and soul-deadening. It linked technology with rationalism, expansion and consumption, and in doing so crushed human and culturally diverse resources in the wake of "progress." For the Modernist artist, it was a conflict that was almost a Holy War. However, it was not really a fair fight. According to some, art itself, as a

self-conscious, self-defining activity, was the ungrateful offspring of the era of modernity. Art came into its own as a specialized discipline, seeking progress and refinement in the parental shadows of technology and science, and looking inwards for its true self, in the shadow of the philosophical developments of the era. (I am paint on a surface, therefore I am.) So Modernist Art, somewhat of a stepchild of modernity, was seriously compromised as it went to war with that very same modernity. This plus other critical observations led some theorists to insist that the fight was lost by Cultural Modernism almost before it began. I have mentioned Walter Benjamin's prophetic insights into how the technologies of reproduction and distribution subtly (and not so?) influence the artist and the art-making process. Art critic and theorist Suzi Gablik asks, "Has Modernism failed?" (Gablik 1985), and suggests that cultural Modernism was, in fact, neutralized and (re)absorbed by this modernity. She goes on, in company with other postmodern theorists, to dissect many of the social and historical dimensions of the emphasis on "art for its own sake," laying bare both the exclusionary and prejudicial roots of such an idea, while at the same time pointing out the ineffectiveness of such an idea to challenge and change the market-driven gallery system and institutional world of art. In essence, the era and aura of modernity gave birth to the possibility of the idea of Art, and the latter day, more market-driven aspects of modernity simply defanged, neutralized and absorbed Modernism back into the system it was complaining about without so much as a whimper, much less a kick and a scream.

Not a Pretty Picture?

As well as the myriad secondary truths that might arise inciden-
tally from such all these excursions, there is also, in my opinion,
one observable truth available to us. From ancient idealist philoso-
pher to contemporary postmodern skeptic, the unquestioned
"true" response to our problematic world has been to seek
transcendental escape, either in the realm of eternal forms or the
ether of deconstructive theory. However, whether we are
premodern, modern or postmodern, we are bound to this world by
(among other things) language, history and culture, the very
means by which we identify our distinction from the world and the
very means by which we articulate our desire to escape. Therefore,
for us to even think or talk about "truth" we have to continually
deal with the issues of culture, language, and our interpretation of
these things. And this is one of the benefits of postmodern skepti-
cism. We recognize that we are somewhere in the picture, and we
are bound up in how we know what we know. We have replaced the
modernist arrogance of "analysis" with its detached god-like
observer and neutral tools of investigation, with the humbler
stance of interpretation. We are somewhere in the picture, and how
we get our information has some influence on what information
we get. A term for interpretation that is used in a wide variety of
disciplines is *hermeneutics.* We are most familiar with the term as it
relates to biblical studies, but the term is a central one in a wide
variety of disciplines, ranging from cultural anthropology to
Renaissance art history. For thinkers in a wide variety of
disciplines, "truth" is completely bound up with hermeneutic
practice, which in turn is grounded in history and context, both of
the interpreted work and also the cultural background of the
interpreter. Truth occurs, according to some, in the overlap of
these horizons.

Lost Horizon?

Many might ask again if there is any possible hope of bridging the gap between this seemingly relativistic, context-bound understanding of "truth" and the "absolute truths" of the Christian faith. Some of us might hope that at this point a seasoned Christian apologist would skewer the vulnerabilities and the self-contradictions of the postmodern position. Surely here, a Christian artist could offer something substantial as an alternative to the fashionable ephemeralities of the contemporary art scene. William Dyrness in a recent article in *Radix* magazine entitled "What Good is Truth? Postmodern apologetics in a World Community," acknowledges the prevailing atmosphere of suspicion about all authoritative claims to truth and suggests that the time has come for a shift in evangelistic strategy away from an apologetic base grounded in propositions (about "truth")and more towards an appeal to character—namely the fidelity and truthfulness of God, and the consistency and faithfulness of the community called by his name. Dyrness is not capitulating to a pragmatic/functionalist "whatever-works-for-you'" model of the truth. He merely suggests that the postmodern climate might be more receptive to ideas about truth grounded in character and observable practice. If it is true that the Church "exists for mission as fire exists for burning," as one recent missions theorist put it, then we might want to consider what Dyrness is suggesting about truth, character, and our mission field. After all, when you think about it, the Gospel of John says more or less the same thing.

The primary experience of hermeneutics for many of us, is—as I said—in reading and thinking about biblical texts and stories. If we go about it responsibly, we try to keep two things in mind. On one hand we will do our best to be sensitized to the nuances of language, context, structure, and genre in the text in front of us. On the other we will be drawn to and involved with the character revealed by the text. The "truth" will emerge from an overlap of *these* horizons: our humility *in front* of the text, and our acquaintance with the Character *behind* it.

When we study the text we try to approach interpretation in an affirmative way, and use our reading and analytic skills to clarify and restore to full view what the author intended to say. We also revise and deepen our ideas about "truth" in the light of what we learn about the character of Jesus. We also employ a critical attitude, not so much to deconstruct the text, as some might, in the shadow of some prevailing literary or political theory, but to critically evaluate the other ideas about "truth" that the author of the text brings into contrast with the truthfulness of Jesus. As we learn to critically read our way into and through the Gospel material, we discover a world in which different ideas about truth prevail. And hopefully, this new world of "truth" affects what we do in our art as we engage the everyday real world.

This Sad Music

Which brings us back to where I began with Pasolini's "Gospel according to Saint Matthew." This film, advertised as "made by a Marxist for the pope" seemed to grasp that there had to be a weave of medium, genre, method, message, context and character. Fine enough. But by any stretch of the imagination Pasolini is to be considered an "outsider." Why is it that an outsider can furnish us with a deeper understanding of what can only be described as "the grit of the gospel" than much Christian art is able to. I believe it was the Victorian art critic John Ruskin who lamented that Raphael's pictorial treatment of Jesus' restoration and commissioning of Peter (John 21) at once obscured the story and also misled as to its intent, all through the artist's compositional subtleties and ethereal color schemes. Rough fishermen took on the appearance and dress of serene philosophers. The disciples did not crowd around their beloved master, but tellingly deferred to a leading disciple, upon whom—some believed—Jesus had said he would build his church. Ruskin lamented that a day would come when the story itself would seem as remote and as fabricated to the ordinary reader as this pictorial depiction. Ruskin's fears have been somewhat realized. The ordinary reader has indeed drifted

away from a biblical text that has been attacked, dismantled and deconstructed by wave after wave of "expert opinion." And a good deal of what is marketed as Christian art offers an "alternative unreality" with more of 19th century German painter Heinrich Hoffman's sugar-coated pieties than Raphael's technical mastery. In order to suggest some possible ways of responding to this situation, let's talk about a very different painting on a biblical theme, and use it to gather together some of these threads. And by way of summary and conclusion I'll set forth some of my own working ideas and methods. In the Russian museum in Saint Petersburg in 1992, I stood in front of Nikolas Ge's painting of the Last Supper. Here was a canvas in which conventional pieties and philosophic subterfuge were all but banished by the dramatic way in which the artist had handled the range of darkness and light and the palpable thickness of the paint. The downcast Christ and the astonished disciples are thrown into high relief by the single lamp in the room. The Judas figure steps towards us, at once shrouded in absolute darkness. His advancing figure completely obscures the light source in the room, leaving us only with its radiant echoes across the simple furnishings and the upturned faces. The story remains familiar, however, the dramatic moment is immeasurably deepened by the formal design and the tonal nuances employed by the painter. If I were to approach this painting as a "text" to be discussed in our exploration of 'truth' in Christian art, I would not only take refuge in the depths of despair and confusion caught in the faces of the gathered disciples, and their Master. I would also want to explore the way in which the central figure all but obscures the light source in the picture, while setting out to put in motion the ecclesiastical and political machinery that would seek to extinguish the True Light. I would also use this dutiful, expedient and pragmatic aspect of Judas in order to caution us all about the dangers of confusing portrayal and betrayal. Jesus' words to Judas, "Whatsoever you do, do it quickly," were never intended as a general mandate for Christian artists and communicators. It seems almost a cliché to insist that

for "Christian Artists" (a forgivable use of the phrase in this context), the limitations, idiosyncrasies and even flaws in our chosen medium—be it words, clay, paint, canvas, film, or sound—become essential ingredients in our vocabulary of "expressed truth." Our attempts to sidestep or ignore these limitations in our quest for "higher truth" often obscure the very light we are so confident we are shining before men. We again betray even as we portray. It was Ruskin who suggested that Raphael's serene and somewhat muted depiction of a biblical story did a profound disservice to the story itself. Ruskin mused prophetically about the day when the text itself would seem as remote and as fictitious to the general reader, as Raphael's canvas did to Ruskin's indignant eye. It was Pasolini who showed me that the limitations of the medium of black and white film, and the contours and boundaries of a particular cinematic genre, only served to enhance and "make present" the truth and the reality of the story he was trying to tell. Every generation has its artists and writers who discover these necessary truths in a fresh way. But they are nothing new. They have a long, and some might say, hallowed history. Matthew himself may well have intentionally decanted the Gospel into a literary/biographical form amenable to the educated Roman reader. Nonetheless, what I did was try to respond to the truth I felt radiating from the painting, by writing a poem based on my experience of it. The challenge was not only to honestly explore my feelings and responses, but also to probe the limitations and the boundaries of the language, both in terms of the sound and also the images the words conjured up. I filled page after page with notes just to get something approximate down so that I would have something to work with. The very process of journaling, of finding my way through emotions and language, is as much about the "truth" as the finished poem. I tried to match the language and the imagery of the poem to the palpable intensity I felt radiating from the painting. At the same time I tried to sketch one or two of the issues I felt the painting brought to the surface. I sifted through the word sounds and the imagery to find elements that carried the

same dark tonal qualities of the painting—themselves emblematic of the "inner darkness" of the subject matter. I hope it becomes obvious that, for me, "truth" is very present in the act of responding and the act of composing, from the earliest drafts to the final poem. I am learning about "truth" even as I am revising, editing, deleting, abandoning and restarting.

I then recorded a version of the poem for my spoken word album *We Dreamed That We Were Strangers* (Glow 1996). I further tried to enhance the poem by recording a musical background of repeating and colliding patterns of cellos and choirs. Again, the sampled instruments and the slowly repeating musical phrases were used as part of my search for the "truth" of the painting's inner radiance (or darkness) and also an attempt to anchor the underlying truth of the poem. And of course I believe there is "truth" in the process of searching for the right sound—even enhancing it with the right kind of echo! In each case I attempted to use the limitations and boundaries of the given medium be it language, metaphor, or recording studio technology, to somehow make present aspects of my encounter with this particular painting, and the story the painting told. As we have been suggesting all along, from inspiration to construction to appreciation, the "aesthetic field" is a location that occupies many dimensions. An idea invariably comes from several places at once, and of course it begins to mutate once you engage with the materials through which you wish to express. All these factors bear upon the truth of the work. I began to think of this poem in terms of the other poems and their background music.

I began to compose the album as a whole, in terms of track and overall title. For example, the poem in question was inspired by a painting in a museum in Russia, but the title was taken from a poem by Indian poet, Tagore. The image on the album sleeve was lifted from a snapshot of some Sri Lankan refugee children taken some years before, and many of the pieces on the album did, in fact, concern children, childhood, and vulnerability. However, the title poem has little to say about overcoming cultural differences

or teaching the whole world to sing. It uses a 19th century Russian painting of the Last Supper as a springboard into a meditation on our potential complicity with Judas Iscariot.

Many fragmentary references and ideas are collaged together behind the scenes of this particular piece of work. But there is more to consider. *We Dreamed That We were Strangers* was not merely written for the page or sounded out for the recording studio. It was also intended for performance in front of an audience. I've found that idiosyncrasies of live performance play into how certain aspects of the work are realized. It surely belabors the obvious point to say that paintings exist to be seen, and music to be heard—but while I would never insist that an audience virtually constructs a new work each time it responds to an existing one, I would want to allow that the context of reception be every bit as complex and multifaceted as the process of inspiration and the messy business of actual art-making. Does an audience in a smoke filled-bar in Amsterdam hear and experience something different than an audience in a large Californian church that has obligingly projected a slide of the Russian painting during my performance of the poem? And where does "truth" come into this? I believe that it is linked, in some ways, to the idea of faith.

I believe it takes faith to think twice about an idea or image or musical fragment or a memory, and to believe that it has significance. I believe it takes faith to pick up a paintbrush, chisel, or to sit down at a piano or a computer keyboard and entrust this fragile fragment of inspiration to the process of necessarily messy translation. And it takes faith to exhibit, perform, and display. But what are we putting our faith in? Is it the purity of our inspiration, and/or the goodness of our intentions? Are we putting our faith in our technical skills and tricks of the trade? Or are we trusting that our audiences will "get" everything we intended to communicate? Or can we learn to trust a process in which different ideas, media, audiences, interpretations, and questions all open the way to a kind of "truth" that is at once resolutely objective, but also profoundly personal? This is the process that I am trying to learn to trust.

When I sit down in front of a blank journal page, or in a studio in front of a keyboard, I believe that there is something "truthful" in my initial explorations of words and sounds, even the ones that get erased or crossed out. For me, there is plenty of truth that comes through the dead ends and the false starts. Given all that I have said about how the limitations and the contours of a chosen medium are part and parcel of how that medium communicates, you should know that I have plenty to unlearn in terms of quick fixes and easy answers. I believe that we are disciplined by our chosen medium, and if we believe that we are in some way called to do— both in terms of artist's craft *and* spiritual formation—we are disciplined, shaped and transformed by the ultimately Truthful One. I sometimes feel like I am weighing words like stones in my hands, turning them over and over to see whether they will drag a poem down or make the lines sing. Or I am holding up a phrase like a piece of broken glass to see whether it clouds the sunlight or bends it in a new way. Similarly, I listen to the musical phrases I put behind some of the poems, or I look hard at the words scattered on the white expanse of the page. Is the white space electric? Does it swarm around the words and lift them up? Or does it support and bolster the lines that allows them to truly *say* what they have to say? Does the music cloud the voice or carry it? Should the musical phrase be quieter, wetter with echo and reverb? In what way can we enhance these elements so that they serve 'truth'? There are some musical elements I have used that are so quiet that they are almost subliminal, barely heard—more truly sensed, or half-remembered. And as I recall those poems, and reread my remarks and observations in this essay (as rambling and collage- like as it is), the questions come back to me. Have I learned my own lessons? Have I been truthful even in the things I have written here?

I have tried to bear witness to my own responses to art, in the context of a few things I have learned about art history and theory. I have tried to bear witness to aspects of my own working process, all the time seeking to anchor truth in both the learning process of

"finding out" and also in the truthful character of the One who called me to 'find out' in the first place. But of course, there is always so much more to learn.

Epilogue: The Sound of Waves

When I was in England in 1998 for the C. S. Lewis conference I had the opportunity to show slides and read poems from my mixed-media collaboration with artist Gaylen Stewart, called "Crossing the Boundaries" [see cover]. This work explored (among other things) the nature and the process of artistic collaboration, through a vocabulary of words, sounds and images drawn from the world of nature. I remember on one occasion showing some of the slides to a small group of artists and thinkers, and trying to put into words the things I felt about the relationships between the natural systems that inspired us, our various methods of collaboration, and the very environmental "feel" of the resulting installation. I am not sure if my descriptions, and my attempts to link them to the idea of the Trinity, made as much sense as the performance of one of the poems in a 15th century church later that week. Here, because of the inadequate blackout, Gaylen's slides lost their jewel-like luminosity and took on the appearance of faded tapestry. It was the stained glass windows and the elaborate church fittings that almost sang with the light. Gaylen's images took on a new appearance and a new resonance in this context. The pre-recorded sound loops of birdsong and synthesizer acquired added depth and timbre in this hallowed space, and I believe that the reading of the poem "The Resurrection of the Body" benefited also. Now I cannot say that when I was out with my children making recordings of birdsong one chill November dawn that I ever envisaged hearing these recordings in such a setting. I had scarcely begun work on drawing together the seeds and fragmentary roots of the ideas that would go into the poems. When I first saw the show installed in a gallery in Ohio, I never imagined that I would see Gaylen's images gain an aura of almost austere sanctity in a

four-hundred-year-old church building. While I cannot objectively judge the performance of that day, I do believe that the interpenetration (without confusion) of all the elements—the seeds of inspiration, contours and limitations of the chosen media, the risks and rewards of collaboration, and the "givens" of that location and audience—all came together and made something quite specific. In the gallery installations the various relationships to natural systems were implicitly woven throughout all the art. But now in this environment, the work, for me, at least, bore traces of what some of the Church fathers spoke of when they described the dynamic and mutually affirming relationships between the members of the Triune Godhead. At least, this is what was true for me. I cannot speak for you.

Searching BENEATH *the* SURFACE

Searching For Symbols

I remember from my childhood a magazine entitled *Highlights for Children.* I recall one issue in particular that contained a drawing of a landscape, which included a tree filled with hidden images. I was engrossed in searching for the embedded pictures. The investigative process employed to locate all the hidden items challenged my sense of discovery and developed in me an interest in the interpretive process.

As a graduate student, I studied Italian and Northern Renaissance art history. Renaissance artists would fill their paintings with symbolic images. I identified with the layering of images to convey meaning. The artists utilized a visual vocabulary of symbols from which to speak to their audience. This idea helped form the pattern for my own visual creativity.

It is interesting to look at how people approach a work of art. Presuppositions are an important aspect of one's interpretation of what one is seeing. One's worldview or personal philosophy coupled with personal experiences determines one's reading of an

art work. Sometimes, the content or information of a painting is complex and difficult to understand. People react to a complex message in different ways. A few viewers engage in a visual dialogue with the art and gain personal benefits from the interaction. Some come to the work determined to understand the work and try to exhaust its possibilities. This may lead to "pigeon-holing" an artist. Others feel overwhelmed by the subtlety of the message in the artwork and give up in their quest to connect with it. Some may be intimidated by the unfamiliar visual language of the art and feel that understanding the work is not within their grasp and reject the art outright as too difficult or too simplistic and not worth their time or effort to investigate. However, each person does react in some way.

Art is similar to other disciplines in that artists have their own language—a visual vocabulary. Like a spoken vocabulary, this language is developed diachronically and synchronically. If one is to understand the artist's work, beyond a subconscious response, one must learn the language in its context. Some people may view art and artists as elitist and feel isolated from them. However, not often are other disciplines (science, medicine, finance, politics, etc.) criticized as elitist for similar circumstances (i.e., speaking a "foreign" language or that their work is difficult to decipher). Today, many artists make an effort to communicate with their audience and desire to help educate the public in order to bridge the "language" barrier. In addition to the artist's effort, it is also important for the general public to educate themselves in the language they are trying to understand or communicate. This communication takes place through symbolic imagery.

What Is a Symbol?

The idea that the mere repetition of an object creates an effective symbol is perhaps too simplistic. At some level there needs to exist a shared understanding between the artist and the viewer of the relationship of the image and its intended content or message. A symbol may not come about easily and risks the

potential of being overused and falling into the realm of cliché. This invalidating comes about via uninspired, mechanical repetition or excessive simplicity. Where fine art is being created with the intent of conveying a more complex content as opposed to a work of superficial significance, the artist can sometimes slip into a mode of patronizing didacticism. Sometimes an artist who desires to make a significant statement about concepts that they are impassioned about find that their thoughts have been reduced to heavy-handed, illustrative representation. The visual culmination appears too obvious, overly self-conscious and overworked. In actuality, the artist may be too "close" to the content and not see this obvious obsessiveness.

Often this happens when an artist is technically gifted. If artists rely solely on their technique at the expense of the idea, the resulting work may come across as being shallow or trite. There are some artists who successfully make art that combines elements of technically superior representation and illustration. A successful artwork may contain an illustrative aspect, but there is a point where that illustrative quality may become excessive and undermine the overall accomplishment of the work. There needs to be balance. If an artist is technically strong and this becomes a pitfall, he may need to develop a working method that disrupts the process and forces new creativity—bypassing his "safe" routine. For example, some may utilize techniques that are outside their comfort zone in regard to art-making in order to create problems or "accidents" that must be resolved in an unfamiliar way so as to produce a new image or symbol.

An example that may clarify the difference between the successful and unsuccessful use of a symbol is found in the dove as representing peace. In one context the dove could be used effectively by an organization such as the United Nations or by any group whose main theme is an advocacy of peace. As a logo or a symbol, the dove communicates quickly and efficiently the idea of peace because of its tradition—its shared historical and contextual meaning. But the dove incorporated into a work of fine art takes

on a new significance, possibly, one less desirable. One of the interesting aspects of fine art is that it isn't easily interpreted. Many artists wouldn't use the dove image to refer to peace in their painting because they would see it as overly obvious. The idea of peace could be more interestingly conveyed through the result of a trial and error process which could produce a more complex relationship between the images and the painting's content. The most obvious solution to a problem isn't always the most interesting. In this line of thinking, much could be said in favor of the struggle to stretch oneself to new dimensions of creativity, rather than doing what comes most easily.

Christian Art Symbols and Efficacy of Symbols

In dissecting symbols, we can look at the validity of symbols used historically throughout Christianity or secular society and see if they are still vital. Do they continue to communicate and fulfill their original intent? In our current society there are limitations in the ability of the average person to understand the concepts of Christianity. Someone who is well-read in the Bible may understand references for numeric symbols like 3, 7, 12, or 40 or sacramental symbols such as water, wine or bread. Anything more subtle, requiring a substantial knowledge of Scripture, will possibly be misunderstood. Additionally, attempts to communicate using biblical symbols can be difficult due to misinterpretations of the referential imagery, especially for non-Christians. For example, art based on a Christian worldview might utilize the triangle as a symbol of the Trinity. But among non-Christians, this symbol might not convey any meaning or be misinterpreted as something totally different than that of the original idea. In this context, the triangle as a symbol can be confusing or useless.

Symbols often have a tradition connected with them. There are also presuppositions/associations tied to certain symbols. The challenge is to balance the possibility of their overuse, which depletes them of meaning, with the stability that comes from their longevity, and to be aware of contextual associations. Historical

symbols can be good communicators, but their value and/or efficacy depends upon the context in which they are used. For example, a laced string of thorns is a somewhat common and recognizable symbol and could be viewed as trite if used without some forethought. At the same time thorns can be a powerful symbol depending on their contextual relationship and how they are visually combined with other objects. The same is true with other symbols of Christianity like hammers, spikes, lilies, a rose, and butterflies. All of these symbols have a historical and Scriptural source but their impact is dependent on interrelationships between them and other images.

The impact of symbols may affect a viewer at a subconscious level. A painting may be powerful even though a viewer may not understand the meaning of the symbols or the content. The strength or success of a painting is not based solely on the efficient use of symbols. Paintings without symbols may be equally as powerful in their impact on the viewer as those that include symbols. Symbols add another dimension to the visual language which communicates some idea, experience or emotion to the viewer. They are like monads strung together to create a phrase—a larger structure. In my opinion, if the content of an art work is effectively communicated with integrity through the images (including symbols), conceptual idea, or physical media, it is a successful painting. The work may still move people even when the viewer doesn't completely understand it. This subliminal connection with the viewer is one of the powerful aspects of the visual dialogue that the artist strives toward. The symbols should serve the painting, not the other way around.

There are certain elements in Western art that are being challenged and broken down—like rules or absolutes (good art/bad art). This imitates society's current philosophical view of truth. Yet, there is a lingering tradition in Western art that there is still some standard by which to determine whether a work is good or bad. In Western art, this tradition is supported using particular techniques and sensibilities that are still being taught in

universities in regard to Western ideas of composition, color theory, design theory, representational drawing, painting techniques, aesthetics, and so forth. These aspects of this lingering tradition may be applied to the usage of symbols within a painting to defend for or against the success of the art work overall. It seems that a good/effective symbol could exist in a bad/unsuccessful painting and vice versa. Just incorporating a well-thought-out symbol in a painting doesn't make the painting successful. There is so much more that determines the success of an art work. The symbol is only one element— one phrase in a sentence. Much of what determines the overall success of a painting is purely subjective. Beyond the symbolic elements there still needs to be some communicative ability of the painting as a painting. Even if the art is devoid of representational images and is reduced to the abstract qualities of colors, shapes, composition or concepts which may evoke a feeling or reaction, the painting itself still conveys or communicates something. This communication is as dependent on the interrelationships of those characteristics as if they were recognizable images.

Creating Symbols

Leland Ryken, author of *The Liberated Imagination*, states

> . . . symbolic art can be defined as the use of physical images to stand for a corresponding spiritual reality. Such symbolic art is a familiar part of everyone's religious experiences, and it appears in verbal form all through the Bible. We think at once of the cross, water, bread, wine, shepherd, and light. Symbolic art was prominent in the tabernacle and Temple. A golden altar symbolized atonement. A golden table with sacred bread on it pictured God's provision for human life. Various types of vessels with water in them made a worshiper aware of spiritual cleansing. Lampstands of pure gold were a picture of the illumination that God's revelation affords. We can profitably link the Christian

sacraments of baptism and communion with the symbolic art of the tabernacle and Temple. We do not ordinarily think of the sacraments as art, but they are based on the same principle on which symbolic art is based. The sacraments use the physical elements of water, bread, and wine to express spiritual realities.

In a forthcoming collaborative art project, elements such as blood, tears, spit and sweat will be incorporated into the work. These fluids are intimately related to the life and ministry of Jesus. These objects/symbols will be utilized in the context of scientific discovery. For example, there exists software that will transcribe DNA structure into music. Again, these symbols have potential to be powerful or trite. The effectiveness of these symbols will be context sensitive and are dependent upon the integration of all the elements of the work—paint, sound, environment, etc. Many elements need to be considered during the entire process of art-making.

I begin the process of creating art by searching for meaningful ways of expressing myself through my visual language, my repertoire. During the formulation stage of musing, praying and dialoguing (even, if it is only to myself), I visualize images that I'm connected to already or have an affinity toward and imagine them in context with the concepts that I'm weighing. I search my mind for the best way to visually represent a particular thought, idea or experience in a painting. An historical example of this was my use of hay bales. Since I am from the West Coast, I hadn't seen the large round bales that dominate the Midwest. Upon my arrival in Ohio in the mid-eighties, the hay bales had a powerful visual impact upon me—like an ominous presence. It was more than merely their size that impacted me. The hay bales connected with my inner sense about symbolically powerful images. The effect was subliminal. I tried to rationally decipher their significance. It wasn't until I viewed them as spiritual metaphors that I came to a realization of their symbolic meaning. I began deliberating about their association to my spiritual ties, historical roots, and personal experiences.

The obvious fact was that they were, in their simplicity, food for domestic beasts. At the same time, they were, in the past, living growing plants—now dead, and yet sustaining life. The connection to the death/life cycle of the resurrection became a clear association for me. As a metaphor, the hay bales became visual transliterations for Christ, Jesus' disciples, myself, and even the Trinity.

A symbol (as well as the art work as a whole) gains substance from the viewer's interpretation. However, there seems to be a referential element to much of modern art. The audience is helped by knowing the experiences, the interests, background, historical influences or passions of the artist. In regard to symbolism, knowing the artist's world view, personal philosophical leanings, religious devotion and interests, gives insight into the connections, choices or relationships that the artist pulls together

Gaylen Stewart. **BREAD OF HEAVEN**, 1989 Acrylic, Gesso, Charcoal. 36 x 96 inches.

in his or her work. This information should encourage the viewer to consider the thought process that led the artist to use these particular symbols in the art and their significance.

If one's desire is to clearly communicate through the use of symbols, it is necessary to consider the viewer's position. If the relationship between content and symbol is too abstract, viewers might give up too early on their quest for understanding. Cultural demographics, ethnicity, and education factor into the interpretive process. These aspects should be taken into account and considered. It's important to me to speak into the lives of those who view my work. I want them to connect with me. This doesn't mean I speak in a patronizing fashion, though. I don't speak down to them, but try to meet them at connecting points of shared experiences. I expect a certain amount of exchange in the relationship. I antici-

pate that the viewers will work at educating themselves in regard to what they're viewing. Although, I know this isn't usually the case, I continue to believe in the possibility. If I speak down to the viewer I will come across as condescending. I want my art to say something about what I'm experiencing in a relevant way to the audience. I continue searching for creative ways to share my experiences. If a symbol or image communicates a concept well it can be repeated—especially in new dynamic juxtapositions. If not, then, it may be discarded or filed for later use.

Just as those viewing the art may give up, in the same way artists sometimes tire and quit. This may be a contributing factor to why some artists succeed (i.e., continue to make art) and some don't. For those that persevere there seems to be an inner drive that won't allow them to give up. At times, ideas are difficult to express or even formulate in my mind. The images don't connect, the symbols are overly simplistic and the art is belabored. I try to shake up the routine at this point, creating "accidents" that force me to "fix" them. My desire to make art is not so much a feeling as it is a decision. I choose to continue in spite of my ineffectiveness. I try to do something— anything— to force myself to continue. It doesn't have to be successful. Many times, I paint over what's visible to push myself into a new level of creativeness and thinking. If the symbols or images are really important to me, I may retain them, in spite of my concern that someone will not understand them. However, the danger lies in the preciosity bestowed onto an individual image at the expense of the entire painting.

Pursuit of Symbolism

I remember a phrase one of my professors used when I was a student; he said that preciosity kills the painting. The artist can fuss over the work obsessed with the technical rendering (or any individual elements) at the expense of the painting overall. This typifies the cliché about not seeing the forest for the trees. I believe effective symbols are selected based on close inspection of an object

and relating that object to one's ideas and experience, whereby a connection is made between the two independent elements.

It is dangerous to approach my work by looking for a specific, effective symbol. This mindset can lead to simple illustration (in a pejorative sense). There is nothing wrong with an illustrator doing illustration, but there is a problem when I intend to make art that involves complex concepts or self-exploration and yet rely on mere illustration of those concepts. A person who is an illustrator has that as his goal. He intends to make pictures that supplement a story line. The good illustrator accomplishes this purpose without compromising his integrity. However, if an artist illustrates rather than expresses experiences then there is a problem with integrity being compromised. I admit this distinction is very difficult to verbalize—or even to defend. It is purely subjective. But there seems to be a line where an artist crosses over from one area to the other. This crossing over without a conceptual reason to do so is where, I believe, the compromise takes place. In this situation, there is the possibility of being overly didactic in a patronizing manner. This conveys that the artist's inner feelings, experiences, or concepts are trivial, simplistically stated in a superficial way, rather than worked out with integrity through the art-making process. If the artist tries to make art that says something personal and reflective, but the result is illustrative of that idea rather than relaying that information honestly as a concept, then the illustration dominates the work and the importance of the content is marginalized. Using a symbol for it's own sake at the expense of the painting as a whole falls into this illustrative, story-telling area. If an artist resorts to mere illustration, he undermines the work by subordinating the impact of the concept or visual imagery to a formula. Rather than working diligently to mature a concept through a complex process, the artist is relying on a gimmick to achieve a fast solution.

As an artist who uses symbols, I constantly tread a fine line. Symbols have positive potential, and they can be misused, compromised or treated as a "slick" trick. On this subject, the artist's

credibility is tied to how symbolism is utilized. There is no absolute standard for the proper use of symbols. The artist has to convey the content of the painting through the symbols via a thoughtful process of integrity. All this aside, one can take something that is cliché and transform it beyond cliché. Some artist's have pushed kitsch so far that it has mutated beyond kitsch and somehow works as high art.

Communication

"Although symbols live and grow, and can be discarded and die, they cannot be replaced arbitrarily or according to expediency. Symbols also open up levels of reality and of ourselves which are otherwise closed to us. And they have a unique and irreplaceable role in human communication," says Jeremy Begbie in *Voicing Creation's Praise: Towards a Theology of the Arts*.

A type of visual communication is printed words. Words are composed of individual symbols (letters or characters). In some cultures the symbolism is more evident than in our alphabet, in that the characters may actually convey "pictures." More specifically, one could think of ancient Egyptian hieroglyphs and other types of written communication. Through time, societies have come into agreement about the given meaning to their symbols (letters/characters) and groups of those symbols (words). Even though language is not set, but changes, the meaning of these individual units and varied combinations has been agreed upon. Some liken language to a living, breathing organism. In many ways there are similarities to a growing organism. As symbolism, words, phrases, etc. (written or spoken) carry meaning that is communicated as the writer/speaker and the reader/hearer agree on the associated meaning to these symbols. The meanings of symbols can change as well. The reason people have agreed upon certain correlations throughout history is the need to communicate an idea as clearly as possible.

Word phrases or word pictures (like hieroglyphics), function similarly to modern day logos. Like hieroglyphics, a logo is a symbol designed to communicate more than is represented— it carries deeper meaning than the immediate image. Business logos intend, through an image conveying a concise idea or impression, to communicate instantaneously. So an effective logo connects with the viewer, bringing to the surface thoughts of the name or the products of a particular business. The idea is to communicate very quickly, at a glance, so that someone who sees the logo thinks of that business, feels connected to it, and remembers whatever is most important to that business. In his book, *State of the Arts*, Gene Veith says, "Symbols are a way of penetrating beneath the surface appearance to explore and present meanings." This shows the close connection between symbols and logos. In both logos and symbols, the more simplistic the image, the more quickly the viewer understands the meaning. In art, the challenge is to balance the easy communication that can be had with simple symbols and the need for a message with substance. Simplicity enhances communication, but sometimes the need for more content requires a more complex visual language. A complex image will take longer to read and decipher. It may provide more information but there is always the danger that the viewer may lose what is being said. Interpretation is part of symbolism and art in general. Total misunderstanding can be negative in terms of connecting with the artist's content— especially if a particular statement is being communicated. Many logos include words with the image. In my art, I also incorporate words with the visual images. We live in a word-based society. People can connect with a word and relate it to whatever image is surrounding the word. Both the word symbol and the image symbol together help strengthen the connection with the viewer when they are used in tandem.

Communication is not always clear. One aspect of life in a world which is in a "fallen" state is the amount of miscommunication that occurs. An early example dates back to the Tower of Babel and the

confusion of languages which severely impaired effective communication and the accomplishment of the goals of the people. Similarly to words, images as part of a visual language can be combined to describe a larger idea. Layered images that interrelate yield even more content as well as visual interest. Visual images have the power to communicate content, though perhaps less precisely and in a different way than words. In my art, I combine words with images because the words themselves are also symbols and they convey information that the images cannot. As mentioned before, there are limitations to any language whether picture symbols or words. If someone does not know me personally, they may not understand my references or the context from which I speak. The viewer may not relate to my experiences any more clearly through the symbols I use. A person's own experiences and presuppositions might skew what they perceive me to be saying. Of course there is always the additional difficulty that I may not express myself effectively. It is difficult enough to express feelings, emotions or experiences that might not translate easily into words, much less images. Yet, the two combined add an extra dimension to the interpretive process.

Made in the Communicator's Image

For an artist, communication is important but its exactness is not absolutely imperative. The interaction between artist and viewer is a kind of give and take. Art has limitations that prevent the artist from communicating absolutely. "Seeing" and "hearing" are imperfect. The attempt to express abstract ideas, share experiences and explore spiritual issues is not always going to connect with the viewer. Powerful content is often difficult to communicate. It should be noted that these limitations and imperfection in communication do not support the currently popular state of existentialism that says true communication is not possible. The lack of being able to communicate is an inherent aspect of humanity—but, I believe true communication (even with its limitations) is possible. This makes the act of creating art through an

unfamiliar language still worth the effort. For me, there exists an element of hope in this.

As a Christian, I stand against such an existentialist view. If true communication is not possible, then Scripture cannot be meaningful (because it cannot truly communicate) and God cannot hold anyone accountable (because he cannot truly communicate his requirements). In the first chapter of the gospel according to John, there was communication— God communicating with all humanity through the Word. God chose to communicate with us and then created us in his image. As a result, we also have the desire and the ability to communicate. This is one reason why I use symbolism.

Art of the past few decades that claimed to be without content ("pure expression" or any variations thereof, including Postmodernist reworking of this idea), all contain content, message, information, and worldview—and none is truly without content. The very idea of trying to make art with no content is its own content. The artist who removes meaning from art presents his own worldview and doctrine. In a similar vein, I think of Jackson Pollack's "chance" paintings created by swinging cans of paint over his canvases and allowing the paint to run from holes punched in their bottoms to create the paintings. His intent, as I understand it, was in part to avoid content using images and to show that everything exists by chance— the earth and the universe was formed by chance, that human existence is by chance, life is a product of chance and there is no meaning other than ourselves and our own self-existence.

At this point, this humanistic thinking produces a level of nihilism which concludes that since we can't communicate there is no purpose for it or ability to achieve it. Christians believe that we were created with purpose by a Communicator. We were designed to be in relationship with God and with each other. So it is not surprising that we have an inherent need for communication, nor should it be surprising that we benefit from communicating. Practical experience shows that any husband and wife relationship

(or any relationship) does not last very long if there is no communication. Communication is as necessary to our existence as water. So, in my thinking there must be ways to communicate, whether in words—or in art.

I am an artist and I don't believe I merely chose it. God, through his Spirit endows us with gifts— some to make art. In Exodus, Moses details the account of the artist Bezalel being chosen to make the most important portions of the Tabernacle. The biblical text says the Lord chose Bezalel and, "filled him with the Spirit of God, with skill, ability and knowledge in all crafts— to make artistic designs for work in gold, silver and bronze, to cut and set stones, to work in wood and to engage in all kinds of artistic craftsmanship." I feel a calling and an enabling to make art that glorifies God. As Christians we are challenged to do everything with our whole being, to the best of our ability as if we're doing it for God directly.

Very early in my art career I realized I had to be myself rather than the most recent permutation of the *avant garde* artist. This required that I analyze myself and determine what makes me the person that I am. Only through this introspection would I know what to communicate. My worldview is inseparable from who I am, and to avoid that would be dishonest in my work. To embrace one's own worldview and give it life in visual terms conveys a level of integrity that is missing in much art. Defending the status quo is still a pit— even if it's the *avant garde's* version. The most powerful artists throughout history appear to be driven by an inner force such as experience or belief. For me, this is best expressed by way of symbolism. I have found that nearly every form of art carries a message of some type and depends upon symbols to make that content known. There is so much similarity within various artistic disciplines in their use of symbols. Music notations are symbols. Poetry has its own cadence, structure and patterning just as paintings do. Even disciplines such as chemistry, biology, mathematics, physics, and engineering, rely upon a symbolic language within their respective fields.

The better I assess what I am trying to say, how to say it, how to make it relevant and what images best convey those concepts, the better the viewer can connect at varying levels with my work. This is, of course, balanced with overkill. I know that this—the idea of "message" and meaningful content—flies in the face of much contemporary art that wants to ask more questions than speak about anything in definite terms. This is only symptomatic of our society, which holds a view that everything is relative. It's almost anathema to speak clearly on a subject. But, this has not been true for most of history or for all cultures.

The rather recent notion that art is better if it asks questions rather than give answers appears to rely on the notion that there are no absolutes, and therefore art can offer only questions. Even those who claim that absolute knowledge does not exist, nullify there own claim by making it. One can not say absolutely that absolutes do not exist without contradiction. Likewise, a Christian has answers to some of life's questions—specifically, questions that are connected to the life of Jesus Christ, the purpose of life, eternal existence, natural and supernatural phenomena, communication with one's Creator and many other areas of existence.

For those who are not Christians it is popular to suggest we are all equally confused. Such worldviews, even in their diverse "doctrines" deny that there are universal truths. So they would say that no one can know what a person is saying because our different experiences and perspective prevent us from understanding what the artist is trying to communicate. In contrast, I believe that people can understand in part what another artist is trying to communicate. I am not averse to putting a statement with my work to explain some of my background, but I don't think it is necessary. In such a statement, I don't try to explain the work exhaustively because I myself don't know everything there is to know about it. There is more to the work than what one intentionally puts into it. To try to describe the entire content of my work would suggest that I know myself perfectly. However, I know myself in part, as every artist does, and I express what I know through my paintings.

I incorporate the things that I have learned or the things that I have experienced in what I say because I find those things interesting to talk about. I share spiritual truths that I believe are factual based partly in faith and evidence. On the other hand, one who does not believe in truth has a similar faith in holding that certain things are not true. Everyone is on the same ground. What we say in our work comes from a personal faith. Since personal experience, feelings and/or one's own intuition are relative in terms of truth, the Christian artist must always be careful that his faith and his truth is consistent with the Scriptures interpreted in context— this is the pure source of Truth.

The deconstructionism, historical revisionism, and propagandism that is so chic today is, in my opinion, empty or dead. One can look at the lives of the philosophers, artists and other purveyors of this thinking and time after time their lives end in tragic misery. I think of it as fashion that will fade out of existence. I believe that purposeful content has exciting and far-reaching possibilities.

So I view my work as more hopeful because of my belief that there is an initial source and purpose for doing it. Likewise, I believe I can convey a certain amount of meaning from my personal experience that can be rewarding to another individual. The audience may relate to my own personal life and spiritual experiences. Hopefully, if they connect with my experiences, they will be able to understand and be able to grow along with me through the work.

Understanding Symbols

Hieronymus Bosch was the king of symbols. Sometimes his symbols were so complex they were very difficult to decipher. His overall message can hardly be missed, however. Even with a loss of references from which to read the symbols, his work is still very powerful. Time and culture can obscure meaning due to the nature of a constantly evolving language. In Bosch's day his symbols may have been more colloquial, integrated into the vocabulary of the time, where the reader would understand more

immediately the metaphorical images. It is a concern to me that time and culture can obscure meaning in a work. For example, one of my paintings might have an entirely different meaning to a person in another part of the world or at some future period. I hold onto the belief that if I continue to communicate through this visual language that it will supersede these limitations and speak generally, if not specifically, and impact those viewers in spite of these limitations.

Someone might think that symbols need to be explained by the artist for the viewer to understand their meaning. The objective of the artist is to communicate without explanation, although this is not always possible. Probably the most difficult paintings for both artist and viewer are those that don't have any images in them. They consist of color, abstracted shapes, values, marks, composition, patterning or something more conceptual. Through these colors/shapes, based on cultural stereotypes or even possibly physiological responses to colors and what they represent in art, these can create a mood or a feeling that communicates something on a deeper level. This is similar to an intuitive, "natural" interpretation of images or objects (discussed later). The viewer may not be completely conscious of what is being said but the parts of the work to which they relate can have meaning for them. Conceptual art is more difficult to understand without specific referential information, but, there is still an overall understanding or a grasp of what's being said.

If my art is dominated by dark or drab color, that tone communicates dark or depressing emotions at a subconscious level. Likewise, the colors and level of brightness create a hopeful, resilient quality. In a painting, light emanating from darkness can give the feeling of hope or inspiration. Rembrandt often utilized this technique in his works. He tends to use light and darkness in contrast to represent hope while focusing attention on some particular element in his work. He communicates using light or a lack of light to represent an idea or theme. Light itself can be symbolic. Light can convey the idea of hope; light can represent

God's presence or healing. Typically light makes people feel better emotionally than darkness. For most people it provides a feeling of safety and security. Some symbols rely on shared, universal, emotional responses or understandings of our experience of life. Light and darkness are good examples of something in our shared experiences that produce a natural reaction.

Conventional and Natural Symbols

Dorothy Sayers makes a distinction between conventional symbols and natural symbols. The idea is that symbols have both an inherent meaning and a meaning by contemporary association. For example a mountain naturally symbolizes strength, majesty, longevity. That is its natural meaning, and is how it could be used as a natural symbol. The same image of a mountain can be used conventionally as a symbol for an insurance company. A natural symbol is directly connected to the universal understanding of something or the intuitive response to something. So hay bales, for example, would naturally bring thoughts of harvest, suggesting a time of plenty, the experience of farming or autumn events like Thanksgiving. In my early work, my use of hay bales and the ideas that I connected to them would make them a conventional symbol.

The red equilateral cross is so widely used as a conventional symbol that we tend to think about the organization it represents rather than what might be inherent in that symbol. As a natural symbol a viewer may experience an emotional response to the red by itself. It appears that the organization chose red purposefully. Whatever other intuitive thoughts occur when a person sees red, one of the first connections we make to a deep red is a connection with blood. The reaction to red can vary depending on the context. Red used in an abstract painting is less likely to be associated with blood. Suppose the red symbol is in the shape of an octagon?

One aspect of the effectiveness of a natural symbol is that it communicates with a broader group of people. In addition, a natural symbol may have a longer life span. However, conventional symbols may more directly relate to the artist's ideas and experi-

ence which would seem more important, even though a conventional symbol may not have as long a life span.

In looking at my audience, I consider their history, background and cultural issues in regard to the usage of the symbols I am considering. However, I don't spend a lot of time psychoanalyzing. In thinking about this relationship, I try to get an overall feel whether the symbolic information will detract or add to the content of my work.

Another question is, "How does one determine what is resonating with people?" The answer to this question is subjective. Unless an artist gets feedback from the public, it may be difficult determining if the viewers are engaging or not. Feedback is often limited to a handful of people at an exhibition who may have written down responses on a comment sheet. If I happen to be at the opening and people talk about the work, I may overhear a few responses. But the amount of feedback that I get as a practicing artist is so small that I have to rely on the subjective quality of what I have learned. I have to be true to my art and my experience. I try to produce a work that speaks to me first and then addresses the audience.

X-Rays and Crossing the Boundaries

One of the better symbols I have used was my own x-rays. During the period I was using them, I was very introspective about my healing from cancer. I would use the x-rays to convey my pain and healing and a discussion about the frailty of human existence in a spiritual context. While that was an effective symbol at that time, my work is now changing. I am currently using natural images as well as found objects (insects, etc.), coupled with scientific imagery and patterns to talk about the inherent design, order, complexity, and structure of life as evidence for God as Creator. My hope is that if I use a wasp nest or a butterfly—items that show complexity and design—it will challenge a viewer's thoughts about origins and the purpose of existence. When I combine those elements with words, the juxtaposition creates a new context for these interrelationships to speak in a new way.

First, the audience might see a butterfly and relate to its natural beauty, but if I combine a butterfly and a word written next to it, perhaps "death/life," the context changes. Some of my butterfly works have appeared in combination with quotes. In one piece, I quote Michael Denton, an Australian research scientist in molecular genetics, talking about the inherent complexity and order—"an elegance and ingenuity of an absolutely transcending quality"—that falsifies the belief in chance as the origin of things. So when I combine a visual like the butterfly with that quote, I am recontextualizing the butterfly symbol. In this case, it says something new and unexpected from the natural, intuitive interpretation of that image.

This recontextualizing of symbols is a furthering of the investigation and exploring that began years ago with my fascination of discovery sparked by the cartoons in the *Highlights* magazine. The discovery is more conceptual now, but the process is similar. Understanding my work reminds me of how children learn to speak when they are very young. Children learn by repetition. They become familiar with repeated sounds and patterns which they eventually connect to meaning. In a similar way, seeing many works which encompass the artist's visual language one can begin to decipher individual elements. As people view the images and as they read the words, they begin to make associations between dissimilar objects, imbuing them with new meaning. This is what I find challenging and exciting about symbolic imagery— connecting with people and facilitating the process of rediscovery.

ART FAITH
and the Stewardship of CULTURE

Has there ever been a time when the public has been more alienated from the world of contemporary art—the art being produced in their own day and age? It's hard to imagine. That alienation from visual arts and classical music is obvious, but it exists even to some extent from the serious literature of our time. The reasons for this estrangement are numerous, and go beyond our era's love affair with pop culture and the general dumbing-down of our society. There are more complex factors at work here, factors that include everything from the emergence of modern art forms a century ago to the changing roles of technology, media, and the economics of making and "consuming" art.

I would like to focus on, however, the more specific issue of the uneasy relationship between Christians and contemporary culture. Having spent the last decade founding and editing a journal of religion and the arts, I have spent a great deal of time reflecting on the role of art and the imagination in the contemporary church. While there are many hopeful signs in the Church and in our culture as a whole, there are also some

disturbing trends. It is my conviction that the Christian community, despite its many laudable efforts to preserve traditional morality and the social fabric, has abdicated its stewardship of culture and, more importantly, has frequently chosen ideology rather than imagination when approaching the challenges of the present.

If this approach remains the dominant one, then the community of believers will be squandering a remarkable opportunity. There are innumerable signs in our society that, on the eve of the new millennium, people are hungering for a deeper spiritual life. Baby Boomers are aging and feeling guilty about their youthful abandonment of religion. There may be more genuine openness to religious faith—in the sense of curiosity and yearning—than at almost any time in a century. One of the powerful ways that believers can speak to that yearning is through the arts—and through faith that is leavened by the human imagination. Whether the Church will respond or not will determine its willingness to be a steward of culture.

Christianity and Culture: Finding the Balance

There is no doubt that we live in a fragmented and secularized society—the polar opposite of the unified Christian culture that writers like Dante, Chaucer, and Milton took for granted when they penned their religious poems, or that Fra Angelico and Michelangelo assumed when they painted church walls and ceilings. The twentieth century witnessed art that frequently mocked religious faith, indulged in nihilism and despair, and engaged in political propaganda. Many artists have created works that are so difficult to apprehend that the disjuncture between the 'elitist' art world and the 'populist' world of art-consumption has widened into a dark chasm. The estrangement between the creators of art and their public is one of the facts we all take for granted.

Within the Christian community there have been many different approaches to modern culture. Some of the mainline

denominations have followed a liberal ethos that welcomes new trends in secular culture. Evangelicals and fundamentalists have moved in the opposite direction, retreating into a fortress mentality and distrusting the 'worldly' products of mainstream culture—so much so that they have created an alternative subculture. To simplify somewhat, you might say that whereas liberals lack Christian discernment about culture, conservatives have just withdrawn from culture.

Among Christians who care about the arts, there are many who cling to the works of a few figures, such as J.R.R. Tolkien, T.S. Eliot, and Flannery O'Connor, who have forged a compelling religious vision in the midst of a secular age. But the danger in celebrating these Christian artists is that we isolate them from their cultural context, from the influences that shaped their art. There is a large body of believers who have essentially given up on contemporary culture; they may admire a few writers here or there, but they do not really believe that Western culture can produce anything that might inform and deepen their own faith. One might almost say that these individuals have given in to despair about our time. For me, the most depressing trend of all is the extent to which Christians have belittled or ignored the imagination and succumbed to politicized and ideological thinking.

The Dark Side of the Culture Wars

Perhaps the best way to get a purchase on this situation is by looking into the phrase that has come to describe the present social and political climate—the phenomenon known as the 'culture wars.' In his book on the subject the sociologist James Davison Hunter describes the two warring factions as the progressives and the traditionalists (terms that are synonyms for liberals and conservatives). The progressives are, by and large, secularists who believe that the old Judeo-Christian moral codes are far too restrictive; they actively campaign for new definitions of sexuality, the family, and the traditional ideas about birth and death—the 'life' issues. Traditionalists, clinging to what they see as the perennial

truths of their religious and cultural heritage, wage a rear-guard action against the innovations wrought by the progressives. Issues such as abortion and euthanasia, homosexuality and the family, school prayer and other church and state conflicts lie at the heart of the culture wars. The stakes are extremely high and the struggle is fierce and bloody—and likely to become even more intense.

I do not wish to quarrel with this description of our cultural politics, nor do I want to suggest that these issues are not crucial to the survival of our social fabric. But I confess that I am astonished by the lack of attention most religious believers have shown to what I call the 'dark side' of the culture wars. The dominance of the culture wars over our public discourse is a striking example of how politicized we have become. It was once a universally accepted notion that politics grows out of culture—that the profound insights of art, religion, scholarship, and local custom ultimately shape the terms of political debate. Somewhere in our history we passed a divide where politics began to be more highly valued than culture.

It is not difficult to find evidence for this assertion. Take, for example, the rise of single-issue politics and the plethora of political pressure groups and the lengths to which politicians go to court such groups. Above all, there is the shrillness and one-dimensionality of most political rhetoric. The quality of public discourse has degenerated into shouting matches between bands of professional crusaders. As James Davison Hunter has put it, the culture wars consist of "competing utopian politics that will not rest until there is complete victory" The result, Hunter concludes, is that "the only thing left to order public life is power. This is why we invest so much into politics."

Even in the circles where I have felt most at home—including the conservative intellectual movement and the many Christian organizations dedicated to defending religious orthodoxy—I have come to see a dangerous narrowing of perspective, an increasingly brittle and extreme frame of mind. Coverage of the arts in conservative and Christian journals is almost non-existent.

Again and again I have seen the emphasis in these circles shift to having the correct opinions and winning political victories rather than on cultivating a reflective vision and seeking to win the 'hearts and minds' of our neighbors.

The very metaphor of war ought to make us pause. The phrase 'culture wars' is an oxymoron: culture is about nourishment, cultivation, whereas war inevitably involves destruction and the abandonment of the creative impulse. We are now at the point in the culture wars where we are sending women and children into battle, and neglecting to sow the crops in the spring. Clearly we cannot sustain such a total war. In the end, there will be nothing left to fight over.

Imagination and Cultural Renewal

Here is where the realm of literature and art comes into the discussion, in two important ways. First, the changing attitudes towards art provide another case study in the narrowing effects of the culture wars. Second, it is my contention that the imagination itself is the key to the cultural and spiritual renewal we so desperately need.

As in any other arena, progressives and conservatives have very different attitudes toward literature and art. Modern progressives have been far more interested in the art of their own time than conservatives, who have seen it as a subversive force, capable of undermining traditional values and making 'alternative lifestyles' more acceptable. The progressives, in their approach, have touched on one of art's most important functions: to force people to look at the status quo in a new way and challenge them to change it for the better. From the satires of Euripides and Swift to the novels of Dickens and Flaubert and beyond, great art has engaged in the paradoxical activity of constructive subversion.

Unfortunately, the progressives have preferred art that is subversive without a corresponding vision of the deeper wellsprings of human and divine order. Being members of an elite that is alienated from the traditional social order, they have

become associated with art that is frequently nihilistic, or simply amoral. With less and less substance in their works, the artists supported by the progressives have resorted to irony, political propaganda, and sensationalism to elicit a response from their audience. Hence, the passing celebrity of figures like Bret Easton Ellis, Karen Finley, Andres Serrano, and Robert Mapplethorpe.

On the other hand, conservatives have been deeply estranged from the art of this century. While they have celebrated artists who have shared their views, including such writers as Yeats, Eliot, Evelyn Waugh, and Walker Percy, conservatives have frequently condemned 'modern art' as if it were a monolithic entity. The idea has been that modern art is somehow tainted by a predilection for nihilism, disorder, perverted sexuality, even an indulgence in the occult. Conservatives frequently mock abstract art, experimental fiction, the theater of the absurd, and functionalist architecture. They prefer art that provides uplift and lofty sentiment. Unlike the progressives, conservatives tend toward the populist attitude encapsulated in the phrase: "I don't know much about art, but I know what I like … "

A corollary of this conservative alienation from modernity is the tacit assumption that Western culture is already dead. The stark truth is that despair haunts many on the Right. When conservatives turn to art and literature they generally look to the classics, safely tucked away in museums or behind marbleized covers. Ironically, many conservatives don't seem to have noticed that they no longer have anything to conserve—they have lost the thread of cultural continuity. They have forgotten that the Judeo-Christian concept of stewardship applies not only to the environment and to institutions but also to culture. To abdicate this responsibility is somewhat like a farmer refusing to till a field because it has stones and heavy clay in it. The wise farmer knows that with the proper cultivation that soil will become fertile.

The tradition of Christian humanism always held that the secular forms and innovations of a particular time can be assimilated into the larger vision of faith. That is why T.S. Eliot could

adapt Modernist poetics to his Christian convictions, or Flannery O'Connor could take the nihilistic style of the novelist Nathanael West and bring it into the service of a redemptive worldview. Only a living faith that is in touch with the world around it can exercise this vital mission of cultural transformation.

Because progressives and conservatives are so thoroughly politicized, their approach to art is essentially instrumentalist—as a means to an end, the subject of an op-ed column or a fundraising campaign. Of course, there is a deep strain of pragmatism in the American experience, and it does not take much to call it to the surface. In the context of American Christianity, the Puritan strain has shown a similar tendency toward pragmatism: art becomes useful insofar as it conveys the Christian message.

In a politicized age, constricted by the narrowness of ideology, few people really believe that art provides the necessary contemplative space that pulls us back from the realm of action in order to send us back wiser and more fully human. For Christians, the idea that contemplation and prayer ought to precede action should be second nature. How many of us have become unwitting disciples of Marx, who said that "up till now it has been enough to understand the world; it is for us to change it"? Marx's preference for revolutionary action over the classical-Christian belief in the primacy of contemplative understanding of transcendent order lies at the heart of modern ideology.

Art and Transcendence

Art, like religious faith in general and prayer in particular, has the power to help us transcend the fragmented society we inhabit. We live in a Babel of antagonistic tribes—tribes that speak only the languages of race, class, rights, and ideology. That is why the intuitive language of the imagination is so vital. Reaching deep into our collective thoughts and memories, great art sneaks past our shallow prejudices and brittle opinions to remind us of the complexity and mystery of human existence. The imagination calls us to leave our personalities behind and to temporarily inhabit

another's experience, looking at the world with new eyes. Art invites us to meet the Other—whether that be our neighbor or the infinite otherness of God—and to achieve a new wholeness of spirit.

The passion to find reconciliation and redemption is one of the inherently theological aspects of art. Before the modern era, this passion often took the form known as theodicy—the attempt to justify God's ways to man. There are, to be sure, few full-blown theodicies to be found in bookstores and art galleries today, but the same redemptive impulse has been diffracted into dozens of smaller and more intimate stories. We may not have towering figures of intellectual orthodoxy like Eliot, O'Connor, or Walker Percy living among us, but there are dozens of writers, painters, sculptors, dancers, filmmakers, and architects who struggle with our Judeo-Christian tradition and help to make it new. The renaissance of fiction and poetry with religious themes and experiences is in full swing, from older figures like J.F. Powers, Richard Wilbur, and John Updike to such gifted writers as Annie Dillard, Kathleen Norris, Anne Lamott, Ron Hansen, Louise Erdrich, Elie Wiesel, Larry Woiwode, Doris Betts, Reynolds Price, Chaim Potok, Frederick Buechner, Mark Helprin, Anne Tyler, John Irving, Tobias Wolff, and poets like Scott Cairns, Edward Hirsch, Paul Mariani, Geoffrey Hill, and Donald Hall.

But it is not only in literature that contemporary artists are returning to the perennial matters of faith. Take classical music, for instance. The three best-selling composers in classical music today are Arvo Pärt, John Tavener, and Henryk Gorecki. All of these composers were profoundly affected by the modern musical style known as minimalism. Yet they felt minimalism lacked a spiritual dimension—a sense of longing for the divine. So they returned to the ancient traditions of Gregorian chant and developed music that combines ancient and modern techniques, and which has brought back to contemporary ears the spirit of humility and penitence.

It is true that some of the artists that I've mentioned may not be strictly orthodox on all aspects of doctrine, and many of them remain outside of the institutional church. But many of these figures are faithful Christians and observant Jews. All of the artists I've listed treat religion as one of the defining components of our lives. I think it is fair to say that if this body of art was absorbed and pondered by the majority of Christians, the quality of Christian witness and compassion in our society would be immeasurably strengthened.

Above all, these artists and writers are neither baptizing contemporary culture nor withdrawing from it. In the tradition of Christian humanism, they are reaching out to contemporary culture and using their discernment to find ways to see it in the light of the Gospel. Just as Christ established contact with the humanity of the publicans, prostitutes, and sinners he encountered before he revealed the message of salvation to them, so Christian artists must depict the human condition in all its fullness before they can find ways to express the grace of God. In other words, Christian artists must be confident enough in their faith to be able to explore what it means to be human. At the heart of Christian humanism is the effort to achieve a new synthesis between the condition of the world around us and the unique ways in which grace can speak to that condition. That is how art created by Christians will touch the lives of those who encounter it.

Christian Humanism and the Incarnation

Behind this vision of Christian humanism stands the doctrine of the Incarnation: the complete union of Christ's divine and human natures. The Incarnation is the touchstone against which we can test the rightness of our efforts. That is because we must remember to keep the divine and human perspectives in a healthy balance. Emphasize the human over the divine, and you fall into the progressive error; stress the divine over the human, and you commit the traditionalist sin. To take just one specific

manifestation of this, consider the need to balance God's justice with His mercy. If all the emphasis is on justice, you end up with a harsh, abstract, and legalistic view of the world. But if mercy is all you care about, compassion will become vague and unable to cope with the complex realities of a fallen world.

All great Christian art is incarnational because art itself is the act of uniting form and content, drama and idea, the medium and the message. If art is dominated by a moralistic desire to preach at the audience, it will become lifeless and didactic. We can easily spot didacticism when its message is different from what we believe, but no one who cares about art should confuse it with politics or theology. Art does not work through propositions, but through the indirect, 'between the lines' means used by the imagination. We need look no further than the Gospels to be reminded of this fact. Christ's parables are marvels of compressed literary art: they employ irony, humor, satire, and paradox to startle us into a new understanding of our relationship to God. If we are too quick to boil these unsettling stories down to one-dimensional morals, they will no longer detonate in our hearts with the power that Jesus poured into them.

Many believers fear the imagination because it cannot be pinned down. But the imagination is no more untrustworthy than, say, reason. Like any other human faculty, it can be used for good or ill. Imagination, because it draws on intuition, can help us to see when reason has become too abstract, too divorced from reality. In a work of art the artist's imagination calls out to the audience, inviting the reader or viewer or listener to collaborate in the act of discovering meaning. Jesus' parables only find their fulfillment when we puzzle out their meaning, interpreting their ironies and paradoxes.

It is precisely this fear of the imagination that has led many Christians in America to create a subculture with Christian publishers, Christian record labels, and Christian art galleries. The underlying message conveyed by these products is that they are

safe; they have the Christian seal of approval. But this is a devil's bargain: in exchange for safety, these products have given up their imaginative power. And this is just where the strangest irony of all emerges. This subculture has rushed to produce Christian versions of almost every secular trend: from Christian heavy metal bands to Christian romance novels to Christian self-help books. But because these products lack the transforming power of the imagination, they are little better than the pop culture trends they imitate.

Ron Hansen: Steward of Mystery and Culture

What is an example of a contemporary work of Christian imagination that truly synthesizes the realities of the culture in which we live with the timeless reality of God's grace? Almost anything by the writers and composers I've listed above would make for a brilliant case study. I could also draw on the work of visual artists, choreographers, singer-songwriters, and many other art forms I haven't yet mentioned. But I will stick to what I know best—literature.

Ron Hansen's *Mariette in Ecstasy,* published in 1992, is a haunting, enigmatic novel that is almost impossible to categorize. What makes *Mariette* especially fascinating is that it deals with a subject that must appear bizarre and esoteric to today's reading public. Set in a Benedictine convent in upstate New York around 1906, it is the story of a young girl who experiences the stigmata, the five wounds of Christ, in her own flesh.

Given the remoteness and "abnormality" of this world, the expectations and preconceptions of the reader undoubtedly play an important role in how the story is perceived. There is, of course, a long and undistinguished tradition of lurid, melodramatic tales of masochism and smoldering sexuality in the monastic enclosure. The genre, which probably began with Boccaccio's *Decameron,* moves on to nineteenth-century anti-Catholic novels such as *The White Cowl* to contemporary psychological fables such as the film *Agnes of God.*

But if Hansen works with some of the same materials, he has fashioned an altogether more serious and profound exploration of suffering and religious passion. The novel's protagonist, Mariette Baptiste, is the daughter of a possessive, hyper-masculine father; her mother died when she was young. Mariette is an intelligent and strikingly beautiful seventeen year-old when she enters the convent. She is the type of woman who would cause jealousy, envy, and adoration anywhere she went, including the monastic enclosure.

Rather than using her intelligence and beauty in the more conventional modes of academic achievement and marriage, Mariette withdraws into an intense inner life. She becomes a spiritual prodigy. All of her sensual energy and vivid imagination is channeled into her courtship with her divine lover, Jesus.

Within her first year in the convent, Mariette experiences the trauma of seeing her sister, who is also a nun, killed by cancer at the age of 37. She undergoes a spiritual crisis in which she loses any sense of Christ's presence. Then, in the midst of this agitation, the stigmata appear on her body; she bleeds from hands, feet, and torso.

When questioned, Mariette claims that the stigmata were given to her by Christ Himself. It becomes clear that, far from being proud and ostentatious about these wounds, Mariette is embarrassed and troubled. The convent is thrown into a turmoil of conflicting opinions and emotional responses.

Here is a subject that is perfectly suited for Freudian analysis. If there was ever a paradigm of repressed sexuality, the apparently masochistic mysticism of the female *religieuse* would seem to be it. And yet Ron Hansen's novel makes no attempt to *explain* Mariette's experiences; there is no sense in which the author stands above and outside his protagonist's life, ready to share a knowing look with his reader about this sadly deluded girl. The story is open-ended, allowing the reader to interpret Mariette's experience in any number of ways. That is exactly what happens in the convent, where almost every possible reaction, from adoration to loathing and fear are evoked by Mariette's stigmata.

The open-endedness of the narrative is not a cop-out, but a sign of Hansen's respect for mystery, that dimension of the Christian imagination championed by Flannery O'Connor. For the writer who acknowledges mystery, O'Connor held, "the meaning of a story does not begin except at a depth where adequate motivation and adequate psychology and the various determinations have been exhausted. Such a writer will be interested in what we don't understand rather than in what we do … . He will be interested in characters who are forced out to meet evil and grace and who act on a trust beyond themselves—whether they know very clearly what it is they act upon or not."

O'Connor's words describe not only Hansen's vision but also his protagonist's significance. Mariette's psychology is more than adequate. The modern reader, consciously or unconsciously schooled by Freud, will note the eroticism of Mariette's spirituality and be tempted to think that in 1906 repressed sexuality led to religious hallucinations. But Hansen's narrative also takes into account the tradition, from the *Song of Songs* through Carmelite mysticism, of Eros as a metaphor for the soul's relation to the heavenly bridegroom.

The final level of ambiguity in the novel concerns the perceptions of those who must interpret Mariette's ecstasies. These perceptions are colored by the characters' deepest hopes, fears, and needs. Mariette's stigmata, like any intense and miraculous religious experience, act as a touchstone, revealing the inner lives of those around her. Though such revelations include jealousy, credulity, and anger, Hansen's compassion is broad enough to forgive nearly all of them.

Hansen seems to leave the reader free to embrace almost any explanation of Mariette's stigmata. But he is doing more than that. In leaving the narrative open-ended, the author is asking us to make our own judgments, and thus to confront and question our deepest beliefs and emotions. Despite the strong evidence for the truth of her experience, why is it so hard to let go of our suspicion

that Mariette may be nothing more than a brilliant fraud? Is there something in us that refuses to accept such signs of God's grace irrupting into our world?

At the end of the novel, Mother Saint Raphael says to Mariette, "God gives us just enough to seek Him, and never enough to fully find Him. To do more would inhibit our freedom, and our freedom is very dear to God." Taken out of context, this might sound like a relativist's creed, but the prioress is talking, in simple and direct language, about the nature of faith itself.

Hansen draws on modern Freudian notions of human motivation only to suggest that there is a far more profound and satisfying answer to the mystery—Christian faith. Here is a work that truly synthesizes elements of the culture we inhabit with the perennial wisdom of the Christian imagination.

Ron Hansen is a true steward of Christian culture, as are the Christians who read and ponder his vision. His art is neither safe nor predictable; it requires, and rewards, a deep engagement of our imaginative faculties. Such an engagement requires us to invest our own time and passion. Which brings me back to my central theme: how committed are we as Christians to nourish our faith and renew our society by becoming stewards of culture? Unless we contribute to the renewal of culture by participating in the life of art in our own time, we will find that the barbarians have entered by gates that we ourselves have torn down.

Appendix I

In the back of Calvin Seerveld's book *A Christian Critique of Art and Literature* there is a booklist section entitled, "Kindred Readings Behind, Around, and Beyond the Text." This appendix works in a similar way. Following is a list of books recommended by contributors to this project relating to both the particular topics covered in this book, and the arts in general.

Bustard—
Stephen Charnock: *Discourses Upon the Existence and Attributes of God* (Baker Books, 1996).
Charlie Peacock: *At the Crossroads: An Insider's Look at the Past, Present, and Future of Contemporary Christian Music* (Nashville: Broadman & Holman, 1999).
H. R. Rookmaaker: *Modern Art and the Death of a Culture* (Downers Grove, IL: Inter-Varsity Press, 1970).
Calvin Seerveld: *Rainbows for the Fallen World* (Toronto: I.R.S.S., 1980).
Leland Ryken: *The Liberated Imagination* (Harold Shaw Publishers, 1989).

Francis Schaeffer: *Art & the Bible* (InterVarsity Press, 1973).

Madeleine L'Engle: *Walking on Water* (Harold Shaw Publishers, 1980).

Sally Fisher: *The Square Halo and Other Mysteries of Western Art: Images and the Stories that Inspired Them* (Harry N. Abrams, Inc., 1995).

Daniel J. Boorstin: *The Creators: A History of the Heroes of the Imagination* (Random House, 1992).

Edgar—

Jeremy S. Begby: *Voicing Creation's Praise: Towards a Theology of the Arts* (Edinburgh: T & T Clark, 1991).

Harold M. Best: *Music through the Eyes of Faith* (San Francisco: Harper, 1993).

Tim Dean & David Porter, editors: *Art in Question* (Basingstoke: Marshall Pickering, 1987).

William Edgar: *Taking Note of Music* (London: S.P.C.K., 1986).

Giles Oakley: *The Devil's Music: a History of the Blues,* 2nd ed. (New York: Da Capo, 1997).

Flannery O'Connor: *Mystery and Manners* (New York: Farrar, Straus & Giroux, 1962).

Charlie Peacock: *At the Crossroads: An Insider's Look at the Past, Present, and Future of Contemporary Christian Music* (Nashville: Broadman & Holman, 1999).

H. R. Rookmaaker: *The Creative Gift* (Westchester: Cornerstone, 1981).

H. R. Rookmaaker: *Modern Art and the Death of a Culture* (Downers Grove, IL: Inter-Varsity Press, 1970).

Calvin Seerveld: *Rainbows for the Fallen World* (Toronto: I.R.S.S., 1980).

Jon Michael Spencer: *Blues and Evil* (Knoxville: University of Tennessee Press, 1993).

Janna Tull Steed: *Duke Ellington: A Spiritual Biography* (New York: Crossroad, 1999).

Steve Turner: *Hungry for Heaven: Rock 'n' Roll and the Search for Redemption,* Revised Edition (Downers Grove: Inter-Varsity Press, 1995).

Gregory Wolfe, ed: *The New Religious Humanists: A Reader* (New York: The Free Press, 1997).

Lamber Zuidervaart & Henry Luttikhuizen, eds.: *Pledges of Jubilee: Essays on the Arts and Culture in Honor of Calvin G. Seerveld* (Grand Rapids: Eerdmans, 1995).

Fujimura—

Jeremy S. Begby: *Voicing Creation's Praise: Towards a Theology of the Arts* (Edinburgh: T & T Clark, 1991).

C. S. Lewis: *The Weight of Glory and Other Addresses* (Simon & Schuster, 1996).

Kathleen Norris: *The Cloister Walk* (Berkley Publishing Group, 1997).

Francis Schaeffer: *Art & the Bible* (InterVarsity Press, 1973).

Calvin Seerveld: *Rainbows for the Fallen World* (Toronto: I.R.S.S., 1980).

Simone Weil: *Gravity and Grace* (University of Nebraska Press, 1997).

Giardiniere—

Jim Cymbala: *Fresh Wind, Fresh Fire* (Zondervan, 1997).

Richard Gaffin: *Perspectives on Pentecost* (Presbyterian and Reformed, 1979).

Sinclair Ferguson: *The Holy Spirit* (Downers Grove: Inter-Varsity Press, 1994).

R.C. Sproul: *The Mystery of the Holy Spirit* (Tyndale, 1990).

Rory Noland: *The Heart of the Artist* (Zondervan, 1999).

Martin Selman: *2 Chronicles, A Commentary* (Downers Grove: Inter-Varsity Press, 1994).

Wilhelm Ehmann: *Choral Directing* (Augsburg, 1968).

Joseph Musselman: *Dear People ... Robert Shaw* (Hinshaw, 1996).

Harold M. Best: *Music through the Eyes of Faith* (San Francisco: Harper, 1993).

Prescott—

Jeremy S. Begby: *Voicing Creation's Praise: Towards a Theology of the Arts* (Edinburgh: T & T Clark, 1991).

Leland Ryken: *Culture in a Christian Perspective: A Door to Understanding and Enjoying the Arts* (Multnomah Press, 1986).

Leland Ryken: *The Liberated Imagination* (Harold Shaw Publishers, 1989).

Gene Edward Veith: *The Gift of Art*

Gene Edward Veith: *State of the Arts: From Bezalel to Mapplethorpe* (Crossways Books, 1991).

Frank Gaebelein: *The Christian, the Arts, and Truth, Regaining the Vision of Greatness* (Multonomah Press, 1985).

Calvin Seerveld: *Rainbows for the Fallen World* (Toronto: I.R.S.S., 1980).

Madeleine L'Engle: *Walking on Water* (Harold Shaw Publishers, 1980).

André Malraux: *The Voices of Silence* (Priceton University Press, 1978).

Nicholas Wolterstorff: *Art in Action* (Grand Rapids: Eerdmans, 1980).

Charles Williams: *The Descent of the Dove: A Short History of the Holy Spirit in the Church* (Regent College, 1995).

Romaine—

James Beck: *Italian Renaissance Painting* (Konemann, 1999).

Jeremy S. Begby: *Voicing Creation's Praise: Towards a Theology of the Arts* (Edinburgh: T & T Clark, 1991).

George Bull: *Michelangelo: A Biography* (St. Martin's Press, Inc., 1998).

John W. Dixon, Jr.: *The Christ of Michelangelo* (Scholars Press, 1994).

Creighton Gilbert, trans.: *Complete Poems and Selected Letters of Michelangelo* (Princeton University Press, 1990).

Vincent van Gogh: *The Complete Letters of Vincent van Gogh* (Bulfinch Press, 2000).

Roger Hazelton: *A Theological Approach to Art* (Abingdon, 1967).

H. Richard Niebuhr, *Christ and Culture* (HarperCollins, 1986).

Flannery O'Connor, *Mystery and Manners* (New York: Farar, Straus and Giroux, 1969).

William E. Wallace, ed.: *Michelangelo: Selected Scholarship in English, 5 Vols.* (Levin, Hugh Lauter Associates, 1998).

Sanderson—

Henri Cartier-Bresson: *The Decisive Moment* (New York: Simon and Schuster, 1952).

Frederick Buechner: *The Faces of Jesus* (New York and San Francisco: Harper & Row, 1989).

John Sanford: *Mystical Christianity: A Psychological Commentary on the Gospel of John* (New York: Crossroad Publishing Co., 1993).

Calvin Seerveld: *Rainbows for the Fallen World* (Toronto: I.R.S.S., 1980).

Poul Vad: *Vilhelm Hammershoi and Danish Art at the Turn of the Century* (New Haven and London: Yale University Press, 1992).

Scott—

Julian Bell: *What is Painting: Representation and Modern Art* (Thames and Hudson 1999).

Timothy Van Laar and Leonard: *Active Sights: Art as Social Interaction* (Diepeveen Mayfield Publishing Company, 1998).

Arnold Berleant: *Art and Engagement* (Temple University Press, 1991).

David Thistlewaite: *The Art of God and the Religions of Art* (Solway/Paternoster, 1998).

Peter Fuller: *Theoria: Art and the Absence of Grace* (Chatto and Windus 1988).

Arnold Hauser: *The Philosophy of Art History* (Alfred A Knopf 1959).

Eric Newton and William Neil: *2000 Years of Christian Art* (Thames and Hudson, 1966).

David Jones: *Epoch and Artist: Selected Writings* (Faber and Faber 1959).

Also, Paul Kiler has compiled a very comprehensive and wide ranging list of books on the arts and faith, and this can be located under the 'arts' section of www.theooze.com.

Wolfe—

Christopher Dawson, *The Historic Reality of Christian Culture* (New York, Harper, 1960).

T.S. Eliot, *Christianity and Culture* (New York: Harcourt, Brace, 1960).

Ron Hansen, *Mariette in Ecstasy* (New York: HarperCollins, 1991).

Image: A Journal of the Arts and Religion (P.O. Box 674, Kennett Square, PA 19348).

Jacques Maritain, *Art and Scholasticism* (Notre Dame, IN: University of Notre Dame Press, 1974).

Jacques Maritain, *Creative Intuition in Art and Poetry* (Princeton: Princeton University Press, 1978).

H. Richard Niebuhr, *Christ and Culture* (New York: HarperCollins, 1986).

Flannery O'Connor, *Mystery and Manners* (New York: Farar, Straus and Giroux, 1969).

Contributors

SANDRA BOWDEN is a painter and printmaker living in Chatham, MA. For the last seven years she has been the president of Christians in the Visual Arts, an international arts organization interested in the relationship between the visual arts and the Christian faith. Her art degree is from the State University of New York and she has also studied Hebrew, geology and biblical archaeology.

She has had over 50 one-person shows including the Bible Lands Museum in Jerusalem, the Haifa Museum in Israel, Patmos Gallery, Toronto, Canada, Foxhall Gallery in Washington DC, and the United Theological Seminary in Minneapolis. Her work has been in numerous invitational shows and juried exhibitions all across the United States and Canada. Featured articles on her work have been found in *Christianity Today* and *Christianity and the Arts* as well as the *Chicago Tribune, Albany Times Union* and Gene Edward Vieth's book *State of the Arts: From Bezalel to Mapplethorpe.*

Sandra's work is a complex meditation on time, incorporating biblical archaeological references and ancient text. The mystery

of the word as a vehicle of communication across generations has been an important component of her personal iconography, using segments of language and text as design within the image.

NED BUSTARD is the owner of an illustration and graphic design firm called World's End Images. He received his B.A. in art from Millersville University of Pennsylvania. He has done work for various clients ranging from the Publication Society of the Reformed Episcopal Church, Veritas Press, and the Heritage Center Museum of Lancaster County, to ICI Americas, Armstrong World Industries and Macy's West. He was also the art director for the late, great, alternative Christian music publication, *Notebored Magazine.* He has had several one-man shows as well and won awards for his painting and illustration work. In his spare time, he is the creative director for Square Halo Books. He currently is living in Lancaster, Pennsylvania with his wife Leslie, and two daughters, Carey and Maggie.

WILLIAM EDGAR is currently Professor of Apologetics at Westminster Theological Seminary. He studied musicology at Harvard and Columbia. He holds the Docteur en Theologie from the University of Geneva (Switzerland). He has taught at the Reformed Theological seminary in Aix-en-Provence. His books include *Taking Note of Music* (SPCK), *La Carte Protestante* (Labor et Fides), and *Reasons of the Heart* (Baker). He has written numerous articles on such subjects as cultural apologetics, the City of Geneva, and African-American music. His favorite avocation is jazz piano. He plays part-time with a professional jazz band. His wife Barbara is Administrative Secretary for the Huguenot Fellowship. They have two children, Keyes, a lawyer in New York, and Deborah, a campus chaplain at Harvard.

MAKOTO FUJIMURA was born in Boston. He graduated from Bucknell University (B.A.) and Tokyo National University of Fine Arts and Music (M.F.A.) where he spent six and a half years studying the tradition of Nihonga (Japanese-style painting) as a Japanese Governmental Scholar. He has had over twenty solo exhibits both in Tokyo and New York. Public collections of his works include The Saint Louis Art Museum, The Contemporary Tokyo Museum, and the Yamaguchi Prefecture Museum. His work was recently selected by two museums in Tokyo as one of 70 outstanding works of Nihonga of the Twentieth Century. He was also chosen to produce works to commemorate the Millenium Christmas at The Cathedral Church of St. John the Divine, New York City.

He is the founder of International Arts Movement whose mission is to "stand in the gap between the arts community and the Church, and be a catalyst for cultural renewal." He and his wife and three children live in New York City.

DAVID GIARDINIERE has been a teacher, conductor, vocalist, dramatist, clinician, adjudicator, and music editor in the Philadelphia area for 20 years. He has served in churches and Christian schools since 1978, and his choral and instrumental groups have performed in 15 eastern states, Canada, and Austria. A graduate of West Chester University, Northwestern University, and New York University, he has received a diploma for studies done in Siena, Italy and in 1998 he was chosen to appear in Who's Who Among American Teachers. He has played major roles in areawide musical productions ranging from Gilbert and Sullivan operettas to Broadway shows and was guest conductor for the 1998 Christian Youth Honors Choir at Carnegie Hall in New York. He resides in the Philadelphia area with his wife and three children.

TIM KELLER is the founding pastor of Redeemer Presbyterian Church in Manhattan. Since its beginning in 1989, many arts and business professionals have found spiritual life at Redeemer. Before coming to New York Dr. Keller was an associate professor of practical theology at Westminster Theological Seminary in Philadelphia, where he continues as adjunct faculty. Dr. Keller has written *Resources for Deacons* and *Ministries of Mercy* (P & R). He is currently engaged in developing curriculum for leadership training at Redeemer and helping to found the Urban Church Development Center and the City Seminary of New York (CISNY). His wife Kathy is the Director of Communication at Redeemer. They have three grown sons: David (at the College of William and Mary), Michael (at Vanderbilt University) and Jonathan (at The Stony Brook School.)

EDWARD KNIPPERS is a painter living in Arlington, Virginia. He received his Master of Fine Arts Degree in painting from the University of Tennessee, Knoxville. He has also studied at the Pennsylvania Academy of the Fine Arts, Philadelphia, and the Sorbonne, Paris, France (summer language program). He has studied twice at the International Summer Academy of the Fine Arts in Salzburg, Austria, once in the studio of Zao Wou-ki (painting) and once in the studio of Otto Eglau (printmaking). In 1980, he was a fellow at S. W. Hayter's Atelier 17 in Paris.

Knippers has an estimated 150 awards and exhibitions of which over 50 are one-man shows and invitationals. These include venues such as the following: the Los Angeles County Museum of Art; the Virginia Museum of Fine Arts, Richmond; the Southeastern Center for Contemporary Art (SECCA); the Tennessee Fine Arts Center at Cheekwood, Nashville; the Roanoke Museum of Fine Arts, Roanoke, Virginia; the J. B. Speed Museum, Louisville, Kentucky; the Billy Graham Center Museum, Wheaton, Illinois; the Biblical Arts Center, Dallas, Texas; and the Universities of Kentucky, Oklahoma, and Tennessee. He has also shown his work in England, Canada, Italy and Greece.

His work has appeared and been reviewed in numerous publications, including, *Life Magazine, The Washington Post,* the *New Art Examiner, The Washington Times, The Richmond Times-Dispatch, The Richmond News Leader,* the *Fort Worth Star-Telegraph, The Baltimore Sun,* the *Los Angeles Times,* the *L.A. Weekly, Artweek, Art Voices, Faith and Forum, Christianity Today, Christianity and the Arts, Eternity, The Critic, Image, Washington Review, Clarity, Rutherford, Poet Lore,* and *New American Paintings,* a juried exhibition.

CHARLIE PEACOCK-ASHWORTH is a singer, songwriter, and record producer with a twenty-four year career in the music industry, including sixteen years in contemporary Christian music. In addition to recording his own albums (most recently, *Kingdom Come*) he has produced and written for numerous artists ranging from Amy Grant to Switchfoot. He is the founder of a study center called The Art House and of Re:think Records. His first book is *At the Crossroads: An Insiders Look at the Past, Present, and Future of Contemporary Christian Music.* His main avocation is fishing. His wife, Andi, is a master gardener and a writer. They live in Nashville in a remodeled turn-of-the-century country church and have two grown children, Molly and Sam.

THEODORE PRESCOTT is a sculptor and Chair of the Visual and Theatrical Arts Department at Messiah College. He majored in art at the Colorado College and received his M.F.A. from the Rinehart School of Sculpture, the Maryland Institute College of Art. He has exhibited widely in the United States, and completed several public commissions, including a recent collaborative commission in Golden, Colorado for the Colorado School of Mines. His work is in several private collections, The Vatican Museum of Contemporary Religious Art, and the Armand Hammer Museum of Art, UCLA. He edited the quarterly publication CIVA for six years, serves on the editorial advisory board of *IMAGE,* and has published several articles on the visual arts. He and his wife Catherine, a painter, have begun the renovation of an

old farmhouse and barn near Harrisburg, Pennsylvania. They have two daughters, Flora and Grace. Prescott enjoys reading, hiking, and working in the landscape.

KRYSTYNA SANDERSON was born in Poland and came to the United States in 1970. She received an M.F.A. in painting and photography from Texas Tech University and moved to New York City in 1979.

Sanderson has exhibited her photographs at, among other galleries, the Photo Center Gallery of New York University, Soho Triad Gallery in New York City, Dadian Gallery in Washington, D.C., and the Narthex Gallery at St. Peter's Church, New York City. Her work is in many public and private collections, including the United Nations, Texas Tech Museum and Davis Polk & Wardwell. Her photographic series "Masks" was published in book form by Texas Tech Press in 1981. She is a recipient of grants from The New York Foundation for the Arts, Artists Space and The Kosciuszko Foundation.

She taught photography at The New School and at St. John's University, was a staff photographer for the New York City Police Department, and is currently a freelance photographer.

STEVE SCOTT is a writer, lecturer, performer and mixed-media artist. Since moving to America in the Mid 1970s, he has published a number of articles on postmodern art, multiculturalism, and the Christian opportunity afforded by these developments in various magazines including *Radix* (USA), *TrueTunes* (USA), *CIVA newsletter* (USA), *Symbols and Reality* (New Zealand/India), *Third Way* (UK), *Artyfact* (UK), and *Salon Da'Arte* (US, online webzine). His two books are: *Crying for a Vision* (Stride Books, UK, 1991) and *Like A House on Fire* (Cornerstone Press, 1997). Transcripts of his Cornerstone lectures were included in *Artrageous: Volume One* (Cornerstone Press, 1992). In addition to this he has published several small press books of experimental poetry both here and in the UK. He has released seven albums of

music, four of which combine his poetry with background music. Much of this poetry and music is based on his travels in Europe and Southeast Asia. He has performed and lectured in the UK, Belgium, Holland, Croatia, Bali Indonesia, the Philippines and the People's Republic of China. Many of the recent lecture/performances both in the US and abroad focused on his mixed-media collaboration with painter Gaylen Stewart called *Crossing the Boundaries.* He is also on staff at Warehouse Christian Ministries, Sacramento, California

GAYLEN STEWART is currently an artist and lecturer based in Athens, Ohio. He received an M.F.A. in painting with a secondary major in art history at Ohio University, and a B.A. in painting from Central Washington University. He has received four grants from the Ohio Arts Council—one was a Projects Grant for an installation created in collaboration with California poet, Steve Scott. He also received a grant from Change, Inc., a foundation directed and juried by Robert Rauschenberg and James Rosenquist. His exhibitions in museums, galleries and art centers throughout the U.S. number nearly ninety, of which more than twenty are solo exhibitions.

He has taught painting courses at Ohio University and Rio Grande University. His art is representational, mixed-media painting revolving around science, documentation of his healing from cancer, and personal relationship with Jesus Christ. He has been happily married for sixteen years to Vicki Stewart, a hair stylist. He plays lead guitar in a worship band, plays keyboards and sings. His favorite music is funky-blues-modern-eclectic-drop D-jazz fusion-proliferation of noise-heavy guitar distortion-gospel—without the "boom chuck boom chuck." He plans on pushing his art into new multi-disciplinary directions. His art work can be viewed at *www.gaylen.com.*

GREGORY WOLFE is the publisher and editor of *Image: A Journal of the Arts and Religion* and the director of the Center for Religious Humanism. He has published essays, reviews, and articles in numerous journals, including *First Things, National Review, Crisis, Modern Age,* and *Chronicles.* Among his books are *Malcolm Muggeridge: A Biography* (Wm. B. Eerdmans, 1997) and *Sacred Passion: The Art of William Schickel* (University of Notre Dame Press, 1998). Wolfe is also the editor of *The New Religious Humanism: A Reader* (Free Press, 1997) and the co-author of *Books That Build Character* (Touchstone, 1994), *Climb High, Climb Far* (Fireside, 1996), *The Family New Media Guide* (Touchstone, 1997), and *Circle of Grace* (Ballantine, forthcoming, 2000). He received his B.A., *summa cum laude,* from Hillsdale College and his M.A. in English literature from Oxford University. Wolfe is currently writing a book on religious humanism.

Square Halo Books

In Christian art, the square halo identified a living person presumed to be a saint. Square Halo Books is devoted to publishing works that present contextually sensitive biblical studies, and practical instruction consistent with the Doctrines of the Reformation. The goal of Square Halo Books is to provide materials useful for encouraging and equipping the saints.

WWW.SQUAREHALOBOOKS.COM